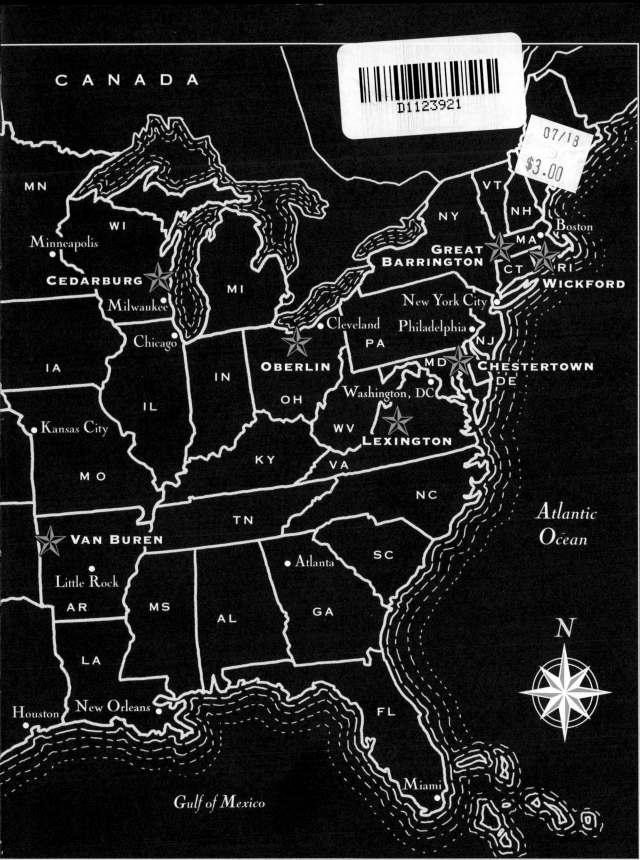

CANADA

MN

WI

Minneapolis

CEDARBURG ⭐

Milwaukee

MI

Chicago

IA

IL

IN

Kansas City

MO

VAN BUREN ⭐

Little Rock

AR

MS

AL

GA

LA

Houston

New Orleans

Gulf of Mexico

VT

NY

NH

MA • Boston

GREAT BARRINGTON ⭐

CT ⭐ RI

WICKFORD

New York City •

Cleveland •

Philadelphia •

NJ

OBERLIN ⭐

PA

MD ⭐ **CHESTERTOWN**

DE

OH

Washington, DC

WV

⭐ **LEXINGTON**

KY

VA

NC

TN

Atlanta •

SC

Atlantic Ocean

FL

Miami •

N

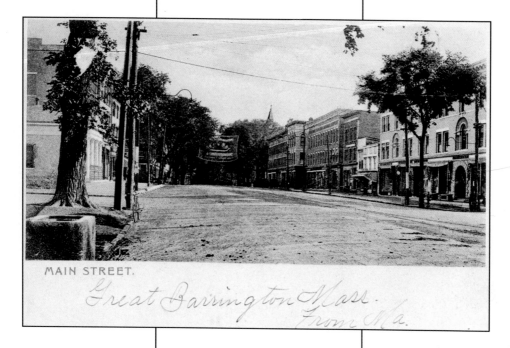

MAIN STREET.

Great Barrington Mass.
From Ma.

*Y*ou could see a town lying ahead in its whole, as definitely formed as a plate on a table. And your road entered and ran straight through the heart of it; you could see it all, laid out for your passage through. Towns, like people, had clear identities and your imagination could go out to meet them.

Eudora Welty
One Writer's Beginnings

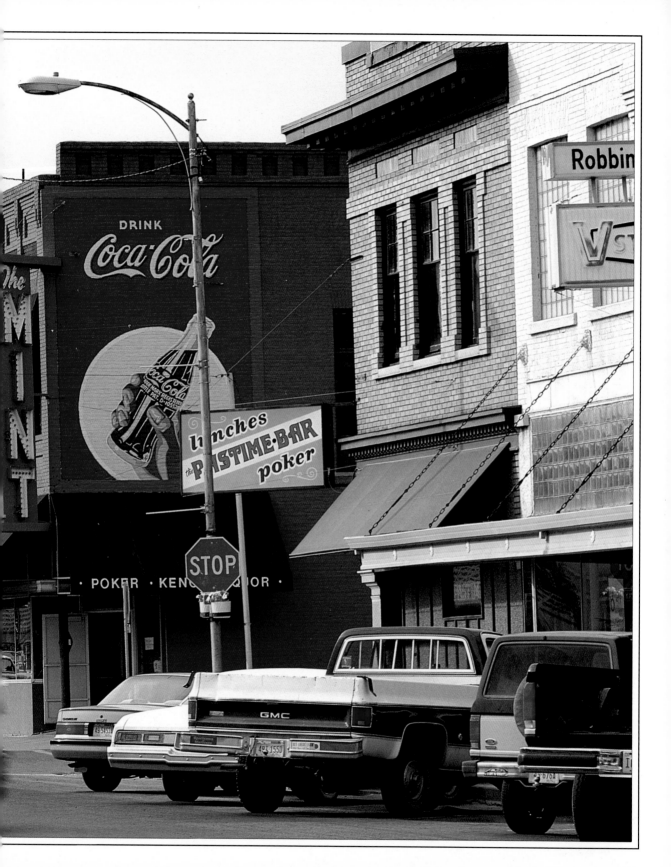

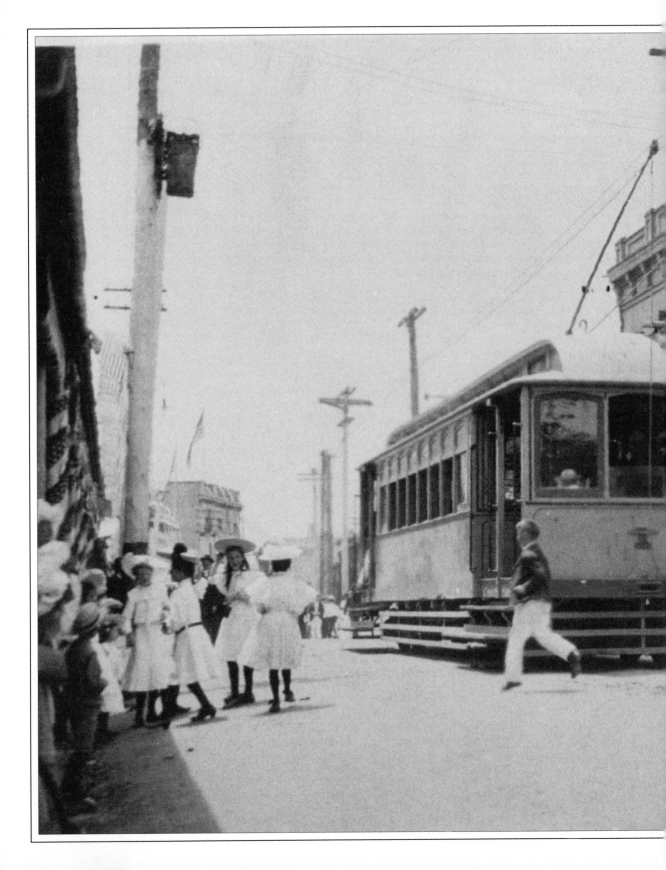

Pat Ross

REMEMBERING
MAIN STREET

*An
American
Album*

Contemporary photography by the author
Historical research by Leisa Crane
Design by Leonard Todd

VIKING
STUDIO
BOOKS

Also by Pat Ross

Formal Country

Formal Country Entertaining

To Have & To Hold

The Sweet Nellie HomeFile

It's Raining Cats and Dogs

The Sweet Nellie Nostalgia Gift Books

With Thanks & Appreciation *The Pleasure of Your Company* *With Love & Affection*
Motherly Devotion *I Thee Wed* *A Christmas Gathering*
One Swell Dad *Baby Dear* *A Birthday Wish*
The Grandest Folks *Son in a Million* *My Delightful Daughter*

VIKING STUDIO BOOKS
*Published by the Penguin Group
Penguin Books USA Inc., 375 Hudson Street,
New York, New York 10014, U.S.A.
Penguin Books Ltd, 27 Wrights Lane,
London W8 5TZ, England
Penguin Books Australia Ltd, Ringwood,
Victoria, Australia
Penguin Books Canada Ltd, 10 Alcorn Avenue,
Toronto, Ontario, Canada M4V 3B2
Penguin Books (N.Z.) Ltd, 182–190 Wairau Road,
Auckland 10, New Zealand*

*Penguin Books Ltd, Registered Offices:
Harmondsworth, Middlesex, England*

*First published in 1994 by Viking Penguin,
a division of Penguin Books USA Inc.*

1 3 5 7 9 10 8 6 4 2

*Copyright © Pat Ross, 1994
All rights reserved*

Photograph credits appear on page 230.

Library of Congress Cataloging-in-Publication Data

*Ross, Pat,
Remembering main street: an American album / Pat Ross.
p. cm.
ISBN 0–670–84784–4
1. City and town life—United States. 2. City and town life—
United States—Pictorial works. 3. Architecture—United States.
4. Architecture—United States—Pictorial works. 5. Historic
buildings—United States. 6. Historic buildings—United States—
Pictorial works. 7. United States—Pictorial works. I. Title.
E161.R78 1994 94–6018
973—dc20*

Printed in Singapore

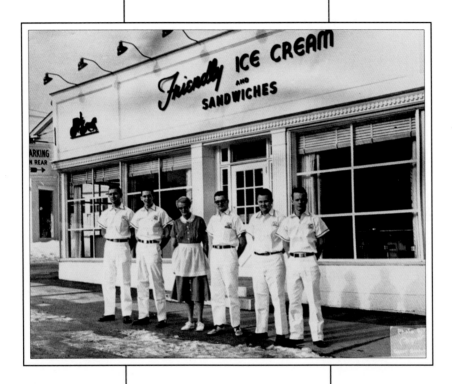

*F*or Erica

with love

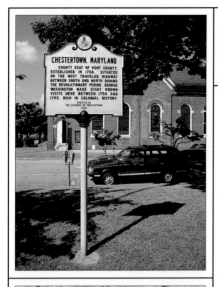

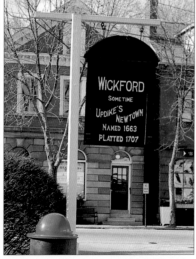

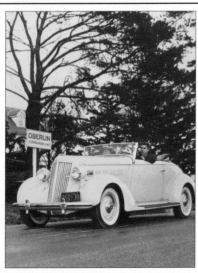

 ★ C O N T

E N T S

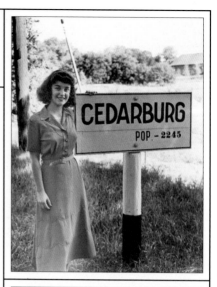

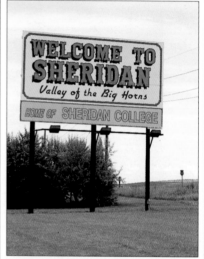

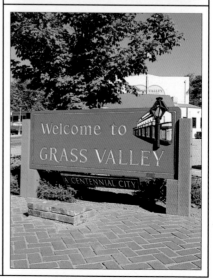

❧ *Acknowledgments* ❧

The seeds for this book were planted during a publishing-style lunch far from Main Street America. Thank you, Michael Fragnito, publisher of Viking Studio Books, for believing that I could go from idea to reality. My faithful editor, Barbara Williams, brought to this project her gentle yet persuasive probing, for which I am always grateful. So many others at Viking Studio Books were indispensable: Cathy Hemming, Amy Hill, Roni Axelrod, Joie Cooney. Leonard Todd, designer for *Formal Country*, again joined our team, producing a sensitive and innovative design.

The lion's share of the historical research and the writing of copious drafts for the historical sections of *Remembering Main Street* were done by Leisa Crane. Leisa's the kid in your class you wanted to sit behind, and the same kid you wanted to share a seat with on the bus ride home. Leisa and I shared many Main Street adventures together. In the text, when I speak of "we," I frequently mean Leisa and me.

During the long western trek, Joel Ross drove many of the seemingly endless miles of terrain between towns, learned to set up my tripod, chased down permissions, and became quite adept at spotting good shots. I give him my heartfelt appreciation for his unswerving support.

At the onset of this project, I met Jose Gaytan, an instructor at The International Center of Photography, and he soon became my coach and my friend. I am forever grateful for Jose's skill and talent, the clarity of his tutoring, and the high goals he set for me.

For technical support, I'd like to thank Jellybean, Scope Associates, L & I Photo Labs, Ken Hansen Photography, and Galowitz in New York.

The endless job of putting this book together was shared with a number of dedicated Pat Ross & Company, Ltd., staffers: Bernice Berkower, Arlene Kirkwood, Sandy Washburn, and Galia Finzi. Amy Berkower at Writers House continues to be my understanding agent and friend.

The support from the ten towns in *Remembering Main Street* was essential. I'd like to thank the following individuals from Chestertown: Hurtt Deringer and Tricia McGee at the *Kent County News*; Nancy Nunn at the Historical Society of Kent County; Edith and Norton Bonnett; Alex and Marjo Rasin; Carla and Al Massoni at the Imperial Hotel; Mayor Elmer Horsey; Michael Bourne; Tyler Campbell; Paul Pippin; the Chestertown Bank of Maryland; Joanne and Don Toft at the Widow's Walk Inn; and Chris Havemeyer at the White Swan Tavern.

From Lexington: Martha Doss at the Historic Lexington Visitors Bureau; Mitzi Perry-Miller at the Ruth Anderson McCulloch Branch/A.P.V.A.; Diane Herrick, Rosemary Purcells, Caroline Swope, and Woody Sadler at the Main Street Downtown Development Association; Lorraine Ennis at the Chamber of Commerce; Matthew W. Paxton IV at the *News-Gazette*; Steve Davis and the staff at Grand Piano & Furniture Co.; Vaughan Stanley and Lisa McCown at the Washington and Lee University's Special Collections/ Archives; Michael Anne Lynn at the Stonewall Jackson House; Nathan and Avent Beck; R. Reid

Agnor, Jr.; and the staff at the McCampbell Inn.

From Great Barrington: James and Lila Parrish at the Great Barrington Historical Society; Marlene Drew at the Mason Library; Bernard Drew at the *Berkshire Courier*; Joan Griswold; Ken Weeks; Morgan Buckley; Barbara Allen at the Berkshire County Historical Society; Gary T. Leveille; Tony at The Snap Shot; Pamla Raye, Bob, and the staff at Main Street Action; Gary Happ at 20 Railroad Street; Norma Marshall; Al Schwartz at the Mahaiwe Theater; Sheila Chefetz at the Country Dining Room Antiques; the staff at Village Hardware; Mario and Karyn Tsakis at Memories; Mark Bachman; Peter Kinne; Officer Heady; and Josephine Mallory at Town Hall.

From Wickford: Karen Pizzaruso and Cynthia Easdon at Askham & Tellham, Inc.; Tom and Erma Peirce; Mary Beth Reilly and Rudy Hempe at the *Standard-Times*; Martha Smith at *The Providence Journal*; Mary Ann and Bill Sabo at the John Updike House; Dave Ryan and the Ryan family at Ryan's Market; Robin Porter; Betsy Steinman; Ralph Henry; Pat Carlson; Susan Berman at the North Kingstown Free Library; Melissa Fisher at The Bookstore in Wickford; Anne Wallau at Topiaries Unlimited; and Violet and Charles Daniel and all the guests at their garden-party reception.

From Oberlin: Roland M. Baumann and Brian Williams at the Oberlin College Archives; Geoffrey Blodgett of Oberlin College; Priscilla Steinberg at the Chamber of Commerce; and the Gibson family.

From Cedarburg: Joan and Harold Dobberpuhl; Edward Rappold; Robert Teske and Cathleen Clark at the Cedarburg Cultural Center; Jim Pape at the Washington House Inn; Kate Myers at the Chamber of Commerce; Tom Wilson and the blacksmiths at The Cedar Creek Forge; Dave Schwalbe; and Brook and Liz Brown at The Stagecoach Inn.

From Livingston: Doris Whithorn at the Park County Museum; Suzanne Schneider at The Sport; Val at Insty-Prints; John Fryer; and John Hudecek.

From Sheridan: Helen Meyers at the Sheridan County Fulmer Public Library; Bill Rawlings; Bobby Ernst; Anita Nichols at Freelance Fotoz; Margie Bliss at the HF Bar Ranch; Christy Love; Marilyn Bilyeu; Dan and Bessie George; and the Sheridan County Extension Service.

From Van Buren: Dr. Louis Peer, former chair of the Urban Renewal Committee; Steven Peer; Richard Hodo of the Old Time Merchants Association; Doug Gibson and the staff at Old Time Photography; Doris West at the Crawford County Historical Society; Margorie Armstrong at the Chamber of Commerce; H.C. Cartwright; Roger Saft at the Fort Smith Public Library; the staff at the Arkansas Room of the Van Buren Library; Ralph Irwin at Art Form Galleries; Chet and Virginia Bridgewater at Bridgewater's Antiques; Joe Lloyd, Jr.; The Glass Barber Shop; Jackie Henningsen at the Old Van Buren Inn; Berry Ann Greer at Kopper Kettle Candies; Suzanne Tongier; Rick Moon and the men at Moon's; Lillie Aguilar at O'Malley's; Jim "Potlach" Parker; Amelia Martin at the Fort Smith Historical Society; and Bradley Martin at The Fort Smith Trolley Museum.

From Grass Valley: Ed Tyson at the Searls Historical Library; the reference librarians at the Nevada City Library in Grass Valley; Carol Scofield at Newstalk KNCO; the members of the Grass Valley Centennial committee; Ron Sturgell and Jack Clark at the Video & Pictorial History Library; Richard Briggs; Helen Williams; Michel Janicot; Marilyn Monzo at the Chamber of Commerce; Lani Lott and Sue Person at the Grass Valley Downtown Association; Linda Rasor, Bonnie Bridge, April Harrell, and the staff at the Holbrooke Hotel; and Bob Paine.

Leading the groundswell for the revitalization of Main Street are the smart people from the National Trust for Historic Preservation's National Main Street Center in Washington, D.C., as well as in many regional offices. Special thanks to: Kennedy Smith, Jim Lindberg, Jackie Redding, Patricia Noyes, Diane Kerr, Karen Vuranch, Jim Davis, and Jennifer Erdman.

Many special friends and family became the glue that kept me together throughout this project. Thanks are due to Jan Arnow, Evan Hughes, Peter Ermacora, Linda Cheverton, Walter Wick, Nancy and Jim Hays, Jacqui Fried, Gene Heil, Charles Muise, Jane Bergere, Lisa Gaytan, Holly Horton, Margie and Tom Haber, Sue Ellen Bridgers, Chris and Keith Scott Morton, Judy and John Doyle, Stan Tusan, Bo Niles, John Livsey, Geri McGavick, Frank and Donna Clemson, and Charles Crane. And, as always, my love and thanks to my mother, Anita Kienzle. Unfortunately, it is impossible to thank everyone who so thoughtfully sent clippings, post cards, and suggestions my way.

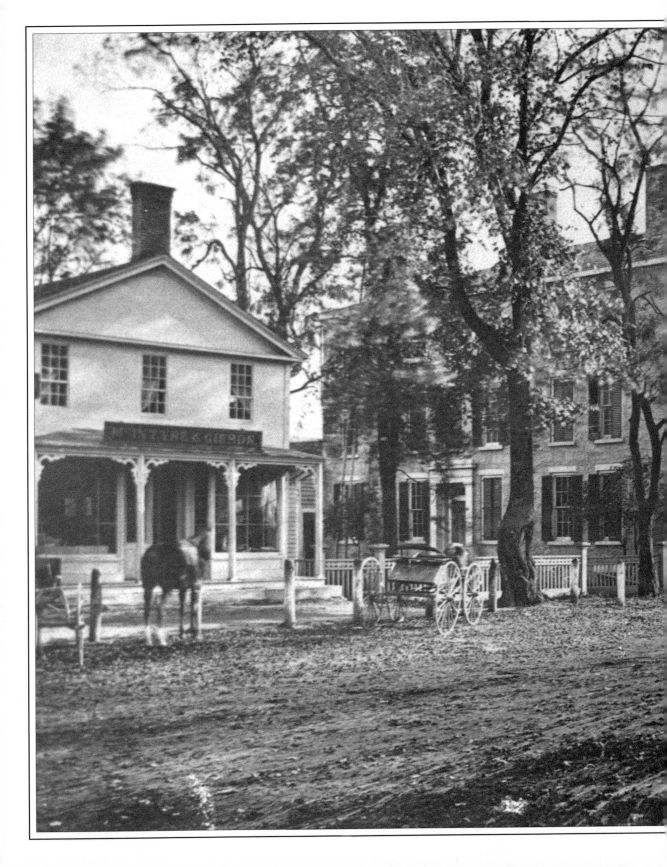

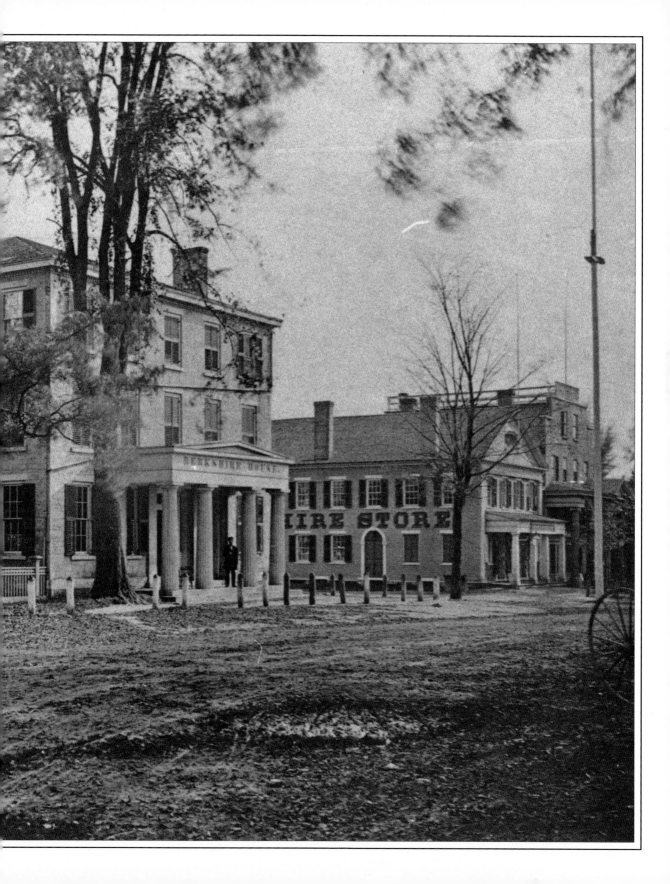

A Brief History

Main Street is a familiar icon of American life. Whether the hometown thoroughfare of our immediate memory is called Main or one of its other no-nonsense designations—High, Broad, Central, Grand, Market, Front—we know this place.

Main Street's beginnings were dictated by logic and need: a settlement sprang up along a widened Indian trail; a rutted stagecoach route was upgraded to meet the demands of a rapidly expanding transportation system; the roadway from a growing port pushed inland. In a relatively brief time, Main Street civilized the American wilderness and gave American small-town enterprise a home base.

There was a sizeable time gap between the establishment of early American agrarian society and the active beginning of nineteenth-century westward expansion, which preceded America's rise as a major economic power. It was at this time that Main Street came into its own, especially with the development of commercial architecture and the growth of the railroad system. While Eastern towns had developed at a more leisurely pace, Western Main Streets virtually sprang up wholesale! Burgeoning land speculation and town promoters often relied heavily on a standardized grid plan. So in the end, Eastern and Western Main Streets, despite the happy variations of regional materials and local aesthetics, presented similar faces.

This book does not attempt to be an academic study of 300 years of Main Street history. Rather it hopes to draw readers—through the format of both archival and contemporary photographs with accompanying text—into the rich and varied historical elements that find common ground in ten American small towns. The towns themselves provide a lively documentation of architecture, transportation, trade and distribution, culture, and community life. Whether through the tale of a thriving port, a bustling railroad town, or a busy riverboat junction, the growth of America can be seen through these strong and remarkable stories.

The familiar appearance of Main Street today—its seemingly haphazard, steppingstone arrangement of building heights, styles, and mate-

rials—offers a record of a town's visual and functional evolution, generally dating from the mid- to the late nineteenth century. Sadly, in most towns, all but a few traces of eighteenth- and early-nineteenth-century history were razed by fire or ravaged by other natural disasters. Historical photography and other archival documents remain the only tangible vestiges of Main Street's physical beginnings—the primitive roadways, the wood-framed buildings, the multipurpose structures that typified Main Street in its infancy.

We have taken the symbols of Main Street for granted: the town green, where good spirit prevails; the local diner and its comfortable fare; the well-stocked five-and-dime; the bright lights that dance around the movie marquee; the imposing facade of the local bank; the stately Town Hall; the church steeple, reminding Main Street of its spiritual commitment; even the old-time bar. In times past, "going to town" meant trading products and livestock on the village green, stocking up on supplies, and socializing with friends. It meant an arduous buggy ride over bumpy roads on Sunday morning to gather together in prayer. For later generations, "going to town" meant piling into roomy family cars and dusty pickups and driving from isolated farms and hamlets on Friday night for supplies and a welcome break. The eras may have been different, but the idea was the same. "Hanging out" is what the generations had always done on Main Street. Main Street was a friendly place to go.

But by the 1970s, Main Street was beginning to look more like a dead end. New superhighways bypassed small towns, siphoning off the traffic flow. America's rural roads were no longer thoroughfares, but out-of-the-way destinations; "just passing through" no longer applied. Strip malls sprawled over the landscape outside of town, offering an easy, albeit impersonal, approach to filling shopping and recreational needs. The chain stores undercut Main Street's prices. The climate-controlled mall tried to be the modern village green. Ironically, when the allure of steel and chrome began to pale, some strip malls tried to recreate themselves in the look of classic Main Street America. In an attempt to compete with the mall, Main Street disguised its aging buildings with modern facades and gaudy signs. Main Street America was little more than a compromise on its way out.

This was not the first time that Main Street had felt threatened by big business. In 1870, a mail-order catalog business called Montgomery Ward & Company—followed little more than a decade later by Sears Roebuck & Company—sent waves of panic through small towns across the country, where locally owned and managed stores were an abiding tradition. Forming local boards of trade in the 1890s, later to be organized as Chambers of Commerce, was one way Main Street fought back. By 1910, the fight was expanded to include the "chain-store menace"—rising giants like A&P and Woolworth's.

But the twentieth-century loss of Main Street meant a loss of history and its visible landmarks, a loss of roots and emotional connections. As contemporary America struggled with the impersonal nature of malls, computers, and fax machines, it needed a way back to the values that Main Street stood for. It once appeared that Walt Disney's staged settings and a handful of "historic recreations" might be all that would be left of this bygone institution.

People talk a lot about the way Main Street has changed and how it will never again be the same. But the history of Main Street *is* a history of change, a history of evolution. Throughout the decades, the fortunes of towns have ebbed and flowed. Main Street has never been static. Traditionally, periods of bust have been followed by periods of boom.

Fighting apathy and an inability to change the course of declining downtown areas, a growing number of people are determined to restore the tenor of small-town life, to bring Main Street back—if not to what it was, then to a new kind of civic health. Using time-tested survival tactics, towns are simply dusting themselves off and starting on a new tack. In short, Main Street is reinventing itself.

In some fortunate communities, a tradition of active preservation and civic responsibility has long existed. Even in the face of economic shifts, these communities are able to maintain the original physical appearance of the downtown, thanks to various buildings codes and zoning restrictions. But an overwhelming number of Main Streets are faced with serious physical decay and overall economic decline. Without a legacy of preservation, a fix-up campaign has not always been enough.

In 1980, the National Trust for Historic Preservation created the National Main Street Center to aid communities around the country in preserving their most valuable resource—their historical commercial buildings—and finding viable uses for these structures. The Main Street approach, working through a fast-growing network of state and regional Main Street programs, utilizes a comprehensive four-point strategy that focuses on design, organization, promotion, and economic restructuring. The first national effort to provide role models and direct technical assistance to communities in their revitalization efforts was provided by the National Main Street Center. Through a series of outreach programs, the Center works toward making community revitalization a national priority.

Aiding these efforts has been the increasing availability of independent Main Street "consultants." At town meetings around the country, local business owners, historic preservationists, and other concerned citizens are posing hard questions about the direction of their Main Streets. Many of the answers are coming from these well-versed specialists, who make recommendations on such aspects of town life as architecture, infrastructure, business, and demographics, working with both the public and private sectors. Main Street now has a choice of approaches available to it.

Although most small towns today depend on tourism for much of their economic survival, the towns represented in this book who openly invite tourism have managed to promote this aspect of their economic health and retain a sense of authenticity as well. What all these ten towns share is vitality, a commitment to using the lessons of history to inform the future, good basic architecture, a refreshing lack of artifice, community involvement, and kindness to strangers. They have been arranged from east to west so that the story of Main Street grows as does the story of the country's settlement.

My hometown of Chestertown, Maryland, has a population that remains fairly constant at 4200. It quickly became a small-town prototype for me because of its continuing commitment to history, admirable architectural preservation, many original buildings, a wide tree-lined main street called High Street that runs from the waterfront up a gentle incline through the town, and, last but not least, townspeople who tell you that they wouldn't live anyplace else.

Sheridan, Wyoming, borders on being a big town—or a small city, depending on how you look at it—with a population of 15,000. It is, in fact, the biggest town and has the longest Main Street in this book. But Sheridan still has a small-town sense of community; the old families are still there; people are happy to take time out and talk. I knew Sheridan from years of vacationing there at a dude ranch with my family. Sheridan is where I buy my boots when they wear out, and where dudes gawk at the real cowboys in the Mint Bar. It's the kind of place where the local paper still considers the county-fair winners big news. Two days after I arrived there, I stopped in a shop on Main Street and introduced myself. A woman behind the counter uttered a phrase right out of an old Western: "We heard you were in town."

At the other end of the population spectrum is the gregarious small village of Wickford, Rhode Island. Its population count is largely unknown, owing to the fact that Wickford is considered—at least by the post office—a part of North Kingstown, despite Wickford's commercial importance. When pressed, locals will venture population guesses that range from 1,500 to 2,500, depending on the borders one chooses. This makes Wickford the smallest town in *Remembering Main Street*. Standing at the corner of Brown and Main gives you a good vantage point for most of the activities in downtown Wickford.

Lexington, Virginia, is a model Main Street town that pulled itself up by its bootstraps and revived its image as a historically charming and economically viable community using its colorful past as a basis for its future. Much the same can be said of Cedarburg, Wisconsin, whose homogeneous limestone architecture and very way of life were threatened by the possible destruction of the town's mill, which now serves as a bustling commercial center. Van Buren, Arkansas, is another jaws-of-death story. It was, in the words of one local merchant, "plain dead" when a group of committed residents banded together and began painstaking restoration of the remarkable Victorian buildings that line Main Street. Now merchants live on the street where they work, in the very buildings they saved.

Oberlin, Ohio, where Tappan Square brings together "town and gown" around a central green

that is host to year-round community activities, enjoys a rich history as a college town with ideals. Community service is held in high regard in Oberlin. There are other college towns represented in the book—in fact, four of the ten towns mention colleges in their own descriptive materials—yet Oberlin embodies the cultural, economic, and spiritual connection between the two entities in a way that represents the best of "town and gown" coexistence.

There's been a natural flow to the development of downtown Great Barrington, Massachusetts, over the years, and a renewed commitment on the part of their Main Street Action group to maintain the personality of the town as it embarks on a revitalization program. It's the town's authentic character that has attracted so many weekenders from nearby cities since the turn of the century.

Contrasting with towns in New England and the East, whose histories date back to the country's founding, is Grass Valley, California, a former gold-rush town in the hills north of Sacramento that celebrated its hundredth Fourth of July with great humor and gusto. Still filled with its original energy, Grass Valley has galvanized a cross section of the community to form a committed core group that does everything from judge parades and inter-view senior citizens to offer assistance with merchants' problems and architectural renovation.

Anyone who's ever driven through a small American town knows there's a rhythm different from the town before, and different again from the town farther down the road. The ten towns in this book only begin to represent the remarkable variety of Main Street. From the glow of the gaslight to the glare of neon, Main Street is rich, unique, diverse.

The future of Main Street has less to do with technology than it does with the zeal of the people who live there and their commitment to making the community vital once again. The towns that flourish have succeeded by finding ways to capitalize on nostalgia while at the same time remaining firmly planted in the present. Through personal service and community activities, the cordial spirit of memory is becoming a reality once again.

Main Street is more than a line on a map. It's a sense of place, a reflection on a simpler past, a connection to a heritage. In our heart of hearts, Main Street means coming home.

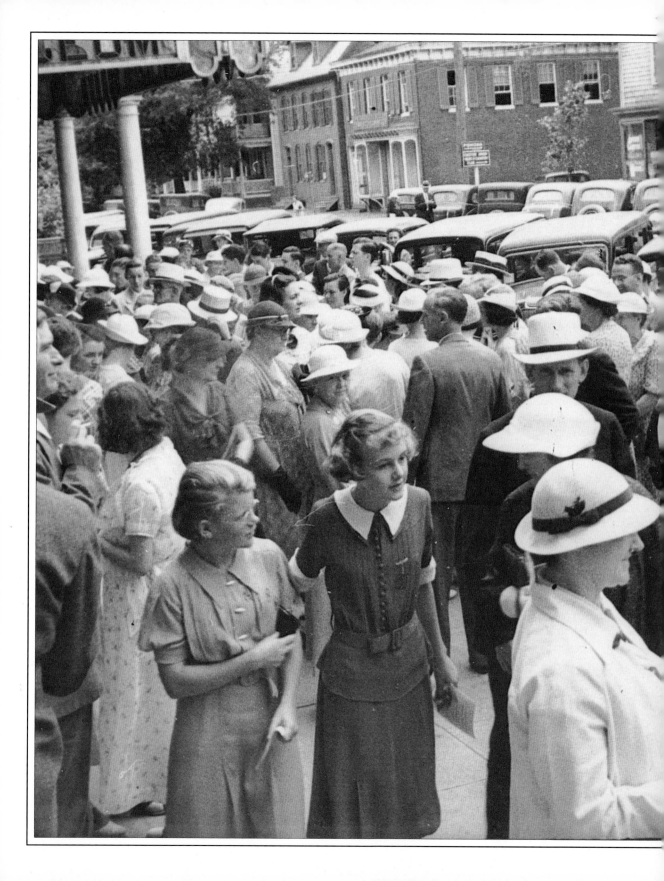

*An
American
Album*

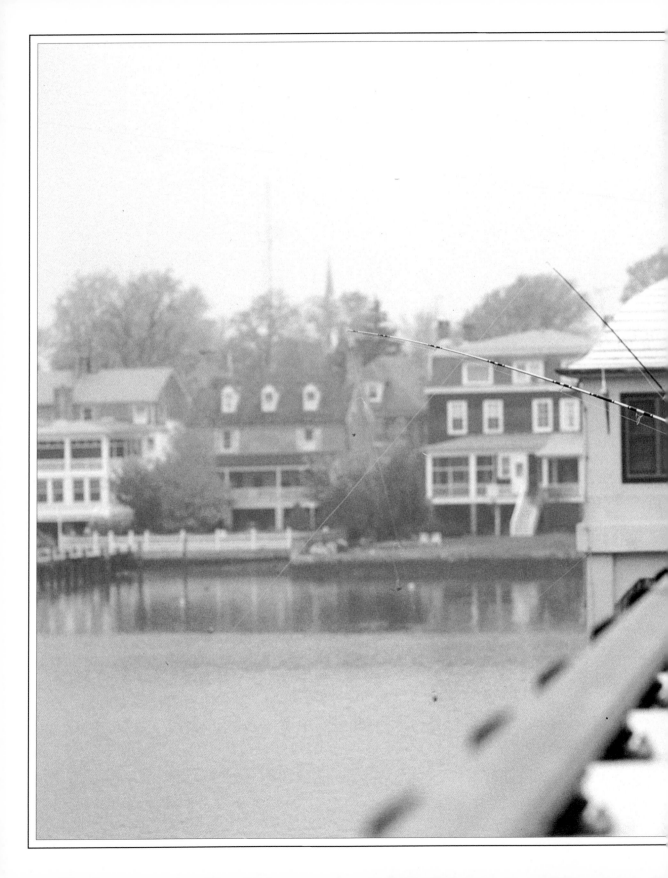

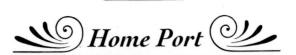
CHESTERTOWN MARYLAND

There's no quick and easy way to get to Chestertown. I was reminded of that as I turned off Route 95 south of Wilmington, Delaware, curling past cornfields and crossroads, wending my way home through tidewater country.

With my family living elsewhere and the old hometown friends now scattered, it had been years since I'd made this drive from New York. Yearning for big-city life and a publishing career in the mid-sixties, when women were supposed to become nurses or teach school close to their roots, I had turned my back on small-town life and concentrated on a faster track. But with the frenzied city pace requiring more and offering less, I was eager to begin this book back home, curious to see how time might have changed those three long blocks on High Street—the model for the generic Main Street of my memory.

Getting stuck behind a tractor on the two-lane Chester River Bridge on my final approach to town quickly reminded me that some things never change. In a rush, I remembered the silliness this same drawbridge used to elicit from my sister and me as we'd chime in unison, "DRAW bridge!" and go searching through Mother's handbag for something to draw with. Then, as though to bring me back to the present, the bridge's warning bells began to sound, its lights flashed, and the draw ascended, letting motorized vehicles know that sailboats are still king around these parts.

On the drawbridge, with time to appreciate the grand colonial homes only a few feet from the waterline on the Chestertown side, I was prompted to recall how the town has always been significantly affected by its proximity to water, being bounded by it on three sides, both protected and isolated by its geography. Kent County, the smallest and least populous in the state, is blessed

Entering Chestertown via the Chester River Bridge (*previous pages*) affords an elevated view of notable waterfront residences and brings visitors within walking distance of the historic downtown.

In 1907, many Chestertown homes and offices had sweeping bird's-eye perspectives of the town such as this one (*right*). These black-and-white, tinted, and color lithographs reached the height of popularity during the late nineteenth century, when mock aerial views of communities were created by artists who recorded their impressions from hilltop vantage points or, in the case of this Chestertown map by T.M. Fowler, from an imagined "bird's-eye" vantage point. These artful lithographs were widely distributed as maps and as posters; they were used to promote overall economic development and nourish the town's pride. A view such as this, replete with finely rendered important town edifices, makes this Chestertown map all the more distinctive. Artists and lithographers found a thriving popular market for their work, and commissions were common. By the 1920s, however, tastes had changed, and aerial photography had largely replaced decorative lithography.

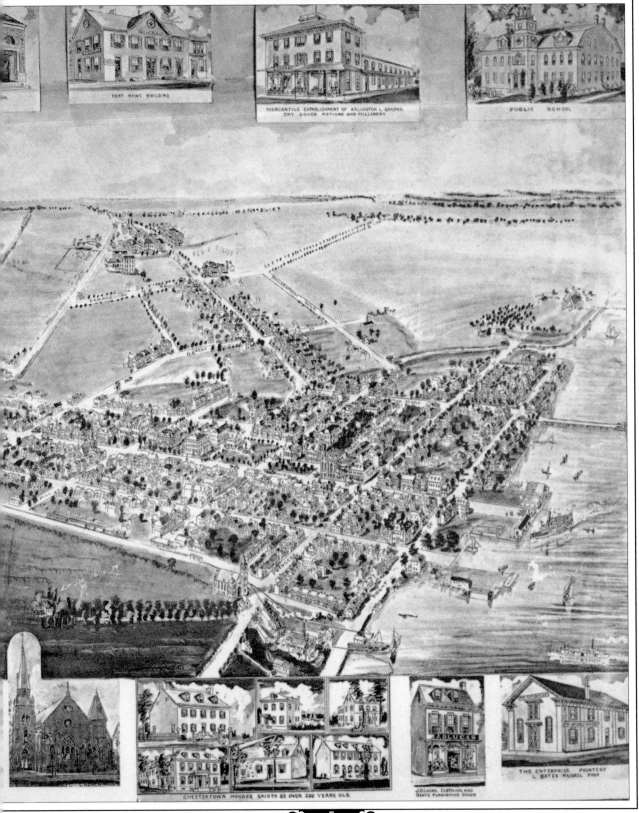

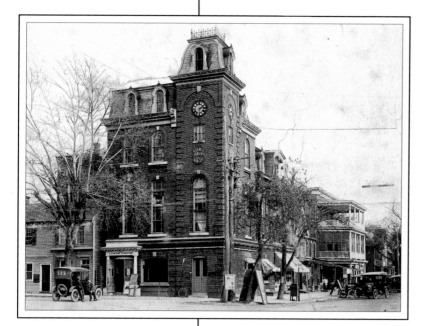

Stam's Hall (*above*), which was opened in 1886 by druggist and merchant Colin Stam, housed Stam's flourishing business on the ground floor. The second and third floors of this magnificent beaux arts building, with its mansard roofs and sandstone details, soon became the town's social hub, offering live entertainment and holding public gatherings. An 1894 *Chestertown Transcript* reported that a Mr. Goshaun, the Canadian mind-reader, held a street performance in front of Stam's, creating "the wildest excitement . . . a surging mass of people, black and white, young and old" among the "unusually quiet population."

A view of Stam's Hall today (*above, right*) illustrates how the majestic tower still dominates the streetscape.

A shot taken from Stam's Hall tower in the 1930s (*opposite*) provides a bird's-eye view of High Street.

with 209 miles of the Eastern Shore's legendary shoreline. It can be said that a town's fortunes lie in its location. Surely the town drew a favorable lot by being settled on this site.

What better location for an early-eighteenth-century port than Chestertown: navigable waterways combined with the area's fertile soil, well suited for agriculture, thus ensuring steady growth for a profitable shipping trade between the town and England—first by sailboat, later by steamer. Designated one of eleven "planned" towns by English governor Charles Calvert in 1668, Chestertown became an official port in 1706. As my car neared the bridge's crest and a tall sailboat passed with barely a wake, I looked to my left, along the waterline, at a wide street that appeared to end abruptly in the drink. The town's beginning, the main street's origin, the reason for its being—it was all right there, leading up High Street inland to the chief public buildings. No longer an active dock, the end of High Street now offers a restful spot to park and be mindful of the river, a romantic spot where the full moon always looks as though it might at any moment drop into the dark ripples below.

Once across the bridge, I took Queen Street to the Imperial Hotel, perversely pleased that I avoided the two traffic lights on High Street. I decided to sneak into town unannounced, needing a work schedule free of social obligations. There is little need here to lock my extra camera equipment in the trunk, yet—a New Yorker now—I did this all the same.

The last time I entered the building that is now the fashionable European-style Imperial Hotel I was a teenager visiting a friend's

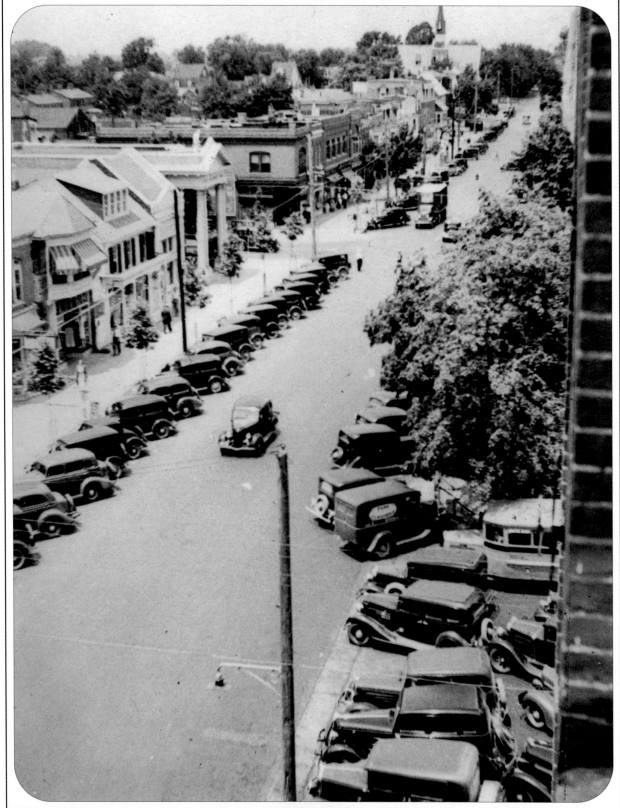

During its early years, the apothecary C. F. Stam & Brothers was located in Stam's Hall. This early drawing shows the soda fountain that made Stam's an institution. Today, when someone says they're going to Stam's, they're either in need of health and beauty aids or a Coke or a milkshake. Stam's, eventually relocated in a building across the street from its former location, is legendary for its flavored Cokes. It's one of the few places that still offer Cokes flavored with an old-fashioned variety of syrups, including vanilla, cherry, lemon, and even the rare aromatic spirits of ammonia—all ordered by the squirt at no extra charge for more than one squirt. Stam's Cokes were special,

but throughout my childhood it was their cool, smooth chocolate milkshakes that made a trip to town worthwhile.

Wondering if my childhood memories might have become exaggerated over time, I returned to Stam's and ordered my favorite. When my shake came, served in a glass, I asked about the old paper cones in metal holders that I remembered. "We've still got the holders," the young man told me, gesturing to a cabinet filled with them, "but nobody sells the cups anymore." Cup or glass, my shake lived up to expectations.

As I left, I noticed an article about milkshakes in and around Chestertown ("including joints across the river") written by a Washington College student named Adam Brown for the

college paper. The article reveals what longtime residents have known for years: "Stam's. Hands down, the winner. Don't try to lead or follow, just get out of the way. Don't ask these ladies what kind of ice cream they use or how much syrup they put in. Don't ask any stupid questions, just stand back and let them work. They know they've got the best shake in town. Stam's destroys the competition with glee and zero remorse. Every cup is consistently perfect in all respects. It's the absolute; metaphors can't contain it. A deadly milkshake they make. The *übermensch* of milkshakes. Call it the *übershake*." Brown goes on to say that, among other things, the competition is "slimy," "lacks thickness," is "too light on the syrup," "lacks the zing of greatness," and that the "waitresses are rude."

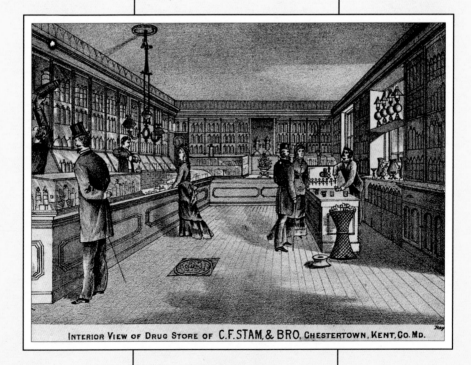

INTERIOR VIEW OF DRUG STORE OF C.F. STAM, & BRO, CHESTERTOWN, KENT, CO. MD.

mother who worked in an insurance office there. Today, diners enjoy gourmet meals in these same rooms, now given old Chestertown names like Vickers and Hubbard. The clock has been turned back to a time when taverns and inns like this one served a bustling town, complete with stately eighteenth-century Georgian and Federal residences as well as newly prosperous commercial establishments. As a child, I gave little thought to the many elegant merchants' homes and the customs house that remain as architectural legacies of the period of shipping prosperity. Today I shudder at the memory of our teenaged crowd hanging out with friends who lived in the elegant eighteenth-century Hynson-Ringgold House on Water Street, their parents unaware of dull loafer scuffs on the ornately carved chairs, sweaty Coke bottles on delicate tea tables, and telltale Camel ashes in fine porcelain bowls. Most of us lived in history, and it made us blasé. It was not until 1973—well after I had moved away—that the town began to stage a yearly reenactment of the Chestertown Tea Party of 1774 as a reminder of British involvement and the fierce community spirit of Chestertonians that continues to underlie the soul of the town.

As I headed for High Street on foot, my bags quickly tossed in my room, an acrid odor overwhelmed me, the lingering reminder of something gone awry. My plan was to ground myself in an establishing shot of High Street, the main street of the town, then work my way up and down the two commercial blocks, eventually moving off the main thoroughfare to Cross Street, a short but active street that intersects High Street. Chestertown is laid out in a simple cross pattern, with rectangular subdivisions fitted neatly onto its natural topography. The resulting figuration leaves the river as a prominent axis of the town. I know the spot on High Street where the street takes a gentle roll downward, offering the best vantage point for a picture. But as I headed in that direction, I was stopped by a yellow police ribbon that cordoned off the entire block.

Since early that morning, when I hit the New Jersey Turnpike and switched to cruise control for that never-ending stretch, I'd been playing Main Street memory games. During my early childhood years, we lived far enough from town to make Friday night trips into Chestertown an event. We would try to spot someone pulling out of a head-in parking spot on High Street, preferably right in front of Fox's Five-and-Dime. (Sadly, the advent of parallel parking has ruined the nostalgic appeal of sitting in your car as though at a drive-in.) While Mother "visited" with the people on High Street, my sister and I checked out things at Fox's. It was at Fox's that I bought my first

New brick sidewalks, arranged in the style of sidewalks from the nineteenth century, are part of the town's historic preservation efforts. Laid during the 1980s, the brick replaced the existing concrete walkways.

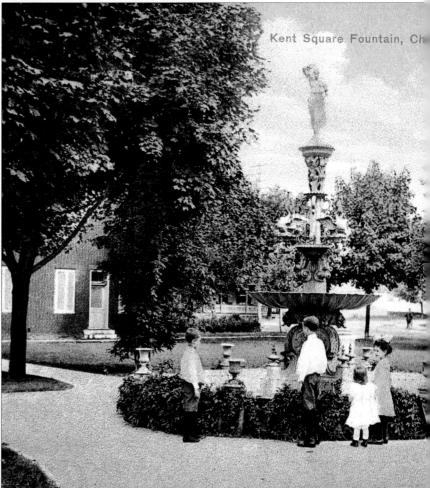

Kent Square Fountain, Ch

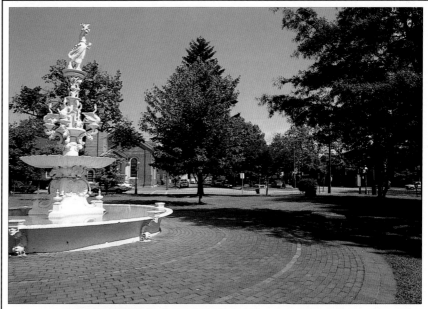

Early town planners called for two town parks on the east side of High Street. From Kent Square, there is a view of Emmanuel Episcopal Church (*above*), one of Chestertown's stately cornerstones. The park area had originally served as a market center. The farsighted plan to set aside an undeveloped tract has long provided residents and visitors with shade and respite from the bustle of High Street.

A vintage postcard view of Kent Square (*above, right*), dedicated in 1899, shows off its graceful fountain, which contains more than 100 components that were purchased from Robert Wood's ornamental ironworks in Philadelphia. At the dedication, bouquets were placed in the fountain's urns.

The postcard was issued by M.A. Toulson, a local apothecary who joined with Stam's Drugs to sponsor a contest to determine which lucky resident would be the one to unveil the fountain.

town, Md.

town, Md.

In Kent Square today (*left*), the fountain's original classic urn adornments have been removed, and only the supports remain. The lush vines at the base of the fountain in the earlier postcard view were probably removed when a brick path replaced the original gravel one. Otherwise, Kent Square remains much the same, maintained today in cooperation with the Chestertown Garden Club.

Evening in Paris perfume—a scent with real staying power, packaged in a curvaceous blue bottle that hinted at forbidden pleasures. Even if we'd had dinner at home, Jeanne and I would pool our change for a gooey grilled cheese sandwich at the soda fountain near the front.

Ironically, had I not postponed this trip by three days because of the imminent threat of rain, I would have been in Chestertown when McCrory's, formerly Fox's Five-and-Dime, burned to the ground in a fire that blazed dangerously out of control for many hours. As I stood on High Street looking at the substantial empty space that ran the full width of the block, I understood the acrid odor lingering in the late summer afternoon.

Fire—a tragic yet common event in any town's early history—is not new to this block. In 1910, fire ravaged the main High Street area. This latest fire took a veritable battalion of fire companies responding from as far away as northern Maryland and Delaware to quell its flames. Later, when I spoke with someone whose child had just heard the news, his comment brought the generations closer: "Mommy, where are we going to get grilled cheese sandwiches now?"

The next day, I watched as the *Kent County News,* Chestertown's chronicler of joy and woe since 1793, hit the newsstand, bringing a full front-page account of the devastating blaze. No newsboy leaves this paper on a doorstep or shouts its headlines. Instead, one of the newspaper's early-bird employees unceremoniously deposits a pile of papers in a rack just outside the news office's front door at 7:30 A.M., leaving behind a small container in which to deposit the cost of a paper. In this town, the honor system still works. Like clockwork, residents pull up their trucks and cars just long enough to pick up an issue, their motors still running. Pedestrians materialize as if by magic.

Later that morning, Hurtt Deringer, *Kent County News* editor for the past twenty years, invited me to make myself at home with bound volumes of the paper's back issues. The fragile, yellowed pages are filled with bits of gossip that speak of a town where everyone knows everyone else, a curse and a blessing. Columns of a social nature include visiting company (if only cousins and just for the day), dances (an 1893 New York Philharmonic concert at Stam's Hall promised to "eclipse anything of the kind ever in town"), church socials, teas, promotions (one fellow is congratulated for his promotion to assistant weigher of grains), clubs ("The Quiz Club" is formed in January of 1892), and, alas, illness, "the grip" being the most rampant of public maladies. Poor Mr. A. H. Crew, in the February 27, 1892, issue "was attacked with the grip several days ago while driving along the public road.

The Imperial Hotel, with its gracious two-tiered porches facing High Street, is seen in an early hand-colored postcard view (*below*) and as it exists today (*below, right*). Erected in 1903, it was known then as the Hotel Imperial and used as an office and store as well as a place of lodging. Over the years the building also served as apartment dwellings, and the Victorian details of the facade and interior were neglected as the need for more functional space arose. In 1985 it was reopened with well-deserved fanfare as a hotel and restaurant, painstakingly restored to Victorian splendor.

The carriages in front of the building in the post-card view might well have belonged to patrons in search of a hearty meal or lodging for the night. Grain for guests' horses was stored in the sub-basement, just below street level, and shoveled from bins to the street.

He became delirious under the influence of the fever and required five men to keep him within bounds." I read on about weddings of the week: "Miss Emma Gilpin, the bride-elect, will be dressed in white with orange blossoms and veil, while the groom will wear a full dress suit." Moving on to hard-news items, I found only a brief rundown of national and state events, followed by a more detailed account of a frightened horse on High Street and the annual spring "snowstorm" of the silver maple trees that was "pronounced a nuisance."

It was still easy to make it into the paper when I was growing up. Finding your name in print for the slam dunk that guaranteed the high school championship, the Lady Baltimore cake that won the blue ribbon, or the Halloween costume someone's mother spent all night making is an unsung gift of small-town life. The town's 250th anniversary celebration in 1956 made the front page for many weeks running. On the day of the big parade, I rode on a local bank's float, dressed like a true Daughter of the American Revolution. Even today, reporters cover every conceivable local activity—from bake sales to bridge club tournaments. Events on High Street can still be found on page one, with a healthy sampling of local and national issues.

For most of the eighteenth century, Chestertown had a well-developed civic center, with an official courthouse (1707), a customs house (1740s), and a flourishing county school, which became Washington College in 1782. Its economy was buoyed by mid-century with the production and trade in wheat

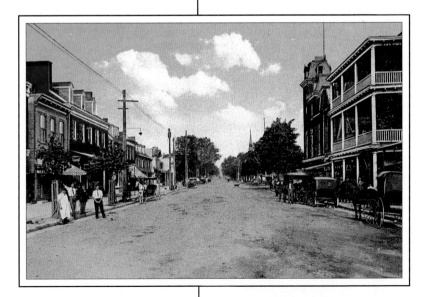

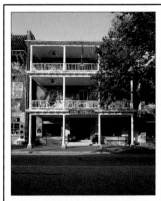

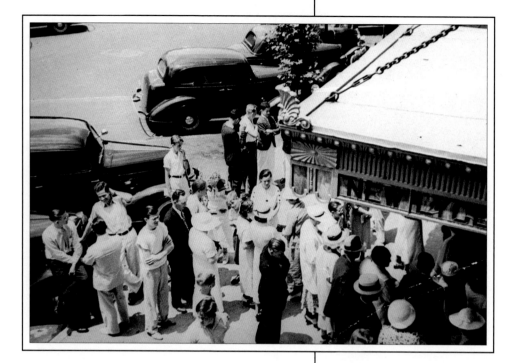

The New Lyceum (*above*) opened on High Street next to the Hotel Imperial in 1928, supplementing the entertainment at Stam's Hall, which became known as the Old Lyceum. The decorative metal details on the New Lyceum's marquee add a modern glamour to an otherwise Colonial townscape on High Street. The New Lyceum was the theater of my childhood, where we'd line up for the double-feature matinees — usually Westerns — every Saturday afternoon without fail. Today, renamed the Royal Prince, the theater has closed temporarily for renovations.

crops. The town prospered, and many new storefronts emerged on High and Cross streets.

The events following the American Revolution, however, did not bode well for Chestertown. The river — its trusted lifeline — had begun to fill with silt. Soon Chestertown saw its shipping trade going instead to the fast-growing harbors in Annapolis and Baltimore. The harbor was no longer filled with the sailing ships that carried away locally grown grain and tobacco, and the town became increasingly isolated. But its fortunes began to rise again in the second half of the nineteenth century, when fruit and tomato farming brought an economic boom, followed in subsequent years by an ever-increasing agricultural industry. The 1860–1900 census figures show the number of residents to have risen to 3,008, fifteen hundred short of the present-day population.

Evidence of that mid-century "boom" period can be seen in the many buildings that remain from that time. The beaux arts Stam's Hall went up in 1886. The prominent 1772 Emmanuel Episcopal Church — long considered a cornerstone of the town plan — underwent changes to its Georgian facade during this time. The Victorian Italianate-style courthouse was built in 1860 of dark brick and centered on the block, with its main entrance facing High Street. The "new" Washington College campus (the first building having been destroyed by fire in 1827) was built between 1845 and 1854 on Chestertown's highest bluff in a combination of

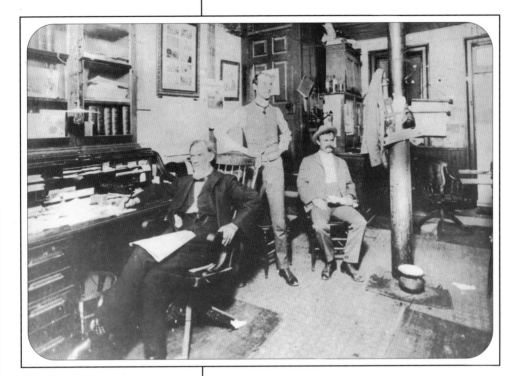

William B. Usilton (*above*), seated in the foreground, was the first editor of what is now the *Kent County News;* its first edition appeared in 1793 under the name the *Chestertown Transcript.* Mr. Usilton's colleagues are unidentified. The weekly paper was put together in this one room just off High Street, a spittoon placed near the support column that serves as a coat rack.

Many of the historical photographs in this chapter have been taken from the Usilton Collection, a rich repository of the town's photography that first appeared in the *Kent County News.* A number of these were taken by the late Bill Usilton, Jr., a descendant of the founder.

Greek Revival and Italianate styles. So many styles were possible in a small town like Chestertown partly because many constituent building parts could be bought ready-made in Baltimore.

Evidence of twentieth-century architecture in Chestertown is not dramatic. Modest growth brought some new buildings in the first few decades. The Imperial Hotel, at that time called the Hotel Imperial, made a splash in 1903, with its double-tiered veranda overlooking High Street. The New Lyceum—now the Royal Prince—located adjacent to the Hotel Imperial, was built in 1928 entirely of yellow brick, an unusual building material for Chestertown. The Chestertown Bank, built of sandstone in the neoclassic style in 1929, is perhaps the showiest of the twentieth-century buildings. I can remember going there as a child, hand-in-hand with my father, awed by the high Roman atrium and intricate tile floor.

The years since I moved away have been times of gradual change, of appreciating the history, solidity, and variety of the town's architecture and shoring up its undeniable physical strengths. The courthouse, having outgrown its nineteenth-century Italianate structure, was expanded with a Colonial Revival addition in 1967. In 1977, restoration of the 1733 White Swan Tavern was begun, taking the building back to its eighteenth-century roots as a tavern and general store, having served as a shoe store and then a newsstand during my childhood. Many small

On the surface, Hurtt Deringer is a mild-mannered writer, editor-in-chief of the *Kent County News* since 1974. But beneath his easygoing exterior, this native Chestertonian carries an inner torch, a passion for retaining the town's character and its relaxed way of life. As a newsboy on the paper, Hurtt remembers hanging around the old newspaper offices. "I realized my boyhood dreams," he told me with enviable contentment in his office, where his computer seems out of place in this paper jungle.

When Bill Moyers visited Chestertown a number of years ago, he participated in a group discussion about the Chesapeake Bay held at Washington College. Hurtt was among the participants and wrote up the occasion for the *Kent County News*. When Bill Moyers read this account, he sent Hurtt a handwritten letter in which he said: "When I was a young man my ambition was to edit the newspaper of a small town. It wasn't a romantic vision; I know the hard work involved. But I believed then that nobody can quite care for a place like the newspaper that lives there, or stick up for it. . . . Your column is evidence of it."

In the first newspaper account to follow the fire at the former Fox's Five-and-Dime site, Hurtt expressed the community's sentiments in a brief, nostalgic eulogy, published on September 2, 1992.

REMEMBER THE FIVE-AND-DIME

Nothing so marked Saturday's tragic fire to some oldtimers as the death of the five-and-dime.

A High Street institution since the 1940s, McCrory's was the descendant of Fox's five-and-ten store. They both became legends.

Nothing so marked the places as the ladies that worked there and their knowledge of their store.

They could find the safety pins with the light out.

Two originals from the late Baurice Fox days were Virginia Usilton and Mary Hanifee.

They had been there for so long they seemed to sense what you wanted even before you asked. They often knew what you wanted when you did not.

They knew the store backward and forward, inside and out.

Part of their tribute was how tidy and neat they kept the place.

But, best of all, McCrory's, like Fox's, always had that five-and-dime atmosphere. There is no atmosphere like a five-and-dime. The aisles have a special smell.

Maybe, the day is over for the five-and-dime in some places in America. Maybe the discount stores are too entrenched. Maybe the shopping malls are too tough to beat.

But, in downtown Chestertown if you wanted something in a hurry—you came to McCrory's.

Hopefully, that day—the day of the five-and-dime—is not dead.

After all, in Chestertown, Maryland, there is still a train station. There is still a movie theater. You can still get a milkshake at the counter at Stam's.

Why can't Chestertown still be one of those places that hangs on to some of the good things, like a five-and-dime?

We heard about a kid who once lived in Chestertown many years ago. She had a Fox's in her new hometown in the north, too. She called it "M-Fox's." She called the one back home "B-Fox's."

Back in Chestertown for a visit to her grandparents, she always yelled out when she drove down High Street, "I'm back, B-Fox!"

Hurtt Deringer
Kent County News

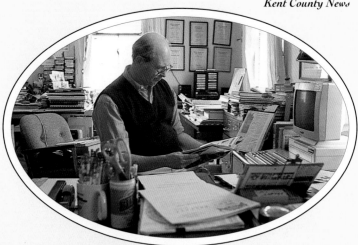

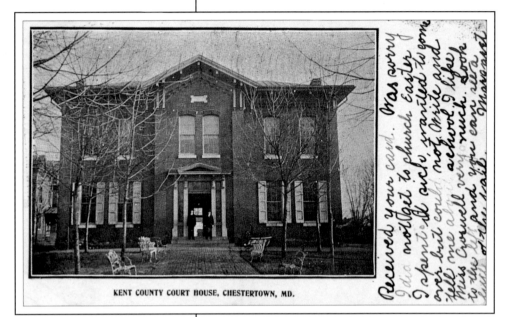

KENT COUNTY COURT HOUSE, CHESTERTOWN, MD.

A postcard, showing the old Kent County Courthouse (*above*), was sent to Miss Aldie Clements in Crumpton, a nearby town. Today we forget that in 1906 telephone communication was nonexistent, or shared on party lines in rural areas, so dropping someone a line on a postcard was sometimes the only way to catch up on news or make one's presence felt. The courthouse scene may have appealed to the sender for the dignity and importance of this landmark.

The original 1707 courthouse no longer exists. The front section of the present courthouse was built in 1860—a T-shaped plan whose main facade faces High Street. Constructed of dark, hard bricks in a Victorian-Italianate style, it served the community well until 1969, when a Colonial Revival–style addition was made.

shops have cleaned and preened their facades. In the business area, the concrete sidewalks were torn up during the 1980s and bricks reminiscent of yesteryear's walkways were painstakingly laid. A few old-timers have been said to grumble about the difference in the new bricks' patina, but no one asks to bring back the concrete.

Having breakfast on the second-floor porch of the Imperial Hotel is like stepping into the pages of a nineteenth-century

novel. On one particular morning, I'd taken advantage of the early light to do some shots of High Street, so my breakfast was running on the late side and I found myself alone on the porch. A pleasant woman, who told me she'd grown up in a nearby town I knew well, brought an impressive tray of coffee and breakfast rolls to my table by the railing. The ornate silver service was set for one. Despite my worn jeans and T-shirt, I rose to the occasion and remembered my manners. Sitting alone on the porch, I was able to comprehend why "gracious," "quiet," "dignified," and "quaint" are often-used adjectives for this town. I could hear the door of a car being closed almost a block away. It was not a slam or a bang, but a gentle conclusion to an everyday journey. Early morning greetings are friendly yet politely restrained. This may not be considered the South, but this is a Southern town at heart.

During my next visit to Chestertown, the news of the day stood in stark contrast to the tranquillity I experienced months earlier on the Imperial veranda. As if the fire on High Street were not enough to deal with, another force introduced itself: Wal-Mart announced its plans to build a 100,000-square-foot store on the Washington College side of town. The existing strip mall in that part of town suddenly seems small by comparison. Over the winter, I followed the debate through accounts in the paper and conversations with friends. The town is split over the mega-store invader. Committees are formed; boards meet; marches take place on High Street. The *Kent County News* takes up the cause in Thomas Paine fashion. The National Trust's Main Street Association offers its full support. All of a sudden, it is not unusual for longtime friends to pass each other on the street without speaking because of the rift that this issue has caused.

Although I am deeply concerned about the fate of Main Streets

Sometime after the 1860 courthouse was built, a movement arose to create street-side offices in the Court Street area for legal practitioners. Soon local lawyers began to erect small offices (*bottom row, this page and opposite page*) in the former market space that faced the courthouse. It was later known as Lawyers' Row. Built close together, with front doors literally opening onto the sidewalk, the townhouse-like buildings are notable for their engaging cornices and attractive shingles. Second- and third-generation lawyers, updated with computers and fax machines, still own and work in these quarters, sharing a long-standing tradition.

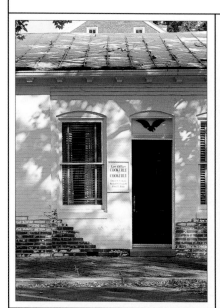

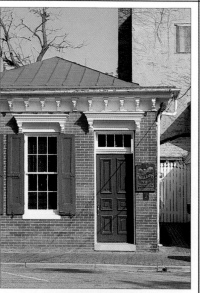

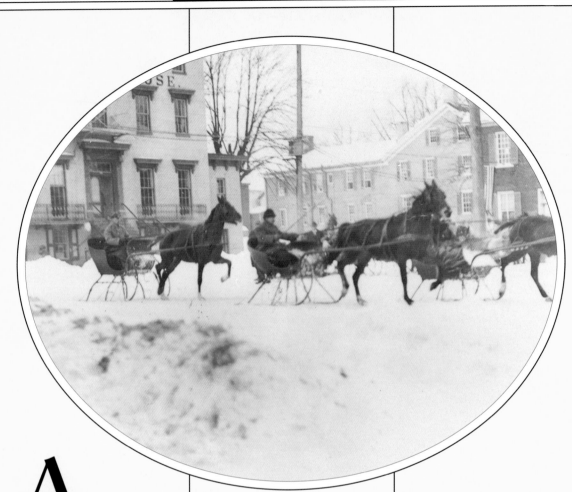

Accounts of sleigh racing on High Street figured prominently in winter news. Racers and their horses were well known throughout the community. According to an account in a February 1899 *Kent County News,* the sport was enjoyed by both sexes: "Chestertown boasts of her fair [residents] at all times, and her success in handling a horse is as great as in many other respects." At the first sign of a good snowfall and a solid base on High Street, the races would begin. The following account from an 1862 newspaper recounts the excitement of an unusual sport open to anyone who had the horse, the sleigh, and the nerve:

"A hundred sleighs were bunched within two squares at times and the skillfulness of drivers is all that saved many accidents. The sight at times was fearful as a score or more of trotters came at a rapid pace down town, weaving in and out, passing and repassing; equally as many were returning up-town and not a single serious accident occurred! The streets were fairly lined with people deeply interested in watching the races and repeated cheers would go up as the finish was made. It was a thrilling scene and we doubt whether a town in the State has such a brilliant time as do the people of Chestertown and Kent County during a sleighing carnival."

and small towns across the country, my concern here is of a far more personal nature. Can the new brick sidewalks compete with the concrete of a shopping center just out of town? Will the milkshakes at Stam's continue to draw fans from far and near? What will be built where Fox's Five-and-Dime used to be? There is a list—albeit a very short one—of small towns that have weathered such storms, but the course is arduous, and change is inevitable, even harsh.

I want to park again along High Street and feel the energy of people who know their neighbors. I want to go back for the Halloween parade every year and photograph my friends' children and grandchildren. But I am an observer now, hoping for the best on the sidelines. Then I recall the bold action of the Chestertown Tea Party in May of 1774, how the stouthearted citizens hurled an untold quantity of foreign tea overboard into the Chester River where High Street ends, letting outsiders know exactly how they felt. For all their gentility, citizens around these parts have always had a fair degree of spunk. As I packed up my car for yet another long drive back to New York, I hoped that memories of my Main Street are still safe and sound.

My first-grade classroom was on the first floor of this grand turn-of-the-century building when it served as a public elementary school (*below*). One of the town's prime examples of the Colonial Revival style, the building features a high gambrel roof and a pair of dormer windows. The entrance tower's second level has a Palladian window, the third level a bull's-eye window.

My most vivid memories are of the fire drills, when we'd have to climb out a window into a gigantic metal chute attached to the back of the building and slide down the covered chute to the playground below. Today, the building (*below, left*) is used for municipal offices. The fire escape of my memory has been torn down. The trees that were planted along the front walk many years ago have grown so full that they block the walkway entirely.

Chestertown's serene waterfront scene has changed little since this vintage postcard (*right*) was published by Louis Kaufmann & Sons of Baltimore, who billed themselves as "Publishers of Local Views." Today, visitors are still greeted by a pleasantly wistful view of the stately homes on Water Street.

The site of the original port of Chestertown is now a popular scenic spot (*below*) for young and old, plus a few feathered friends. On the far side of the river, a classic shoreline scene (*opposite page, bottom*) depicts the symbolic and geographic connection to the water.

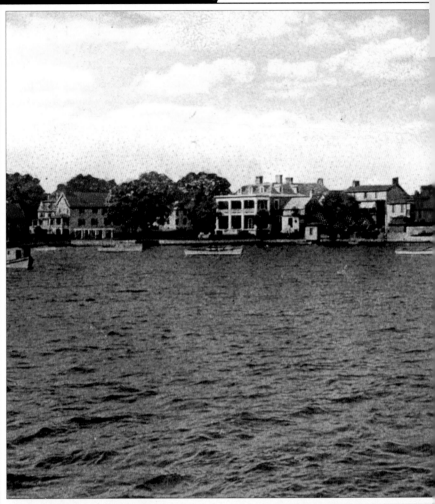

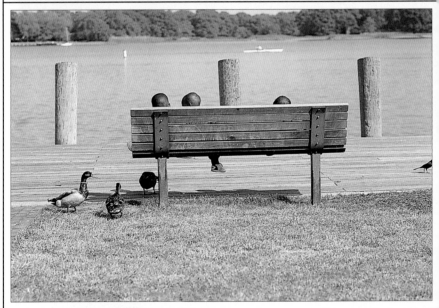

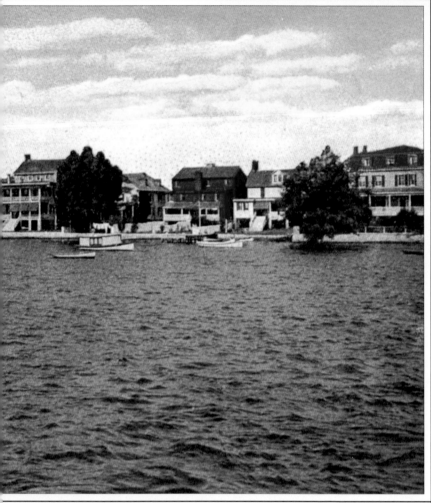

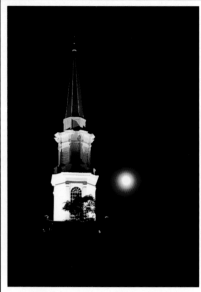

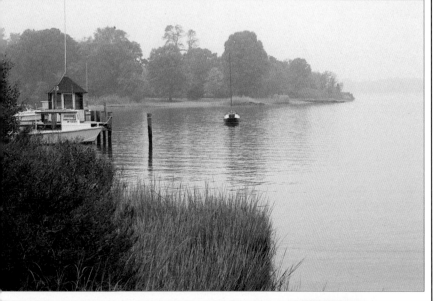

On my final visit to complete the photography and research for this hometown chapter, I stayed at the Widow's Walk Inn, a bed-and-breakfast located in a grand Victorian house right next to the elementary school of my childhood. I kept hearing the voice of my first-grade teacher, scolding the class about disturbing the people in the house next door. Now I *am* the people in that house next door.

I was considering an early bedtime when I heard a gentle knock at my door. Don Toft, who owns the inn with his wife, Joanne, came to let me know that a full moon was rising above the tall spire of the First United Methodist Church (*above*). He said I could get a good shot from their yard. So, in the coolness of the summer evening, the ghost of my old school hovered like a dinosaur in the dark while I shot the lemon yellow moon, its movement across the sky imperceptible except to the camera's long gaze.

LEXINGTON VIRGINIA

We arrived in Virginia on a perfect spring day. The drive through the lush Shenandoah Valley felt like an unexpected vacation, sunlight casting soft shadows across the early spring plantings and warming my disposition. For months, the weather had shadowed me with sleet, blizzards, rain, gray overcast, and even a barrage of hailstones, making conditions for photography unpredictable and frustrating. Although I needed little excuse to make return trips, nature's little games had begun to wear thin, playing mean tricks with my deadline and with my spirit. Then, as if by magic, Lexington, Virginia, broke the spell.

Lexington is protected and blessed by a still-rural location close to the Blue Ridge Mountains. Leisa Crane joined me on this trip, and together we traveled in the same principal migration and trade route taken more than two hundred years ago by journeymen heading into the West and Southwest, with Lexington as our destination point. As there were no full-fledged towns in this area prior to 1778, Lexington was destined from its early days to be an important court and commercial center in the region. What we now know as Lexington was sparsely settled with Scotch-Irish and German settlers when the Virginia legislature decided to create a new county and a new county seat. According to Royster Lyle, Jr., and Pamela Hemenway Simpson, in their book *The Architecture of Historic Lexington*, residents in the surrounding areas had grown "beastly tired of jogging along through sleet or heat, mud or dust to far Staunton and Fincastle when court duties required several days' stay in addition to riding."

An observer in 1855 saw "an indifferent town and rather small, with muddy streets." In 1873 the local newspaper said that the streets were "uncleanly" and the sidewalks unworthy of the name.

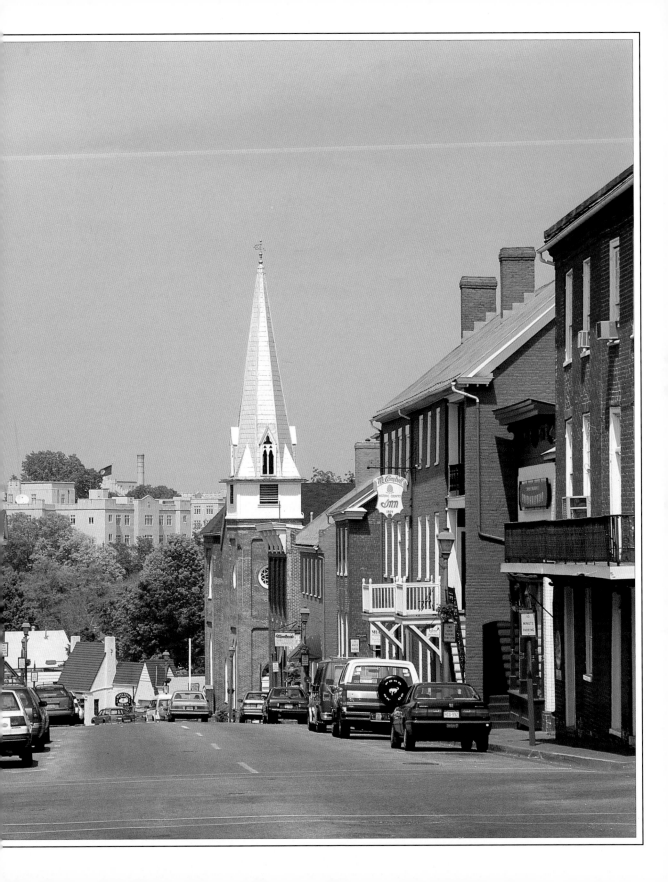

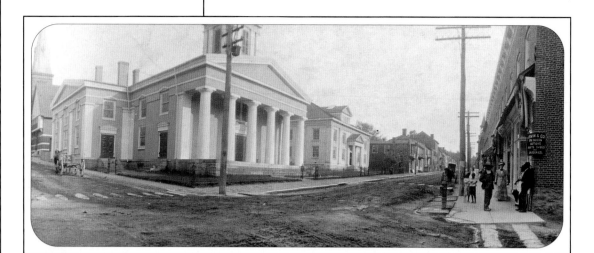

As they drive down Lexington's Main Street today (*previous pages*), visitors are immediately impressed by the absence of utility poles and the presence of electrified gaslight fixtures. The steeple in the distance is that of the First Baptist Church (1867). The national flag flies alongside the state flag above the Virginia Military Institute.

I am told that this panoramic shot (*above*) was taken by a person on a trip through Lexington around 1880. As the viewer looks south on Main Street, the Lexington Presbyterian Church dominates the streetscape. Utility poles become eyesores in this expansive shot.

Eight years later, however, there were paved streets, brick sidewalks, and waterworks. We entered town through a route that took us past the high fortress walls of the Virginia Military Institute and then past the rolling campus of Washington and Lee University on our way to the downtown area. The impeccably preserved buildings, attractive storefronts, and well-manicured lawns would surely have pleased and surprised even the most severe of Lexington's early critics. We headed down Main Street at a speed that any self-respecting horse could better, suddenly aware that in Lexington, Virginia, history turns back the clock.

Our room at the McCampbell Inn, formerly the historic Central Hotel, has a small balcony overlooking Main Street at a point where the hilly street makes an abrupt decline. From this bird's-eye view, I was able to do some scouting. In fact, I scouted uptown and down just by leaning out over the railing. From that vantage point, it was possible to see several historic buildings on Main Street, including the pillared Willson-Walker House—now a restaurant—where lunch was being served on the veranda, and the grand Alexander-Withrow House—now an inn—known for its exquisite diapered brickwork. My Mary Poppins perspective across the low roofline of the town was also directly in line with a glorious church steeple that appeared to have broken through the leafy skyline.

A large box containing dozens of historic photographs had been left for us at the desk of our inn, courtesy of the Lexington Downtown Development Association. I struggled up several flights of stairs with the heavy box, wondering why this photo file was matted on boards. It was not until we visited the association's headquarters the following Monday that we realized that an exhibition there had been, quite literally, taken down so that we would have the photographs for the weekend as reference.

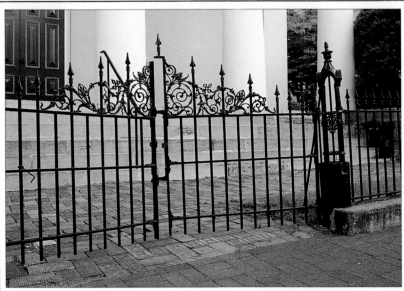

The Lexington Presbyterian Church as it stands today (*above*), a prominent landmark in the center of town, was built in 1845 according to the plans of Thomas U. Walter and is the best example of Greek Revival architecture in Lexington.

Beautiful ironwork details adorn the gates leading to the church entrance (*left*).

A somber procession in 1870 on Main Street shows residents and admirers of the legendary Robert E. Lee gathering to bury him. Viewers can see the Lexington Presbyterian Church on the right. The fancy brickwork on the prominent building in the center is evidence of the superior architectural details of the time. This building, sadly, is no longer in existence.

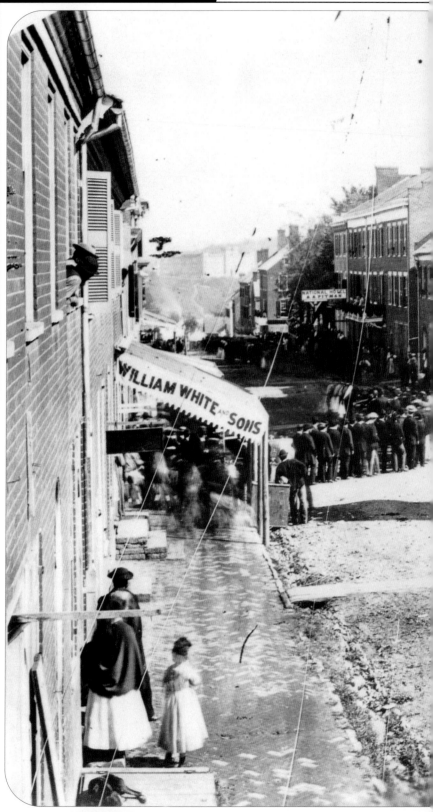

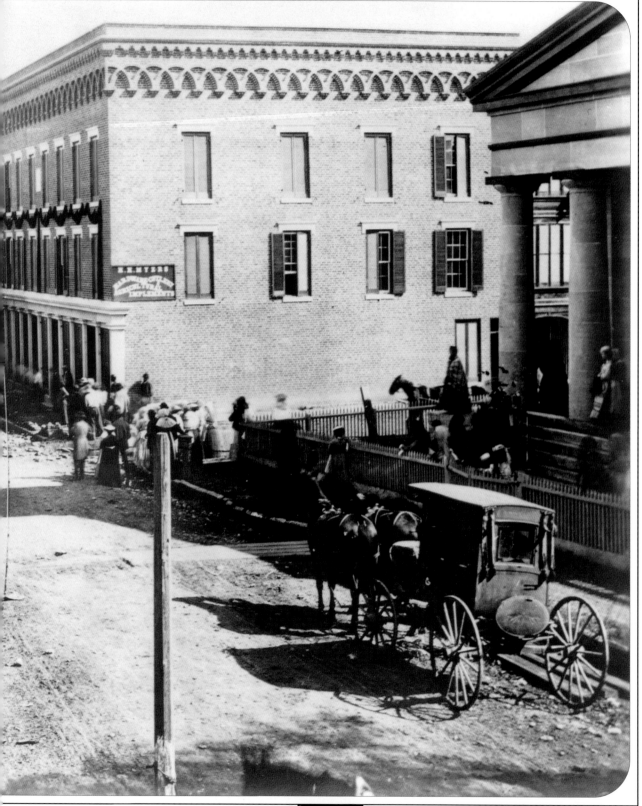

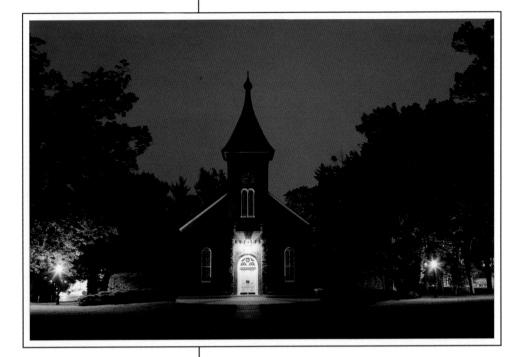

In 1867, at the request of Robert E. Lee and under his supervision, the Lee Chapel (*above*) was built on the campus of Washington and Lee University. Lee and his family are buried inside; his famous horse, Traveller, is buried just outside the chapel. Lee Chapel has become a national landmark.

I stood in front of the Washington Hall antebellum colonnade in a light rain, taking long exposures to capture this night view of Lee Chapel.

The aroma of freshly ground coffee was a dead giveaway to the contents of the gift bag that was left for us by the Lexington Visitors Bureau. There was also a tape by a local musician and a package of local postcards. A brochure describing "109 ways to enjoy yourself in Lexington and Rockbridge County, Virginia" did not seem to be stretching the point. It's been many years since I attended school in Virginia—northeast, in the Tidewater area—but I quickly recognized the familiar warmth of Southern hospitality. My Virginia education included frequent references to Robert E. Lee and "Stonewall" Jackson. Now I was about to take a refresher course.

History was indeed made on Lexington's Main Street. Robert E. Lee rode his horse, Traveller, down its simple dirt road when he came to assume the presidency of Washington College in 1865, a school that would later honor him by adding "Lee" to the name. Mourners thronged the street for his funeral in 1870. Later in our visit, we would find a rare photograph of this historic event. In 1891, some 30,000 people gathered at the Stonewall Jackson Cemetery off Main Street for the dedication of a statue in his honor. Visitors continue to pay honor to this fixture of Southern history.

As we walked up and down Main Street to get our bearings, then began to explore the cross streets, we found evidence of Lexington's rich history everywhere. Street signs bear the names of Virginians who were prominent figures in the Revolution: (George) Washington, (Thomas) Jefferson, (Thomas) Nelson,

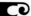

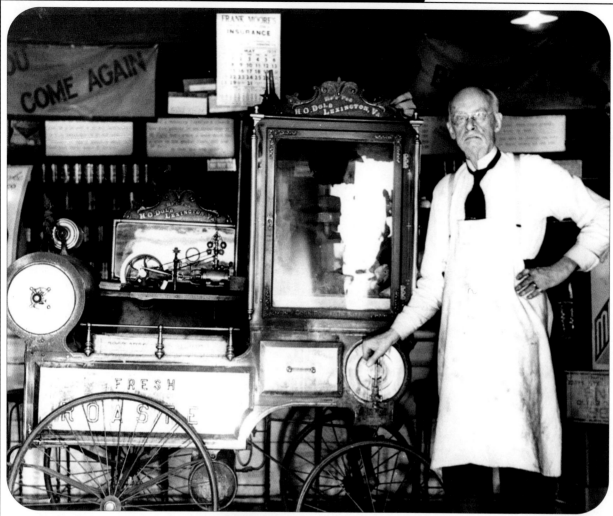

The popular merchant H. O. Dold, who billed himself as "the students' friend," was the son of the founder of an 1818 general store often called Dold's Corner (*right*). Mr. Dold is shown above with his famous peanut-roasting machine in 1939. His hot dogs and fireworks also got high praise, making Dold's a celebrated place to smoke, eat, and drink for thousands of students and cadets. Today, a gift shop operates out of the street level.

The main portion of the Central Hotel (*right and below*), which dates from 1907, was built on Main Street in 1809 by Joseph McCampbell as his town residence. During the 1800s it housed the Lexington telegraph and post office, a jewelry store, and a doctor's office. Decades later, twentieth-century students remember the hotel for its Central Lunch restaurant and bar, also known as "The Liquid Lunch." During the 1960s, it was a mod boutique called the Limit. In the 1970s, a psychedelic shop known as the Land of Oz was located on the first floor.

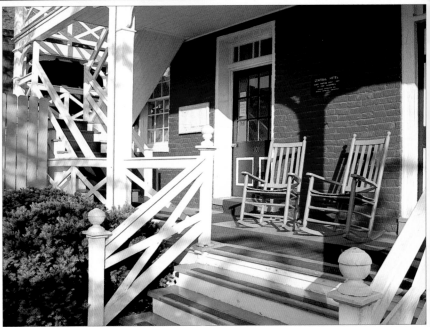

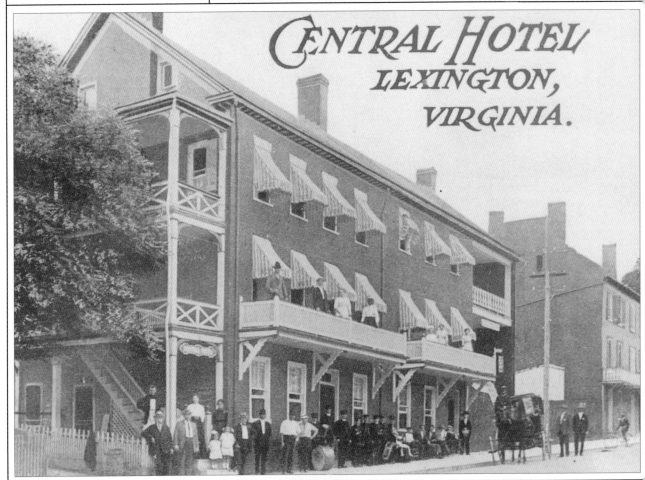

CENTRAL HOTEL LEXINGTON, VIRGINIA.

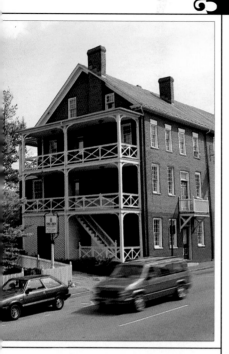

The old Central Hotel has come full circle today (*above*), having been renamed the McCampbell Inn in 1982 in honor of its builder. Over the years, porches were added to the side and to the rear of the original building; a second-story balcony was also added to the front. In 1965, fire gutted the third floor and damaged the roof. For one hundred and eighty-five years, this fine edifice has undergone alterations to serve the changing times. Today it is maintained as an admired landmark building of the town.

(Patrick) Henry, and (Peyton) Randolph. The town itself is named after the battle of Lexington, fought in the Massachusetts town where the Revolution began. I was grateful when we came to a plaque on the side of a handsome old building on Washington Street that reads: N. O. N. Historical Marker. This town also has a sense of humor.

Somewhat overwhelmed, we did what no self-respecting researchers would do: We acted like typical tourists and stood in line for a carriage tour of the town. Sitting in a surrey with fringe on top and nineteenth-century shock absorbers, we bounced along as our driver, a most congenial native named Bob, gave us a tour. His Southern drawl is warm and occasionally thick, so we strained to take in all the lively information and amusing anecdotes. The horse's hooves on the brick streets were muffled by the rubber shoes they wear. Being in the surrey, with someone else worrying about the driving, gave us a chance to appreciate the original town plan.

A traditional grid plan—or some variation of it—was most frequently employed by early town-planners in fast-developing rural areas. The grid plan was simple. A main street was established with streets running parallel to it. These were crossed at right angles by streets running in the other direction, forming neat rectanglar blocks. Developers seized on this quick and convenient plan, which required a minimum of surveying and little attention to topography. Typically, the central square was reserved for the courthouse or other important public buildings, creating a focal point for the downtown.

In the case of Lexington, the surveyor, James McDowell, reserved a prominent location for the new county courthouse, fronting Main Street and extending two full blocks. As the courthouse "block" developed, with a jail and a "lawyers' row" flanking it, the town took on a dignified air—except on certain Mondays. It was said that no self-respecting nineteenth-century lady would set foot on Main Street on Court Day, the first Monday of each month, when the many taverns and "groggeries" on the street offered a lively respite after local justice was dispensed with.

As our carriage passed the courthouse square, I realized how well this aspect of the plan worked for Lexington, as well as for many small towns across America, giving the town a physical and emotional center that still serves the community. Other facets of the grid plan did not work as well for Lexington, however.

McDowell, working within a 26-acre, 1,300-foot-long by 900-foot-wide rectangular plot, followed the common application of a simple grid form. Unfortunately, this plan was better fitted to paper than onto the actual hilly topography—typical Shenandoah Valley terrain. By 1850, the steep streets were considered such a nuisance that the town undertook a major grading project in the center of town. The natural upward slope of Main Street, from the courthouse northward, was painstakingly lowered by as much as eight feet—a most formidable labor at that time.

The Willson-Walker House (*right*) was built as the Classical Revival home of Captain William Willson in 1820 and remained a private residence until 1911, when Harry Walker converted it into a meat market and grocery. It appears from the delivery wagon and the white apron of one of the employees posing out front that this shot must have been taken during the later commercial occupancy. The interesting architectural details of the house (*below*) include a Tuscan portico, an elliptical pediment window, and a doorway containing a delicate fanlight and elongated hearth. It is currently a popular restaurant on Main Street, offering table service on the breezy first-floor porch.

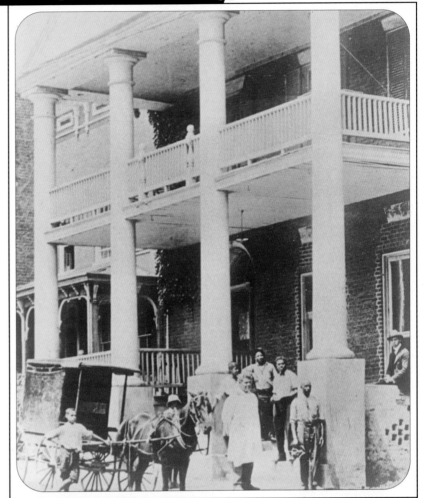

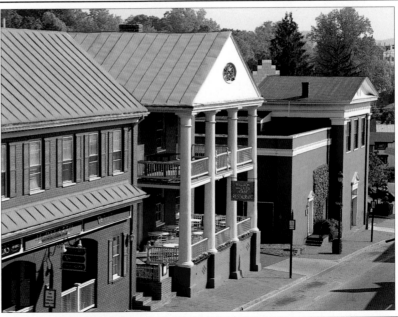

Our carriage driver guessed that twenty years' labor with pick and shovel finally accomplished the restructuring. He went on to recount harrowing tales of wagons careening wildly down Main Street, out of control because of the steep grade. On an icy day, a walk down this main thoroughfare must have been perilous. Even today, our horses slow as if to watch their footing as we reach the crest of Main. This curious history explains why the front doors of certain storefronts and residences open many feet off the street level, sometimes into midair. In most cases, porches or graded entrances have accommodated the variation without calling much attention to themselves. But we learned of a few residents who stubbornly resisted the change, preferring instead to take up their steps, close off their front entrances, and use the back doors instead.

At the time the Great Fire of 1796 swept down Main Street, more than two hundred and fifty people had settled in town, with most of the lots filled. In a familiar early-American scenario, fire destroyed many frame buildings, as well as the brick 1786–87 courthouse. A few brick structures survived with minor damage. But it is primarily from drawings and descriptions that we can picture the early Lexington. Most of what we could see on our tour were postfire buildings, more substantial and lasting than the original structures. Isaac Burr of New York, traveling through the valley in 1804, recorded in his journal that "Lexington is a handsome village, with good buildings." With most of the lessons of the past behind it, Lexington was on its way.

As our tour drew full circle, a fellow passenger commented that the horses appeared to recognize the signals of the traffic lights and obey accordingly. Bob nodded in agreement, then loosened the reins at the next light to test the point. Right on target, Lucy and Lester stopped on red, then moved along again on green.

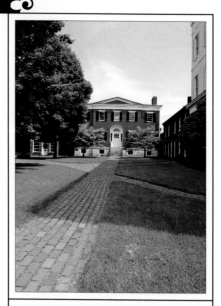

The former county jail (*above*) is the most elegant building on Courthouse Square, built in 1841 and designed by Philadelphia architect Thomas U. Walter, who was responsible for the U.S. Capitol dome. The handsomely proportioned brick section in the front housed the jailer and his family, while the stone section to the rear held the cells. Before it became the national headquarters for the Kappa Alpha fraternity, it was one of the oldest working jails in the country.

The late afternoon sun had been unprotected by any cloud cover, which made us extremely thirsty, doubly so when the horses were led to buckets of water in the shade. We learned that Lucy and Lester refuse to drink city water, so their liquid refreshment is imported. Bob suggested that for our thirst we stop in at Grand Piano and Furniture on Main, which seemed an odd suggestion at first. But the folks at Grand Piano have been greeting customers with an ice-cold bottle of Coca-Cola since their grand opening in 1911. We decided that showing up near closing time would put them to the true test.

The large furniture showroom—no pianos in sight in the front—was clear of customers. We could see several people in a glassed-in office working busily, probably closing out their books for the day, but they did not see us. We wandered toward the mid-

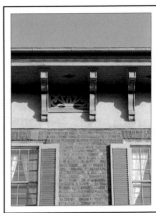

The stately Alexander-Withrow House (1789) (*above*) at the corner of Main and Washington streets reflected the wealth and standing in the early community of its owner, pioneer merchant William Alexander. It served as both his residence and business before it later became Lexington's first school, the post office, and a bank. A magnificent edifice with fine detailing that includes four corner chimneys and glazed headers that form diapering patterns on its brick walls (*above, right*), it was one of only a few buildings to survive the fire of 1796. The exterior was restored by the Historic Lexington Foundation in 1970. It is now a privately owned inn.

dle of the floor, where several stairs lead to another level and more furniture. Our expectations about Cokes and small-town hospitality were in jeopardy of being unmet when a lively young woman ran up the stairs, startled to find us there. "Why, I didn't hear you come in!" she cried, and I wondered if we looked suspicious. "Can I help you with anything?" she added quickly, with enormous good cheer. I was about to head for the door and the nearest soda fountain when, in the nick of time, she asked brightly: "Would ya'll like a Coke?" Without waiting for our reply, she headed briskly for a gigantic cooler by the stairs, slid open the top, and flipped two frosty trademark bottles under the opener on the front. We could hear the Cokes fizz.

"I have a confession," I said, reminded of the days when Coke used to cost a nickel, and the thick glass bottle came barrelling down a chute, announcing its arrival with a thunk at the bottom of a hulking Coke machine. "We're visiting and we just wanted to see if you really give away Cokes." The woman laughed. No doubt it was not the first time this had happened. "Why, I'm supposed to just knock you down at the door with a Coke!" she said, "but you two got by me somehow." It was practically an apology. Then the manager came over and explained how this goodwill campaign is not without its problems lately. Seems they're having trouble getting the old returnable bottles. Another modern-day crisis threatening congenial tradition.

The incredible architectural diversity of Lexington is matched by an unusual amount of early primary documentation and writing about its builders and buildings. Royster Lyle, Jr., and Pamela Hemenway Simpson, in their *The Architecture of Historic Lexington*, refer to an impressive local architectural archive—

When location scouts from a movie company were seeking a nineteenth-century Southern town still rich with history, they decided on Lexington. The movie was *Sommersby,* and the town was soon crackling with excitement as the preproduction and set people came into town to prepare for the production crew and Hollywood stars who followed for the actual filming. Tons of dirt were hauled into Lexington to cover the asphalt. Local photographer Nathan Beck captured much of the action in black and white in respect for historical tradition.

Approximately two thousand people showed up for an open casting call for *Sommersby.* According to Woody McDonald, a local building contractor, only fifty "core extras" were selected to appear in the film. McDonald was among the chosen few. As the filming got under way, residents and visitors crowded the streets for a glimpse of cinematic history being made in Lexington. Television personality Oprah Winfrey visited the set and interviewed many of the local residents who were acting as extras. One extra told Oprah it was the best job he'd ever had because all you did was stand around and loaf all day. And you got paid for it!

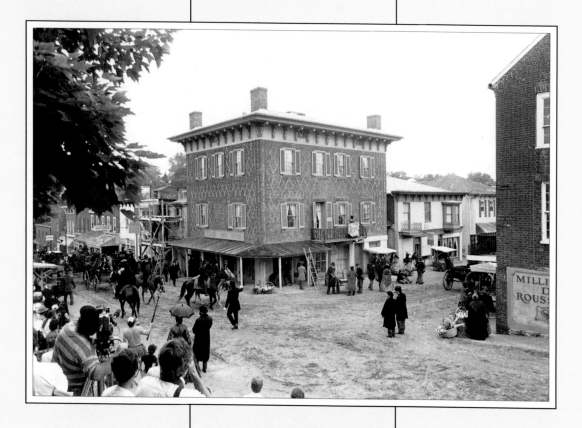

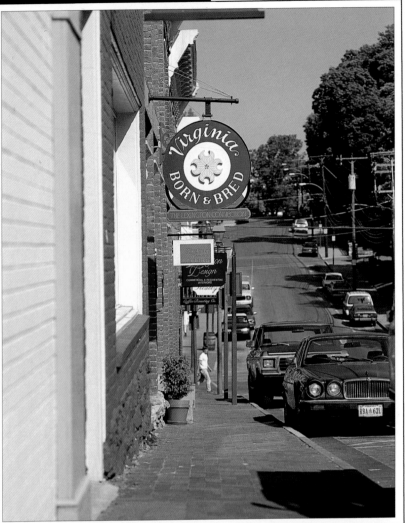

To maintain historic accuracy and visual continuity, the town established a sign ordinance in 1972 that requires a review board to approve signage in the historic district and provides for a nine-square-foot size limit for signs. These signs complement the town's many late-Victorian commercial buildings, with their heavy cornices and Italianate brackets. Inspiration and whimsy combine to provide a graphic treat, especially on side streets, where small shops cater to the tourist's shopping needs and the student's sweet tooth. It is difficult to tell which signs are made to look old and which are truly old. The overscale millinery sign painted on the former Dold's Corner building was created especially for the filming of the movie *Sommersby* and thought to be so attractive that it remains a town showpiece.

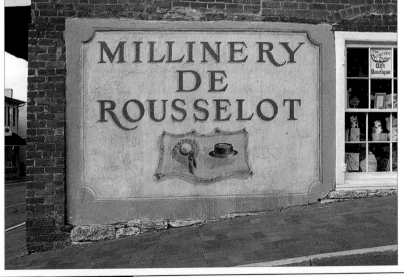

including a collection of architectural books known to have been used by builders and researchers in this small, rural community—that explains how so many architectural styles came to Lexington's streets. Movers and shakers in the town included builder-architects (most notably partners Col. John Jordan and Samuel Darst), gentleman-architects (most notably Samuel McDowell Reid), and various building committees responsible for choosing architects and directing the growth of the town. Even the condensed walking-tour booklet amply describes the fine and varied architecture and how it came to be, from the early Federal-style town houses to the Greek Revival buildings. The pride in every brick and stone is undeniable.

The Southern Inn's neon sign—the only neon sign in present-day Lexington—is protected from the new zoning rules by a grandfather clause.

Lexington is a visual feast for any photographer. The intricate ironwork, rare brickwork, delightful signage, and noteworthy architectural details, combined with so many superb examples of historic architecture in such a small town, made narrowing down the choices for photographs exceedingly difficult. The wonderful light made every nook and cranny an artistic possibility. Block by block, we learned about the town, and had to guard against taking its wonderful historic buildings for granted. When we saw restoration work in progress, or buildings in need of such work, we had to remind ourselves that the meticulous appearance of most of Main Street's buildings is the result of two hundred years' worth of inspiration and determination.

We felt like experts on the town by the time we met Diane Herrick, who headed up the Lexington Downtown Development Association. Diane suggested we meet at the Southern Inn on Main Street, called "a family restaurant" in its ads since its founding in 1932. Students who live off campus can be seen having breakfast, lunch, and dinner here, where student charge accounts are still a tradition. We spent the lunch hour being given a quick course by Diane in downtown Lexington's revitalization efforts.

The LDDA was founded in 1985, the same year, coincidentally, that the state of Virginia was selected as a National Trust Main Street state participant. Although Lexington was not chosen as a Virginia Main Street City in the first round, it enthusiastically began to implement a revitalization program as though it were. It was then selected to participate in the second round.

In addition to serving as a facilitator and clearinghouse of information about low-interest loans, tax credits and abatements, and facade/design assistance, the LDDA helps businesses identify market niches within the town's economy. It also provides support in the form of promotional material, special events promoting downtown development, and other activities, such as the weekly farmers' market.

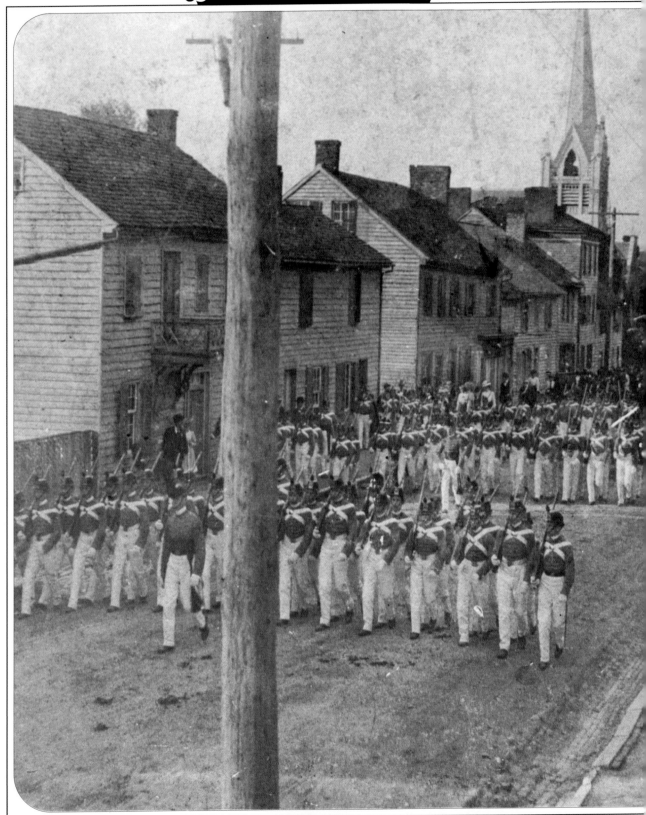

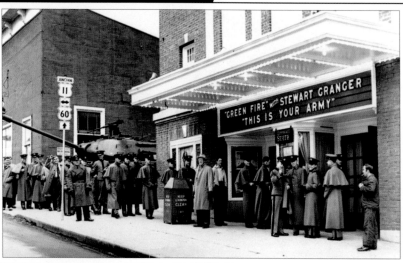

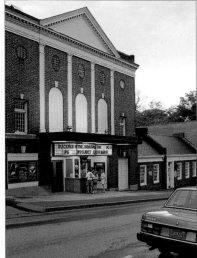

To these 1903 cadets from the Virginia Military Institute (*opposite page*), a parade down Main Street was the most exciting entertainment of the time. Everyone in the town was said to have turned out for a hometown parade.

It's no wonder that there was an enthusiastic turnout among cadets (*top*) for this 1955 double feature at Stanley Warner's State theater. Now the State Movies 3, the old Stanley Warner's (*center, left, and below, left*) still attracts cadets, who wear more informal military attire.

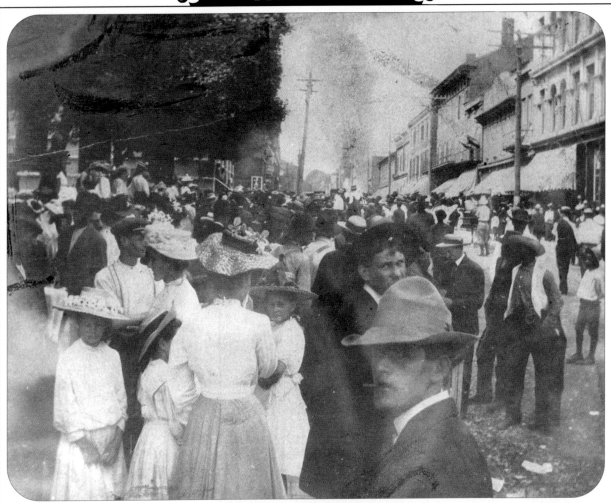

The crowd (*above*) has spotted the photographer in this exceptionally spontaneous vintage shot on Main Street.

It's Sunday morning on South Main, and Tom's Taxi and Buck's Barber Shop (*right*) are closed for a day of well-deserved rest. Both businesses have been in this location for thirty-plus years.

The Historic Lexington Foundation works in partnership with the Lexington Downtown Development Association on such matters as facade grant programs and the physical restoration and preservation of downtown buildings, as well as economic revitalization. Each time we passed the Alexander-Withrow House (1789), for example, we stopped to admire the distinctive diapered brickwork. Soon it was impossible to imagine this street corner without it. Sitting on the principal corner of the city, opposite the courthouse lawn, the Alexander-Withrow House is one of the few buildings of its age to have survived the Great Fire of 1796. It was later saved from oblivion by the work of the Historic Lexington Foundation, founded in 1966 because of the plight of this very building. The group restored the exterior in 1970, eventually selling it to a family who restored the interior and now operates a historic inn there.

Day after day, the perfect late-spring weather made me forget the abysmal light of the past seasons. Leisa and I spent hours driving long country roads in the area, happily lost more than once. My passion for old barns was soon satisfied by a wealth of these weathered structures close enough to the road to photograph them without invading someone's privacy or getting chased back to the car by someone's dog. It was not until our last day in Lexington that we realized how much we still had to do in the few hours that remained. Then it began to rain.

I had tried in vain to locate the old blacksmith who shoes the carriage horses and whose grandfather is said to have shoed the horse of Robert E. Lee. Whenever I stopped by his smithy, on a street that parallels Main, it seemed that I had just missed him.

Modern-day vending machines have replaced the produce and soda-carton displays of an earlier time; otherwise, the White Front has retained much of its 1950s character (*above*). A place for early birds, the grocery opens at 7:30 A.M. The original awning has been replaced by a marquee (*above, left*).

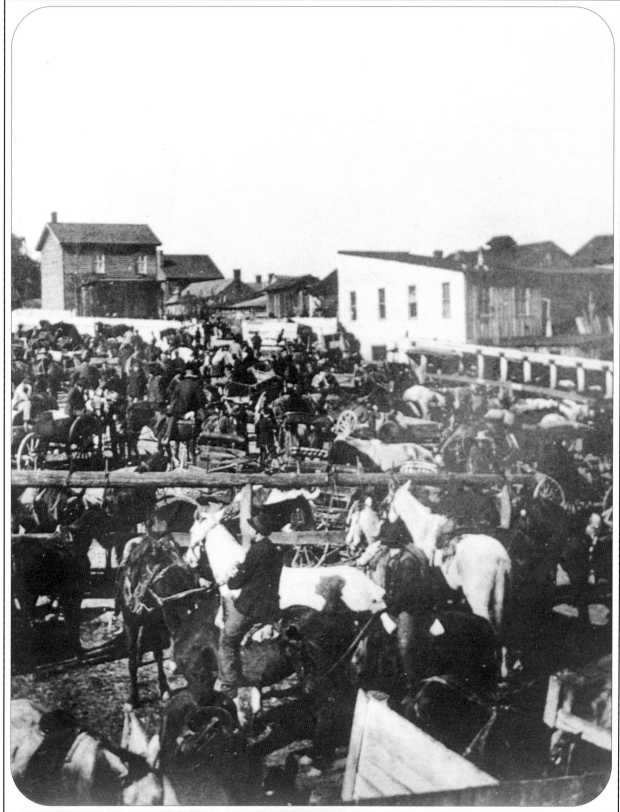

Thanks to the courtesy of our inn's staff, however, I was able to quickly photocopy some last-minute research finds, leaving a precious extra few minutes to try to find Mr. Brown.

I was in luck. But quickly Mr. Brown evaporated my fantasy of getting a rare, personal anecdote about Robert E. Lee by telling me flatly that he had no memory of any such stories told by his grandfather. When I noticed a bin of handcrafted wrought-iron objects by the door, I hesitated. It seems that Mr. Brown is also an artisan—actually a folk artist who works with the scraps of his trade. He brightened when I complimented him on two miniature chairs—horseshoes forming the seats and backs—then brightened even more when I reinforced my compliment by purchasing both of them.

Mr. Brown consented to pose for me holding a piece of his handiwork, an attractive candleholder. Mr. Brown was busy at his forge so the shot had to be quick. An impatient subject suited me just fine, because I was very late, and it had begun to rain. I cursed the dark sky and fired off a rapid series of portrait shots. Then I packed the chairs safely in a sweatshirt and shoved them in my suitcase with not a minute to spare.

The late-nineteenth-century's answer to the parking lot, this busy hitching post area (*opposite page*) was deemed necessary and convenient—a place for those with business in town to hitch and feed their horses, a place for ladies to store their wraps. On court days, much horse trading transpired at the yard. When the automobile replaced the horse, the lot was sold to make a parking lot, signaling the end of an era.

Manley Brown's blacksmith shop (*below*) adjoins the old hitching yard. He follows in the steps of both his father and his grandfather, who is said to have shod Traveller, the horse of Robert E. Lee. Mr. Brown's business is primarily the smithing of the horses who pull the carriages on the tours. A naturally gifted artisan, he holds a candleholder made from iron scraps.

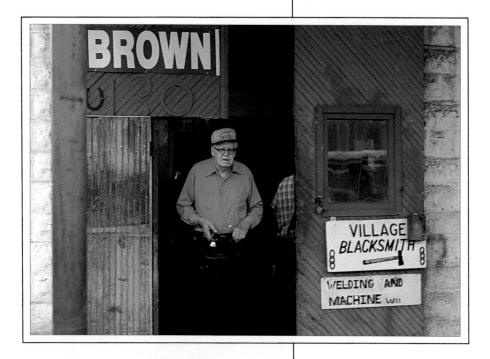

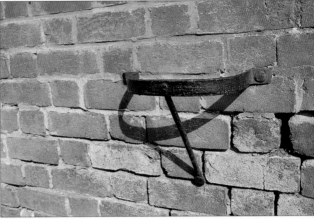

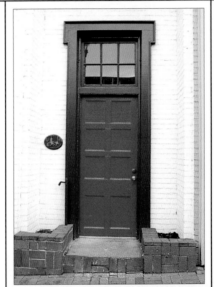

The decorative and functional stonework and brickwork seen throughout the downtown area dates to a time when edifices, walls, streets, and pedestrian thoroughfares were built to last. It is difficult to walk more than half a block without stopping to admire such work. Ivy with roots as old as the stonework (*above*) makes a latticework on the sides of many buildings; an old iron bootscraper (*above, right*) remains intact; early sundried bricks have been patterned at an entranceway (*opposite page, top left*). Much of the brickwork on sidewalks and roadways in Lexington has a metallic-looking glaze (*opposite page, top right*) that reflects sunlight. The textured surface was meant to keep people from slipping.

When the street was graded, many homeowners used stone and brickwork to construct new entranceways (*above, center*). The town's deed restrictions regarding exteriors have prevented even the smallest remnants of architectural history (*right*) from being inadvertently removed.

This stairway leading to a home on Main Street (*left*) shows clearly the former street level—where the painted bricks end—and the resulting plight of the homeowners when the plan to grade and lower the street was effected. The street runs below the fieldstone foundation level. The stairs and railing now lead to the front door.

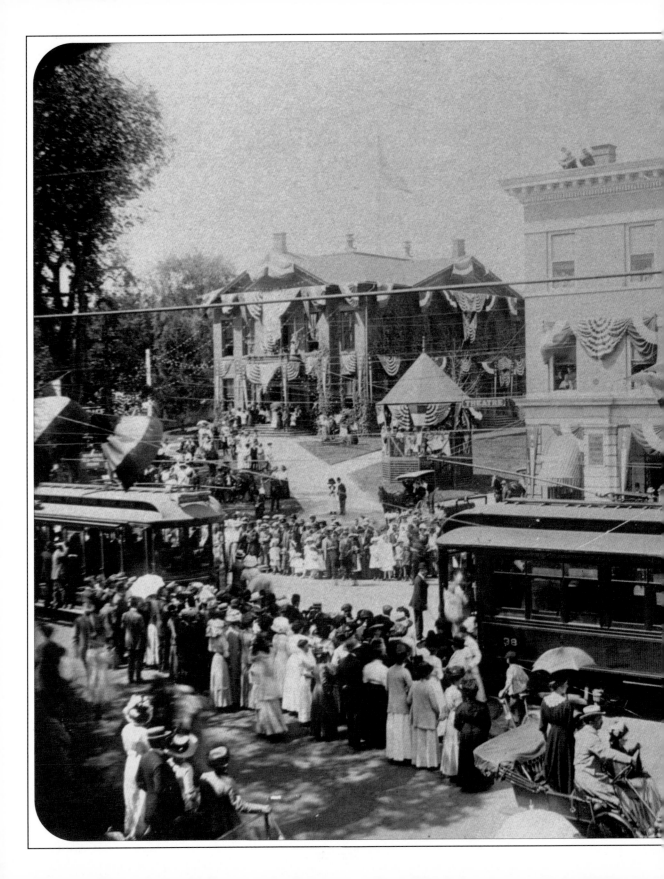

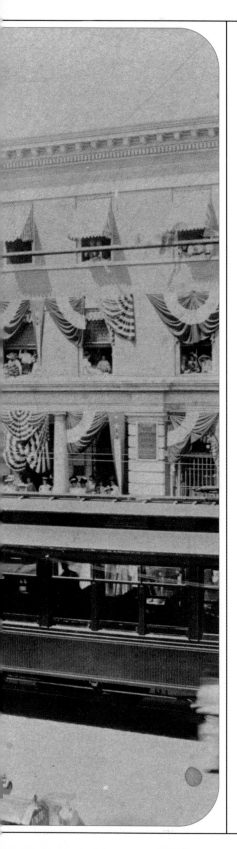

Going to Town

GREAT BARRINGTON MASSACHUSETTS

I was just a Sunday driver—one of those annoying day-trippers who can give tourism a bad name—when I discovered the town of Great Barrington. I had taken a summer house across the Massachusetts border in a wonderful Connecticut village—miles from urban distractions—to write. There is one store in Norfolk—a multipurpose pharmacy where I bought my morning paper and milk. After I had spent a month as a reverse time traveler in this quaint village, Great Barrington looked like bright lights, big city.

The midsummer day was breezy, and the untamed hills surrounding Great Barrington evoked pastoral scenes from an English landscape painting. In the distance was the promise of a majestic mountain range—vivid and unclouded—just beyond the town. Going to Great Barrington was my friend Linda's idea. No tourist, Linda is a professional shopper—a local antiques dealer. When she said, "I think you'll like Great Barrington," she was not thinking about the book, and neither was I at the time. I needed a day off. But as soon as we drove through the first set of traffic lights, I was seeing this day-trip from an entirely different perspective.

Sometimes called the "Gateway to the Berkshires," Great Barrington is less frequently a final destination than a town travelers pass through on their way to its more famous Berkshire cousins, Lenox and Stockbridge. Yet the numerous motels on the outskirts of town and a charming small house that serves as a visitors center are indications that many visitors do stay a while. In fact, I found out that tourism accounts for a large percentage of the town's economic base. Yet this could hardly be called a "tourist town," the greater year-round community providing texture and balance. The town also has a long history of "summer people" dat-

ing back to the period after the Civil War, when city dwellers in Boston and New York in search of homes in the country ventured to Great Barrington because of its close proximity to both cities and breathtaking scenery, both of which remain drawing cards for the town today.

Route 7 is the primary regional artery going north, a fast two-lane road that, in a seemingly odd reversal, opens to four lanes for a brief expanse on Main Street inside the Great Barrington town limits. The broad street is said to have started life as an Indian trail, near the home of the Mahican tribe. The road's course still follows the Housatonic River in typical fashion until rolling topography makes the Great Bridge north of town a necessity. The width of the road was a saving grace during a transitional era, when horse, auto, and trolley were all competing for the roadway. During the twenties, when the auto became a road hog, the town placed a police box in the middle of Main Street for traffic control, retiring it at night. The police box lasted well into the sixties. As a sixteen-wheel semi bore down on our insignificant car, I wondered how this police box would stand up to traffic today.

In time-honored tradition, Main Street here is the geographic and commercial center of town. In 1742, the pioneering settlers—primarily the New England English joined by the Dutch from adjacent New York State—erected their first crude meeting-house. By 1761, when the colonial government named Great Barrington the Shire Town of the New County of Berkshire, thereby giving Great Barrington the courts, Main Street was still a muddy expanse, serrated in places and freshened by silty streams. It remained a dirt roadway until 1882.

Some early efforts at street beautification were attempted. Elm trees were planted as early as 1770. Considering it a pompous innovation to plant trees on the highway, a disgruntled townsman is said to have driven over the young seedlings with his horse-drawn wagon. Such gussying up caused others to call the developing Main Street "Strut Street." It was enough, they thought, to have the road as a means to an end; making more out of Main Street seemed to some an unnecessary waste of time and effort.

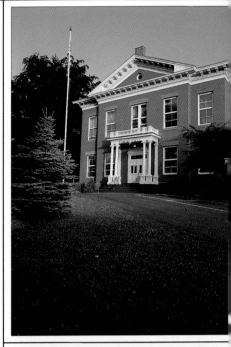

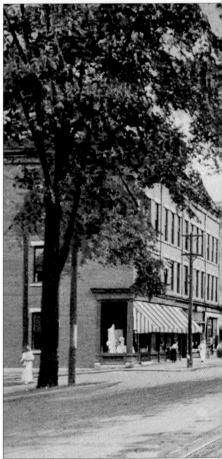

The citizens of the town had erected a courthouse and jail in 1764 "at some considerable expense." While the loss of the courts to the more centrally located Lenox in 1787 diminished the immediate business enterprise of Great Barrington, public buildings and private dwellings continued to be built. At this time, agriculture was the dominant economic force, and much business was conducted out of private dwellings in and outside of town. Still, as late as 1810, the total number of buildings in

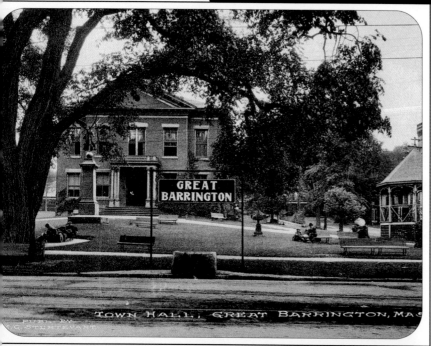

TOWN HALL, GREAT BARRINGTON, MAS

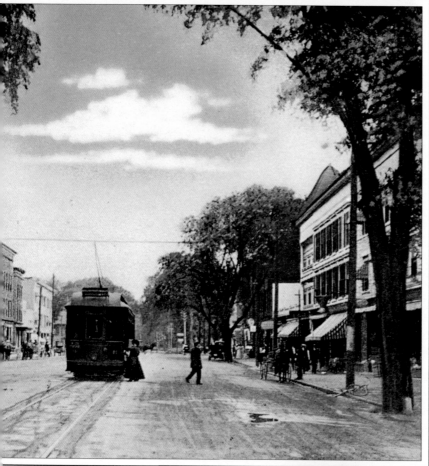

An exceptional photograph by A. M. Costello (*previous pages*), a well-known local photographer, shows the festivities for the town's 150th Anniversary—September 4, 1911. At the far left, Town Hall has been decked out with banners and bunting, as has the pavilion and the buildings that front Main Street. The Berkshire Street Railway made perilous trips through the sea of people.

The stately Georgian Revival Town Hall (*opposite page, top*) has changed little over the years. An 1845 fire had demolished the original Town Hall, forcing the town to lease space elsewhere. The "new" Town Hall (*above, left*) was built to coincide with the town's 1876 centennial celebration. For many years it served as a multipurpose home for city offices as well as the public library until the library was relocated. The one-and-one-half acre lot was paid for, in part, by subscription. A plan by E. L. Robertson, which cost $50,000, included a fireporoof vault, a smart investment given the town's unfortunate history with fires.

An early postcard view of Main Street (*left*) shows the Berkshire Street Railway, which could take Great Barringtonites all the way to Bennington, Vermont. After the First World War, the tracks were torn up, then eventually paved over in the late twenties, when the trolley was an outmoded means of transportation.

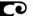

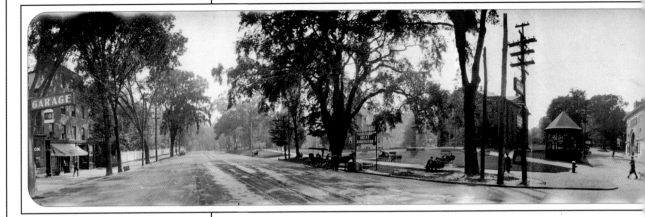

A panoramic shot of Great Barrington (*above*) taken in 1901 shows the Berkshire Street Railway tracks running down the center of Main Street, competing for space with horse and automobile traffic. The bandstand on the corner of the City Hall square was built around 1900 and used as a trolley stop until 1929. A horse drinks from a three-ton dolomite trough that replaced an earlier watering tub thought by many to be "undignified." The cannon on the front lawn of Town Hall, known as "Old Macedonia," was occasionally fired off during Fourth of July celebrations until, in the 1940s, a group of "young hoodlums" fired it off for kicks. Soon after, the barrel was plugged with cement. During World War II, the cannon went the way of scrap metal.

Many of these large elm trees along Main Street survived Dutch elm disease in the thirties and forties, only to be killed off by beetles in the 1950s. The sheltering elms are still the object of fond reminiscences among older town residents.

town barely exceeded forty. And only one side street—Railroad Street—diverged from Main Street, the number of side streets being a sign of town's growth and prosperity.

A great building boom took place in the 1820s, due, in large part, to the developing mill industry. By 1829 there had been added two taverns, four merchant stores, two large tanneries, a gristmill, a plaster mill, and various shops catering to repair work. Additional side streets opened in 1839. Local industry was bolstered by the building and opening of the Berkshire Railroad in 1842, which "effected a great change in business and appearance of the village, and has added to its growth and appearance," according to a source of the day. Street improvements, such as the grading of ground and filling out of hollows, gave the town and street a new topography. As Great Barrington became the center of trade for many neighboring towns, new businesses and enterprises sprang up. The town had found a mission and importance—a fresh start.

As we drove through town, we saw little to remind us of the prerevolutionary or colonial village it once was, or, for that matter, little of the buildings erected during the mid-nineteenth-century building boom. Natural deterioration, as well as "progress," accounts for this in many towns. But in Great Barrington, fire was

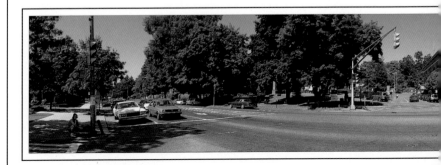

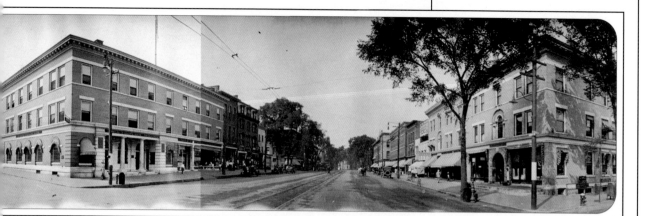

also a major culprit. No fewer than fourteen major fires ravaged the town between 1844 and 1904. Churches, hotels, and mills as well as shade trees were destroyed. Railroad Street was twice devastated—in 1854 and then again in 1896, the frame structures there acting as ready tinder. A series of fires in 1901 was particularly destructive to Main Street, where several entire blocks were lost. Only by reconstructing from written text and historical photographs can we imagine what a work-in-progress—wittingly or unwittingly—Main Street was.

We quickly merged left with other local traffic for a turn onto the street called Railroad, happy to escape the congestion of Main Street. Railroad Street takes traffic in just one direction for a block before routing it back onto Main Street, a circuit that soon becomes familiar to drivers cruising for a parking place. On a busy weekend, residents, vacationers, and visitors like us can be heard uttering that familiar litany, "Look for a space!"

It's easy to reflect on the changes that time has brought to this pretty town, bounded on one side by the river and on the other by a hilly incline where comfortable Victorian residences lie near the local hospital. Anchors north of Main Street include two magnificent churches, a beautiful library, and the post office; the most notable anchor to the south is the imposing Town Hall on its

Today, Main Street is a bustling thoroughfare (*below*), serving as the main route from the south into the Berkshires. Although the old bandstand is no longer located at the corner of Main and Castle, a new one has been built in the park behind Town Hall, a popular gathering spot for picnics and concerts.

With a resurgence of interest in panoramic photography, professional photographers, such as José Gaytan from the International Center of Photography, who took this shot, are using sophisticated new 35-millimeter cameras to document contemporary streetscapes. Yet even the amateur photographer is capable of capturing comparable views with today's fully automatic and disposable panoramic cameras.

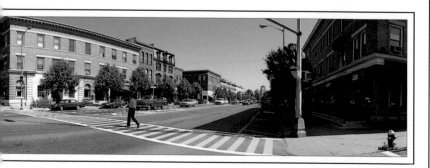

The Mahaiwe Theatre was built on Castle Street, only steps off Main Street, in 1904 and 1905 in a French Renaissance style, its Pennsylvania-pressed Roman bricks and marble trim offering sophistication and excitement. A local architect designed the fireproof interior to seat 1,000. Originally intended as a live theater for stage productions, the Mahaiwe changed with the tastes of the times, adding silent movies in 1914 and then "talkies" in 1929. The facade was changed in 1930 with the addition of a marquee, presumably to better advertise the current production.

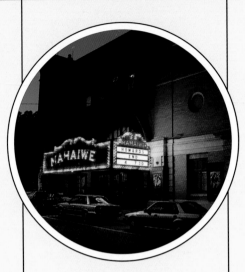

Threatened with destruction, the Mahaiwe was bought in the late 1970s by a local resident and painstakingly restored to much of its former splendor. It now plays first-run major motion pictures, as well as

offering concerts, ballets, and yearly benefit performances.

As I stood on the hill across the street from the theater waiting alone in the darkness to take this shot after the Mahaiwe's first evening show, when the wonderful old marquee lights would be switched on briefly, a police car pulled over and signaled to me. Wondering if I looked like a threat to small-town security, I was relieved to find that Officer Heady simply wanted to let me know that the Mahaiwe had exactly 386 blinking lights on the marquee, just in case I was curious (I was!). His wife had counted them once during a scavenger hunt.

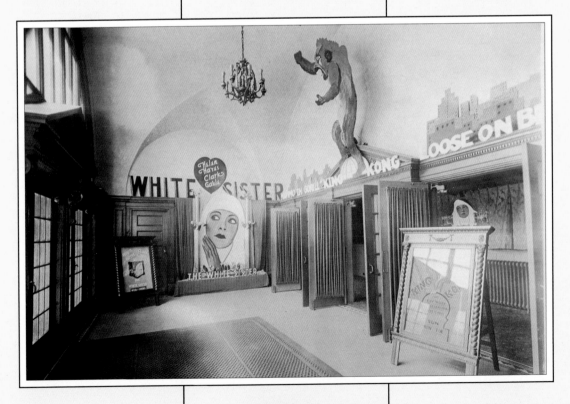

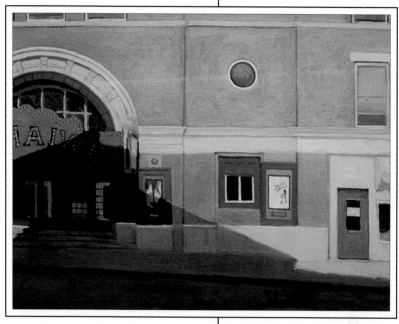

pleasant park, with a bandstand harking back to an earlier time. Town Hall stands across from Castle Street, where the imposing Mahaiwe Theatre echoes another age and another style. Towns like Great Barrington deserve a longer look. My first visit was merely a rubbernecker's start. We looped the loop one more time, then found the perfect space on Railroad Street.

While many locals express the opinion that Great Barrington is getting too fancy for its own good, catering to outsiders ("We don't shop at those places," huffed an older resident), I found no pretense, no glitzy exteriors, and a minimum of designer labels. Instead, the facades offer a homey welcome, merchants having worked with what they were given rather than creating something jarringly new. I immediately noticed an artistic sign or two that announces the bent of the town, bright red trim that cries out WET PAINT, and a row of plants on stands that cheerfully overflow onto the sidewalk. It's true that one or two relative newcomers have created a stir with their supposed "city airs," but I found even those shops an attractive and forgivable part of the mix. Because Main and Railroad streets are lined with such a pleasing variety of shops, restaurants, and service businesses, it's hard to remember that, until the recent past, no self-respecting woman would have been caught dead on Railroad Street.

Railroad Street has a colorful and infamous history. Running from Main Street one block west, it once served as the only route to the railway depot at the top of the hill. Everyone in town has a story about Railroad Street, and on the many trips to Great Barrington that followed my first visit with Linda, I heard the best of

Local artist Joan Griswold paints streetscapes of small towns across the country, paying particular attention to her own. She says she loves the abstract play of light on the flat surfaces of the buildings. We are both, not surprisingly, heartfelt admirers of Edward Hopper.

Here, Joan has done a painterly version of the Berkshire Roasting Company (*above, left*), her favorite breakfast spot. Here customers can order coffee—either the traditional American brew, strong and black, or a fancier European variety—a frothy cappuccino, or *latte*. I am also partial to her painterly version of the Mahaiwe Theatre (*above*). Joan works in a studio located, appropriately, on Main Street.

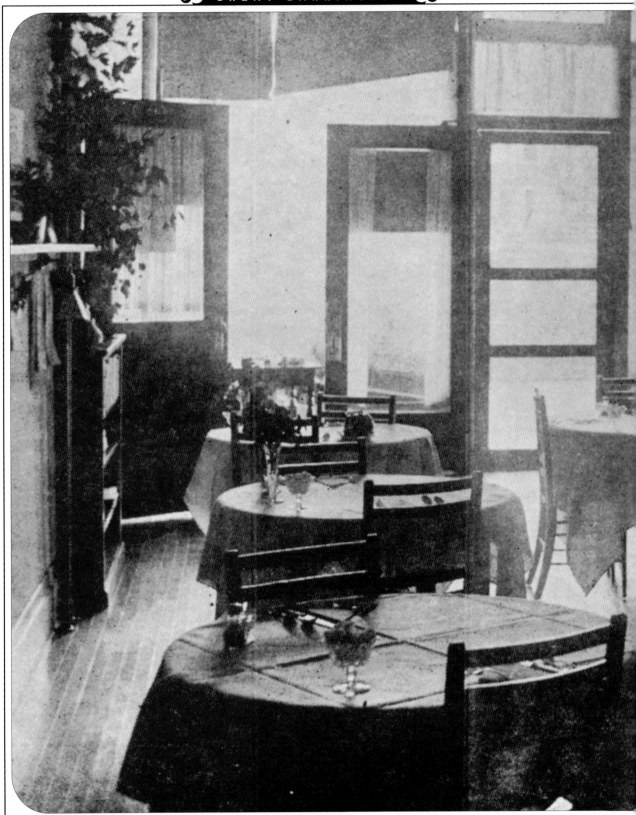

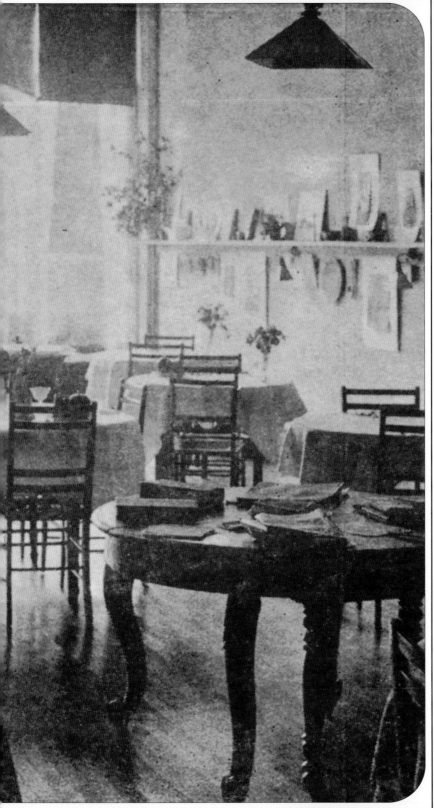

The Berkshire Tea Room, located next to the Mahaiwe Theatre on Castle Street, was one of many tea rooms in the area that sprang up in the 1920s and 1930s during Prohibition. According to native Lila Parrish, the popularity of the motor car and Sunday outings spurred the opening of tea rooms throughout New England. "Genteel women" frequently opened these small restaurants in private homes as well as in public places, serving delicious home-cooked meals and, of course, tea and lighter fare. When Prohibition came to an end, so did most of the tea rooms, as patrons switched from tea to cocktails at local bars and cafes.

Known for its charming atmosphere and its excellent food, The Berkshire Tea Room was run by a Mr. Willoughby, one of the town's black businessmen. Great Barrington boasts a long history of black entrepreneurs within the community, largely due to the fact that blacks were granted their freedom by the Massachusetts Constitution after the Revolutionary War.

Today, the Berkshire Tea Room is the Castle Street Cafe, a restaurant that retains the elegant mood of its predecessor with a variety of spirited libations added to its menu.

Silas Sprague, a Great Barrington businessman, was one of many shrewd nineteenth-century developers of towns across the country. Coincident with the opening of the new railway in 1842, Mr. Sprague began plotting out a stretch of land off Main Street that was formerly a wet meadow. With the town's side streets developing slowly, Mr. Sprague must have seen the commercial opportunity for a street running from the freight depot to the main thoroughfare. The street was called Railroad Street (*right*), named for its proximity to the tracks.

The new street—just one block long—was devastated by fire in 1854, then was soon built up again with more than its share of saloons, barrooms, taverns, pool rooms, and brothels. No self-respecting woman would have been seen anywhere in the vicinity of this infamous street. Then the great fire of 1896 swept through Railroad Street, wiping out most of the frame buildings. When rebuilding took place, new buildings were constructed of brick and stone so that this sad history would not be repeated.

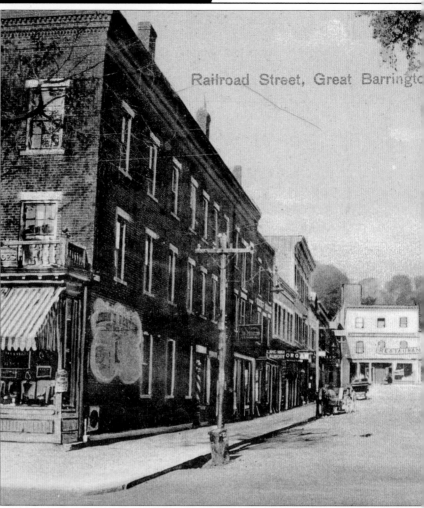

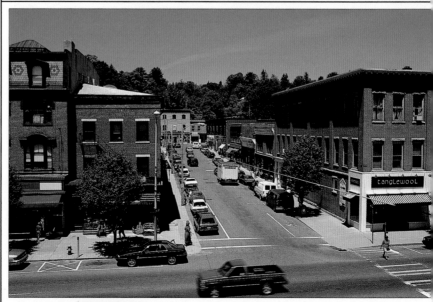

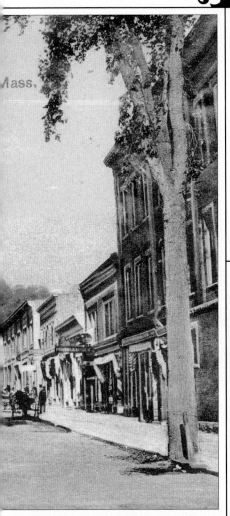

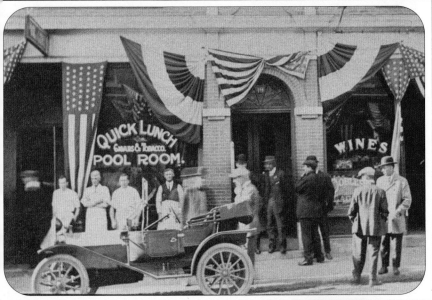

Railroad Street today (*opposite page, bottom*) is a bustling stretch where cars cruise in search of parking spaces and the shops are busy with trade from both full-time residents and the "weekend people" who contribute to the town's economy.

Railroad Street has been revitalized in the last decade, making a welcome comeback from a period of sad decline. One after another, storefronts were renovated by independent business owners, giving a fresh new look to the street. The development was sporadic at first, yet the result has been a natural evolution without pretense.

Over the years, a series of businesses were located in this block of Railroad Street, called the J. F. and F. T. Sanford block, built in 1894, including a garage and pool hall (*below, left*). Now, fashionable clothing is sold in one of the street's quaint shops (*left, center*).

In times past, side alleyways served as routes to loading areas and service roads behind stores and restaurants. Today (*top*), they are frequently used as shortcuts and illegal parking spots.

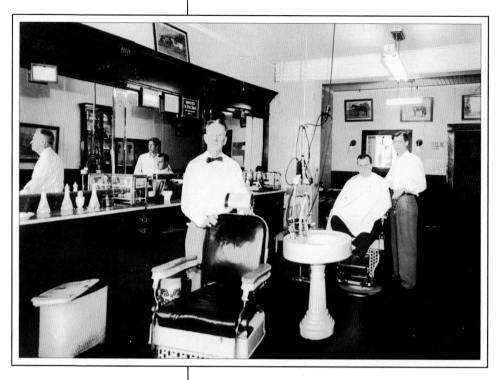

In 1905, Robert Weeks took over an existing barbershop only a few doors away from the present location on Railroad Street. He did haircuts, shaves, shampoos, and massages. For twenty-five cents, you could get a singe with a taper, thought to seal the hair and prevent possible blood loss. Kenneth Weeks joined his father in the business in 1940, when he was twenty-two. Here (*above*), father and son are seen together with a customer in the early years.

them! I started with Gary Happ, owner of 20 Railroad Street, a popular restaurant and bar. Times certainly have changed, and even an unaccompanied woman today is respectable, and indeed comfortable, at this Railroad Street establishment. Gary served customers while I sat and listened at the grand old twenty-foot-long mahogany bar, shoving my notebook aside when dinner arrived. Gary is credited with bringing respectability to Railroad Street as a local entrepreneur who, in 1977, decided to open a place to dine, not simply to drink your dinner. Many in the town believe that Gary pioneered the revitalization of this now-vibrant block, but Gary is modest. Bearded and burly, Gary looks as though he's heard his share of bar stories. Now it was his turn to tell a few about Railroad Street.

From earliest times, there was no lack of liquid refreshment from the many bars and pool rooms that lined Railroad Street. Men could be seen leaning up against the storefronts, shuffling a stack of shiny half-dollars, acting tougher and richer than they were. There was a "Last Men's Club" on the street. To join, you simply brought a bottle. When you died, the boys would open the bottle and toast your passing. Naturally, the local ministers preached against this sinful boulevard in their good town. One minister in particular considered the purification of Railroad Street his mission in life, admonishing his parishioners on a regular basis that it was the street to hell. When this minister died, his

casket was borne down Railroad Street, the only route to the depot, where he was taken to another resting place.

During Prohibition, the bar at 20 Railroad Street was so brazen that it had combs manufactured to advertise its wares. A man I spoke with on the street said he can recall "shot and beer barrooms where you could see the bodies come flying out the door, even as late as the fifties!" Many other towns have their own versions of infamous side and cross streets, but the stories here are, hands down, the best.

Weeks's Barber Shop on Railroad Street was for many years a respectable spot on the block, having established itself in a prime location for a business catering to a male trade. Today, its barber's pole is still out front—and the town's most respected barber is still inside. I waited till I could see that no one occupied either of the two chairs (it's still a male club as far as I'm concerned), then I went in to introduce myself. The man who would later tell me, "I like to say hello. It doesn't hurt, or take any time. And best of all, it doesn't cost anything," smiled warmly and said hello. Making people feel comfortable comes easily to Ken Weeks, and I relaxed into the leather seat of a barber's chair that, I reflected, is a collector's delight.

Ken Weeks does indeed have vivid memories of the notorious street. His father, Robert Weeks, opened his first barbershop there in 1905, just doors from the present location. Ken joined his father in 1940. As a child growing up in the town, Ken remembers a colorful character on Railroad Street named Crocodile Scotty, who was missing one eye and one leg. There was a saying: "Crocodile Scotty, the one-eyed gunner, who shot all the birds that died last summer." No matter, the young Ken went to see Crocodile

Weeks's Barber Shop has changed little, if at all, since the early part of this century (*below, left*). Even today, it doesn't have a telephone. Ken Weeks says his father had a phone once—until two fellows asked to use it on a busy Saturday, tying up the phone and making it look like there was a waiting line for a haircut, which naturally deterred new customers from walking in. The following Monday, Robert Weeks had the phone taken out. Ken Weeks never had it reinstalled. "I don't think I've needed it," he says.

A display of shaving mugs in a glass-fronted cabinet on one wall holds an interesting barbershop history (*below*). Having your shaving mug in the shop was a sign of prestige for loyal customers, who enjoyed regular professional shaves. After these customers died, their mugs were retired.

Located in what is the oldest brick commercial block in Great Barrington, having survived the fire of 1891 and a fire in 1896 that gutted stores next to it, TP Saddle Blanket on the corner of Main and Railroad (*above*) caused quite a stir when it refaced the exterior to create a cabinlike image and placed a full-size canoe on the first-floor balcony level. The facade of the shop next to it, which deals in nostalgia from the early twentieth century, remains largely unchanged.

Scotty to "hang around." He also remembers that in the spring you could lose a horse in the mud, that a few "brave women" ventured into the barbershop for a haircut, and that even construction workers wore jackets, hats, and ties to work. When I asked more about the "good old days," Ken Weeks paused, then went on about how we've been blessed with "forgetters." "If you remembered everything that happened, you'd be in tough shape," he said wisely. "You remember the high spots . . ."

I soon found out that Ken Weeks is an inventor at heart, a man who's been known to install a few capital improvements with a minimum of fuss and a bit of ingenuity. I noticed that when he finished a haircut, he switched on a small vacuum with a long hose and vacuumed off his customer. I told Ken that I wished my hairdresser had one of those vacuums. He beamed and told me how he'd simply hung an old Electrolux vacuum cleaner just below the floor on springs, then brought the hose up through a hole in the floor. "I like to tinker," he added modestly.

As my visit drew to a close, Ken Weeks let me browse through a pasteboard box filled with personal memorabilia while he cut someone's hair. As they chatted easily within earshot, I came across a thank-you note from a friend who visited him in 1956. In that note, she wrote: "You may say to yourself that you did nothing but sit around and talk awhile, but to Warren and myself it was as good as a banquet." I knew how they had felt.

I spent the rest of the afternoon at the Great Barrington Historical Society with James Parrish, who promised to copy quite a number of historical photographs for me. James offered to give me a driving tour of the town and surrounding area, which I gladly accepted. Luckily, my tour was air-conditioned, as the temperature was in the nineties. As we drove through streets, James rattled off names, dates, and critical information as though he were born knowing it—and perhaps he was, since his mother, Lila, is a longtime member of the historical society and a dedicated gatekeeper of the town's history. When we paused to have tea with Lila Parrish, her kitchen seemed warm as an oven. That was because she'd whipped up a batch of brown sugar bars on one of the most sweltering days of the summer, which she served us hot, with ice-cold lemonade and iced tea. It was home-style hospitality at its finest.

One of the best ways to get to know a town is to try the local restaurants, especially the breakfast hangouts. This town's regulars can be found at The Coffee Shop at the far end of Main. Norman Stedman has owned the shop for the past eight years, but he says the business goes back at least forty years. I kept hearing The Coffee Shop referred to by dyed-in-the-wool regulars as "Arlene's" for the name of the woman who serves up a mean cup of coffee as early as 5 A.M. A counter stretches the length of the small luncheonette-style restaurant, with a mind-boggling variety of doughnuts in a case as you enter. Some tend to double-park and leave their motors running while they dash in for a bag of dough-

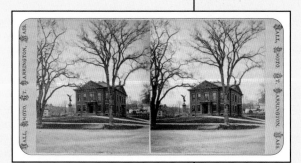

Around 1870, stereoscopic cards (or stereographs, or simply stereo cards) were gaining in popularity. A pair of identical photographs was placed side by side on cards measuring approximately four inches by seven inches. A simple optical device allowed viewing the two images together, creating a most convincing three-dimensional impression of the subject, be it an exotic vacation spot or a street in town.

It was common for a professional photographer who specialized in stereographs to take a variety of views of the community. Typically, this photographer captured the vista from a nearby hill, and would include the town green or square, assorted important buildings, and, most important, Main Street. The result is a documentation of Main Street history across the country in stereoscopic images.

In past days, these cards were purchased as souvenirs and gifts and cost about twenty cents apiece by the 1880s; today, they are sought after by collectors of vintage photography and historical documentation, who often pay top dollar for rare and artistic images.

In Great Barrington, local photographer Julius Hall photographed and published many stereo views of the town in his "Artistic Series," billed as the "largest collection of Berkshire and Housatonic Valley Views." Hall was a newspaper dealer as well; his concession stand was located right on Main Street.

GREAT BARRINGTON, Mass. Railroad Station from Castle Hill, looking East.

Built across the tracks behind the back lawn of Town Hall in 1901, the railroad station (*above*) is located on Castle Hill. This stick-style brick structure was the passenger depot, offering a porte cochere for horse and carriages at the center entry. The freight depot was located a short distance down the tracks at the end of Railroad Street. The anonymous artist of this vintage postcard has left his or her sign in the lower left corner: a palette and easel with the letter *T* inscribed. The postcard has been carefully taped, the center fold so fragile that it began to tear.

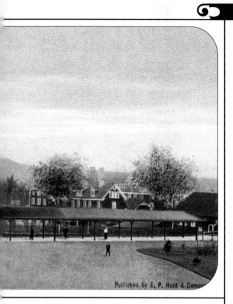

Published by E. P. Hunt & Comp——

Today, the depot is in the process of being renovated by a local restaurateur who intends to bring the waiting area back to its former splendor and level of activity. During the summer months, the platform is the site of the early morning Saturday farmers' market (*left*). The roofed platform offers shade and protection against wilting for both produce and people.

nuts and coffee. When I walked in, a mostly male crowd warmed the stools, a talkative group clustered at the far end near Arlene. I had missed the 5 A.M. crowd, but breakfast here goes on indefinitely, or till the doughnuts run out. My glazed doughnut was fresh and tasty; my coffee was hot and strong. On the wall in front of me, a sign read: *You are looking at a high performance WOMAN. I can go from sweetheart to bitch in 2.1 seconds.* Arlene pulled a slim lighter from an apron pocket and lit a cigarette in just about the same amount of time. Arlene told me that she starts work at 4 A.M., and her one baker makes as many as 200 dozen doughnuts on a good day for this and another place. The doughnuts are excellent, but it's the no-nonsense, down-home feeling that keeps people coming back.

If The Coffee Shop is a trip into the fifties, then lunch at The Deli at the other end of town is a trip into the sixties. The hiking boots, ponytails on both sexes, mountain-man shirts, and disintegrating jeans were, for me, echoes of the Woodstock generation. Then I noticed a table of pleasant white-haired women in pale flowered housedresses and a fair share of people in business suits. The Deli is clearly a melting pot.

Regulars at The Deli know the rules for self-service. If you don't know the system, it's spelled out in clearly written instructions that blanket the walls and countertops. There is even a sign about the signs: *Signs were made to be read, so READ.* There are lots of rules about things you must not leave: dirty dishes on tables, empty coffeepots on burners, and empty sugar packets on counters. There are more homey reminders: *Please do NOT, we repeat, do not . . .* And there is no shortage of helpful arrows. Feeling like an incoming freshman, I was grateful for all this help. With the crowds that descend daily for the hearty soups (a cup or a big bowl, self-ladled) and the healthy sandwiches named for local heroes, a system that works is clearly part of the operation's success. I ordered an Arlo Guthrie on whole-grain bread and sun tea from a large jar. When I paid, I noticed a Pepsi cup nearly toppling over with the weight of lavender peonies. While I ate lunch on a folding chair at a simple Formica table, I read the wall next to me. It was papered with hundreds of local business cards, a small-town network in action. I found everything from guitar lessons, Polish sausage, plasterers, karate lessons, and painters to specialists in cantilever construction. I made sure to dump my trash in the correct recycling bins before I left.

At the far end of Railroad Street is Martin's, where the customers, very often tourists and weekend people, don't have to lift a finger. Here a friendly and efficient group of mostly women serves up the best blueberry pancakes around. On weekends,

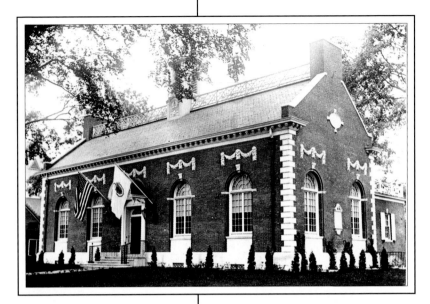

The Mason Library (*above*), located in the heart of the downtown area on Main Street, owes its name to Mary Mason, a summer resident who, in 1911, bequeathed a sum of money for a new library in honor of her husband, Captain Henry Hobart Mason. The fine Georgian Revival building, designed by Blanchard and Barnes and constructed of Harvard brick, was featured in *Architecture* magazine, which devoted several pages to praising its design when it was dedicated in 1913. The stacks in the Mason Library open into the gracious reading rooms (*above, right*), where the high vaulted ceilings and elegant fireplace surrounds further create a sense of serene contemplation. Today, the same space has been updated with a copy machine in the front by the door; otherwise, it remains much the same.

there's usually a line out the door, an obvious disadvantage if you're in a hurry, but the sign of a thriving business.

There always seems to be a line at the Berkshire Roasting Company, especially in the mornings, when the clientele ranges from artists and writers to local laborers and a few of the town's "forever types." On weekends, it's mostly tourists who line up for the designer brews, the cappuccinos and the *lattes*. Joan Griswold, a local artist who frequently paints streetscapes of small towns, offered to take me to morning coffee at the Roasting Company during the week—the more "authentic" time. Everyone in line seemed to know everyone else, so the wait didn't cause the sort of New York City impatience that I had been conditioned to expect. Space was limited, but the atmosphere was cozy. A man had spread out the pages of a manuscript at a back table. No one seemed to mind.

I told Joan that I wanted to use two of her paintings of Great Barrington in the book, so we talked about that. When I mentioned that I needed to talk with someone about local zoning restrictions and objectives for improvement, Joan suggested I simply turn around. The newly formed Main Street Action Association was holding an informal meeting at the next table. I could not have planned it better.

After a quick round of introductions, our mutual interest made us natural friends. Formed in the spring of 1992 and still brand-new, Great Barrington's Main Street Action Association is filled with boundless energy and spirit. Within minutes, I went through all the blank pages in my Filofax and began to write on the various business cards that were passed to me. Our group of seven was soon blocking the limited traffic flow of the Roasting Com-

pany, so we made a date for later that morning at the association's nearby offices.

Pamla Raye, the town's Main Street manager, told me how the town was recently awarded grant money by the state and is part of the National Trust's Main Street Program. It works hand in hand with other local groups, primarily the chamber of commerce, on growth and revitalization efforts, considering personal service and traditional values to be two assets that need preserving along with the architecture. A few dissenters, however, believe that progress will take place without some complicated organization. One die-hard merchant in town told me: "If you have to tell a businessman to smile, his business isn't worth saving." While I agree, this is to miss the point of a community-wide effort such as the one being made by the various Main Street programs across the country, where downtown cooperation and civic concern work hand in glove with individual incentive.

Great Barrington today is taking a good hard look at itself. It likes the distinct personality it presents, the way the storefronts have grown without regulation. Happily, there's no cookie-cutter look, but rather a blending of tastes and styles. But no town today can rest on its laurels. So Great Barrington has plans—for a new parking area (hurrah!) behind Main Street—where at present cars hunt for space among boulders and rubble—for attractive back entrances to stores, for more sidewalk benches, for a motorized trolley to shuttle shoppers. "We're not looking to fit a feasibility study," Pamla told me, "we are looking for vibrant change."

The town also places a high value on social conscience and the environment. And the most ambitious plan in that regard is a river project created by Rachael Fletcher, who emphasizes the town's relationship with the river. Pamla took me on a tour of Rachael Fletcher's work down by the riverbank, which is just a short walk from the east side of Main Street. Plot by plot, Fletcher and her group get permission to work on the Housatonic's banks, clearing the heavy underbrush to create resting areas and a footpath that will eventually run parallel to the entire length of downtown Main Street. There are distant plans for boats and water activities, which could make coming to this town an event. This seemed to fit in with what one Main Street Action member told me about the need for all Main Streets to keep in step with the future. He said that we have come eyeball to eyeball with the malls and the bypasses, but now we must confront the home-centered movement—the electronic age in the home, where shopping and entertainment are controlled by a mouse or a remote control. While people still have fond memories of Main Street, he stressed, we need to capitalize on those memories to bring them back to town. If this theory is correct, then Great Barrington is certainly on the right track.

MASON LIBRARY
GREAT BARRINGTON
MASSACHUSETTS

Mason librarian Marlene Drew told me that the library custodian recently found the original copper plates for this dedication bookmark (*above*) in a pile of rubble. Luckily, they are still in good condition. The bookplate, created from a woodcut, shows a citizen engaged in reading a book by one of the library's two fireplaces. Fires no longer blaze in the hearth on cold winter days, and the landscape scene in the painting is now a different Hudson River Valley painting.

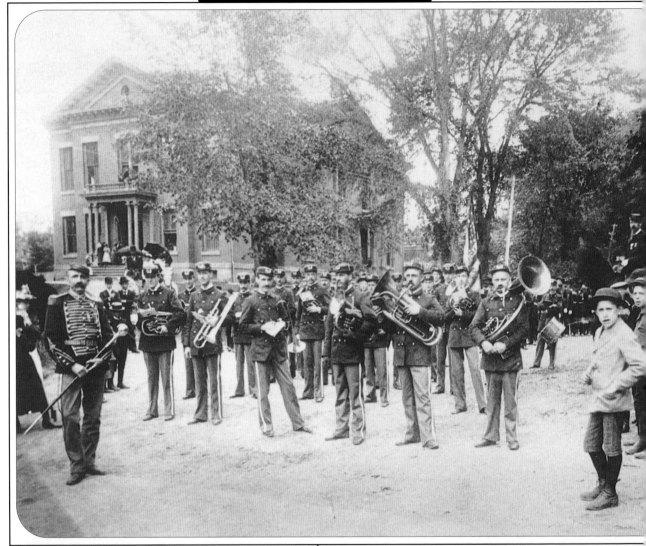

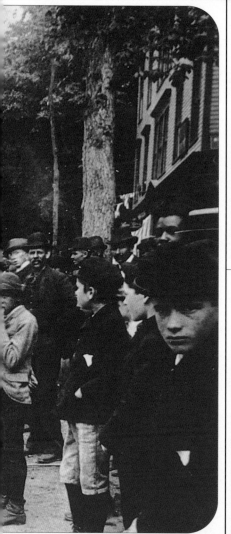

Town Hall has long been a gathering place for musical observance and commemoration. The Silver Coronet Marching Band (*far left*), a local brass-and-drum marching band, is pictured during the July 4, 1894, celebration.

The bandstand (*top, left*) was built in the 1980s, when former town selectman and custodian of Town Hall Michael Cleary suggested that the old bandstand be re-created. It was through his insistence and lobbying that the funds were raised by the town. The concerts draw many local residents, who bring blankets, picnic suppers, and lawn chairs—as seen here—to make the evening into an occasion.

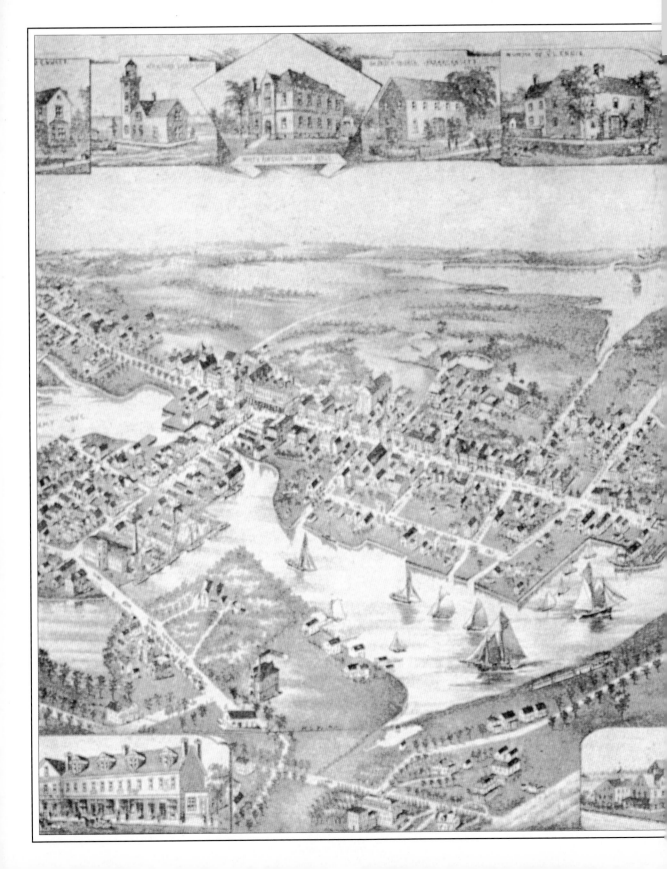

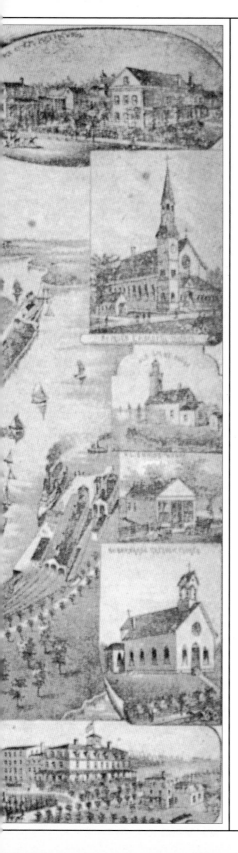

WICKFORD
RHODE ISLAND

I

n the days of my childhood, one could walk from end to end of the quiet hamlet, and meet only the familiar citizens, and hear no sound but nature's music, the hum of insects, the song of the birds, the rippling waters, and the wind in the tree tops. Now the influx of summer visitors has changed the place. There are signs of life and wakefulness and progress.

> Mrs. F. Burge Griswold
> *Old Wickford: The Venice of America*
> 1900

Wickford's character has changed little since Mrs. Griswold wrote so fondly of her home at the century's turn. More New England village than town, Wickford's streets and roads fit neatly onto a peninsula surrounded by the tidal pools of Narragansett Bay. Main Street is lined with large clapboard houses of the late eighteenth and early nineteenth centuries, whose well-tended gardens and entrances frequently meet the sidewalk. Doubling as retail establishments, many houses continue the village tradition of combining commerce and comfort. As for the summer visitors, now they come year-round. As one resident maintains: "I think they come to see the town. Then they do some shopping while they're here."

There's something radiant about the light in Wickford, especially the early morning brilliance and the sunset glow. Perhaps the village wears a halo, a natural illumination made by the many waterways that surround this mitten-shaped piece of land. Perhaps it's just the seasons—late spring and mid-summer, when I came to Wickford. Light is something I used to take for granted. Photography has taught me to cherish it when it's there and yearn for it when it's not. The quality and direction of the light give an

Amazingly, all except seven of the landmark buildings pictured on this 1888 map of Wickford (*previous pages*) are still in existence today.

Main Street—also called "The Grand Highway" and "The Lane"—stretched from the waterfront and ran a direct course through the town to "The Country Rhoad." Most of the streets were laid out in the early 1700s, but were not officially named until 1856.

By 1870, steamships such as the *General* (*right*) became the maritime complement to the local railroad, whose new three-mile line brought private railway cars right up to the dock at the end of Main Street. Together, the two brought visitors on their way to Newport *through* the town, marking a critical point in Wickford's economy. The *General,* in service from 1893 to 1922, was much like a first-class hotel. Saturday nights featured a moonlight sail complete with dancing and a brass band.

The dock at the end of Pleasant Street (*opposite, top*) was the site of the Art Center of South County, Rhode Island.

Commercial fishing (*opposite, bottom left*) still plays a role in Wickford's economic life, yet longtime residents feel indignant about the coming of modern aluminum lobster pots.

Spacious old homes stretch all the way down Main Street to the dock, the last house being suitably named "End-O-Main" (*opposite, bottom right*).

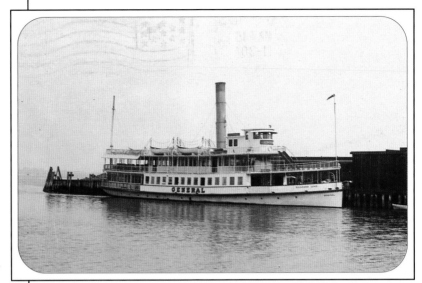

image its sparkle, its essence, its soul. Which is why as soon as dawn broke, I was up and out, checking the light.

Although the diner "downtown" on Brown Street—a minute's walk away from my bed-and-breakfast without rushing—had been open for business since the crack of dawn, the eastern stretch of Main Street, lined with residences and three churches, was still waking with care at 6:30. I was the solitary figure on the street, and without contemporary reminders like traffic and T-shirts, I might as well have been standing in the Wickford of two hundred years ago. At that delicate hour, even the zipper on my camera bag sounded intrusive.

Mother Nature and Narragansett Bay have been regular players in Wickford's history. A series of hurricanes spanning the nineteenth and twentieth centuries have brought real drama to Main Street, proving to be the most destructive agent against the remarkably preserved streets and buildings. Centuries-old trees were toppled, docks and marine businesses were swept clean, and flotsam and jetsam flooded through businesses and residences. To my uninitiated eye, Wickford's buildings seem fully intact, its trees tall and straight. Only a 1938 high-water mark in the form of a plaque on the historic Gregory building gave me any clue to what was lost or nearly lost.

Although The Great One of 1815 was devastating to much of Rhode Island, it's The Big One of 1938 that Wickford residents seem to use in reckoning time, as in "before [or after] The Big One." The Big One brought high winds followed by a rushing flood, which swept water into the lower parts of the village. The stately old elms are reported to have "swayed like straws in the wind," many toppling onto homes and businesses. The town was

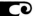

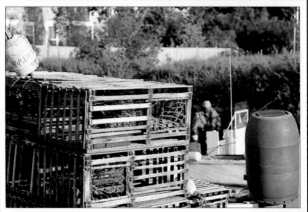

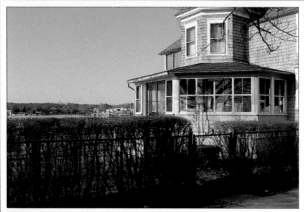

without water for months, during which time the fire department provided water from a water wagon. Lugging 500 gallons of water at a time, the firemen are said to have run hoses from the truck directly into bathtubs! In the years since, the fierce hurricanes with placid names—Carol, Edna, Diane, and Donna—have been the unwelcome visitors. The people of Wickford have always stood in relation to Narragansett Bay—sometimes as the recipients of its largesse and other times of its wrath. So come late August and September, residents and merchants look to the bay with a vigilant eye.

During Wickford's early history as a vital fishing village and commercial port, the street that ran from the waterfront across a ford and all the way to "the Country Rhoad" (now Route 1, and originally the Narragansett Indians' Pequot Trail) was also referred to as "The Grand Highway" and "The Lane," later to be named Main Street. All along the street, the merchants plied their wares. The first time I drove into Wickford, I assumed that my route through the more commercial stretch of town was Main Street, when, in fact, I was on Brown Street. With the gradual decline of the fishing industry, a commercial center filled with service businesses sprang up on Brown, the street that runs perpendicular to Main, merging at a busy intersection that is today the hub of Wickford. When the older residents of Wickford talk about how some things have changed, they invariably refer to Brown Street, where a large parking lot behind the drugstore accommodates shoppers. The commercial section of West Main that hugs the residential area is devoted to smaller, more specialized shops.

Most of the town's forty merchants are hands-on owners, there to open as well as to close. At the corner of Brown and Main, a full range of businesses and services is readily apparent to the casual observer: Ryan's Grocery, The Bookstore of Wickford, Wickford Gourmet, a garden shop called Topiaries Unlimited, an engaging mix of clothing, craft, and antiques stores, a furniture maker, a toy store, and an ice-cream parlor. The chain stores that have sprawled through other New England villages have not darkened Wickford's door. Local accommodations are provided by comfortable bed-and-breakfasts located in historic houses that bear prominent names such as the John Updike House and the Narragansett House.

I stopped at Askham & Telham, Inc., an attractive home accessories and gift shop close to the residential section of the village. Because of the village's early English connections, I immediately assumed the name was properly British. Then I said it fast, and laughed at my presumption and their lack of it.

The village of Wickford, England (*right*), was the birthplace of the wife of the governor of Connecticut when that state claimed Narragansett County as its own. In 1663, the tiny American fishing village was given the notable English name, in honor of the governor's wife.

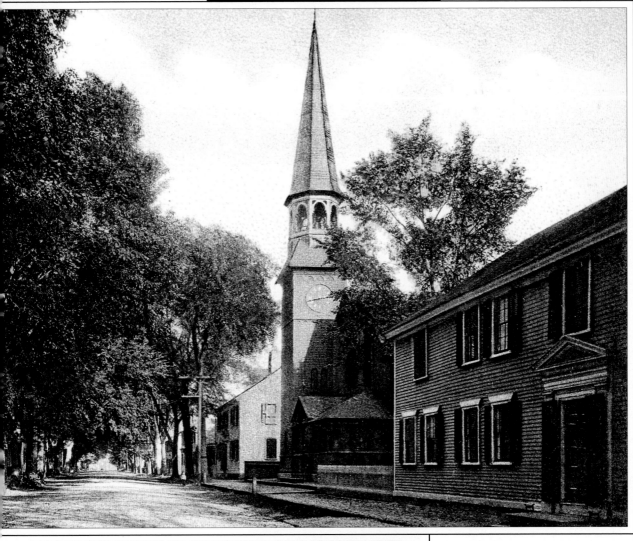

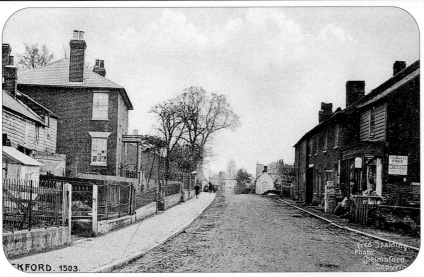

The town's American namesake (*above*) also boasted a lengthy thoroughfare, with dwellings that combined residential and commercial needs, and a peaceful way of life.

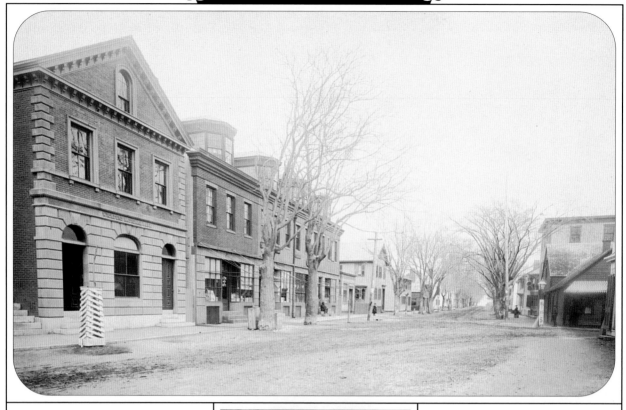

A view of Main Street where Brown intersects it (*above*) was taken when Main was the principal commercial stretch. At the far left is the Wickford National Bank building, where *The Standard-Times* is located today; the Avis block on Main Street abuts it. The absence of the Gregory building—which would later be constructed on the corner at the right in 1891—gives some clue to the date of the photograph.

It was difficult to get a shot that was not obstructed by the traffic flow at the busy intersection of Main and Brown (*right*). At the right is the Gregory building; to the left is the Avis block. Drivers slow down in polite New England fashion as they bow to another's right of way.

The American flag is a permanent fixture on the Gregory building (*left*).

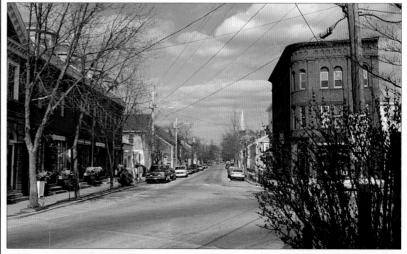

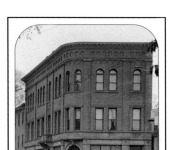

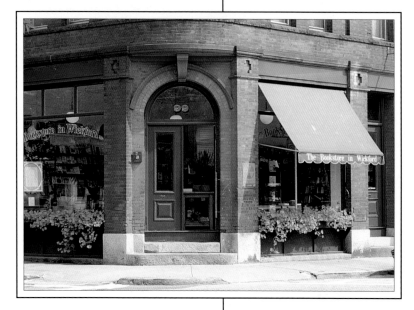

Karen Pizzaruso and Cynthia Easdon, the owners of Askham & Telham, are true to their store's name. Eager and willing to dispense suggestions, advice, history, and local news, Karen and Cynthia quickly became my Wickford pipeline. They told me about the merchants' drive to place benches along Main Street. During the day, I noticed that these tree-shaded benches were especially popular with older folks in the village, who appear to gain more from the chatting than the browsing. Another well-coordinated effort is the window boxes and planters "downtown." On my first visit, jonquils were lining the windows all along Main Street. While businesses elsewhere may have to work on their welcome, the merchants in Wickford naturally reflect the generous and cordial spirit of the town they serve.

Twenty-four years ago, an artist named John Huszer set up a sidewalk stand on Main Street and sponsored his own one-person art show. According to local accounts, everyone thought John Huszer was crazy—and were proved foolish when the unconventional artist sold twenty-seven paintings that day. Thus began the July Wickford Art Festival, a weekend-long event that has been the catalyst for a crafts-oriented merchant community. Over the years, shops in Wickford have run the gamut from carrying leather goods (a sixties craze) to today's broader selection of anything handcrafted.

Some old-timers credit the Village Fair as being the forerunner of the Art Festival. For many years until 1957, the parishioners at St. Paul's Episcopal Church raised money for the parish by sponsoring games of skill for the community. According to native Dorothy Belden, in a valuable senior-citizen videotape project

The Gregory building is an imposing three-story structure of brick, stone, and terra-cotta at the corner of Main and Brown (*above, left*). It was built in 1891 by Williams Gregory, governor of Rhode Island from 1900 until his death in 1902, and once housed the post office.

Today, a bookstore especially well stocked with books on boating, gardening, and local history occupies the prominent corner space of the Gregory building (*above*). It's a warm and cheerful place, where the sunny service is of the old-fashioned variety. The owner, Melissa Fisher, frequently leaves fresh seasonal vegetables just outside the door with a "FREE" sign.

An inscription hastily scrawled in red pencil on the back of this early-twentieth-century photograph showing the view down Brown Street to the Avis Block on Main Street (*above*) reads: "Photo taken by Dr. Elwin E. Young." Dr. Young was the local druggist and an avid photographer of town buildings and events. The buildings on the left were later torn down to make way for a town park and monument.

Iron-and-slat-wood benches (*above, right*) have been added outside the store-fronts in the Avis block.

sponsored by Historic Wickford, the Village Fair also had a merry-go-round "till the men got too weak to put it up."

I came to Wickford on Memorial Day for a dose of genuine, small-town celebration. Wickford is the sort of town that doesn't require a special occasion to fly an American flag. But that day there were flags of every conceivable dimension fluttering in a perfect breeze as far as the eye could see. The parade was due to start at ten; it always comes down West Main into town, then rounds the curve that spills into Brown Street. There the down-town's historic Avis Block acts as an impressive backdrop for the colorful procession of scouting troops, civic groups, local bands, and, of course, the veterans. People began to gather as early as eight o'clock, staking out their spots with folding chairs, blankets, and strollers. Long before the street parking filled up, I'd parked my car in a space recommended by a friendly longtime resident as prime for parade watching.

Wickford's Memorial Day parade was a first for me—the first parade I'd ever photographed. After spending the early morning hours shooting buildings that stood still, the street scene suddenly seemed like nonstop commotion. For a fleeting moment, I panicked and forget why I'd come to Wickford on Memorial Day. The music, the color, the excitement, the pomp—the highly charged combination came at me full tilt. Then a Cub

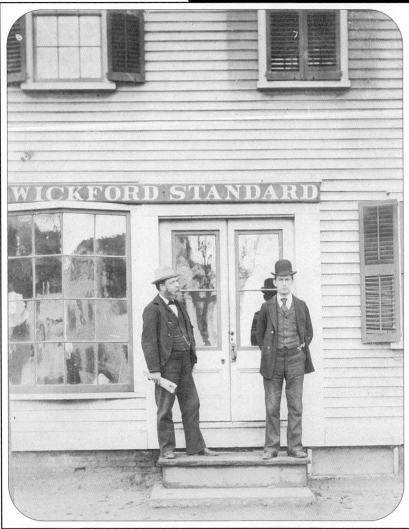

The *Wickford Standard* (*left*), now *The Standard-Times* (*below*), has served as faithful chronicler of village history great and small since 1888. Tragedy struck in 1938 and then again in 1954, when its offices were wrecked by flood waters, resulting in the loss of most of the paper's valuable archives.

The man on the left in the historical photograph is thought to be Claude Gardiner, the first publisher.

According to copy that accompanied this photograph when it ran in the centennial edition of *The Standard-Times*, it was taken in 1892, when the newspaper was located on Main Street "across from the First Baptist Church." The office made a number of moves back and forth on Main and Brown, in 1969 settling in the historic Wickford Bank building.

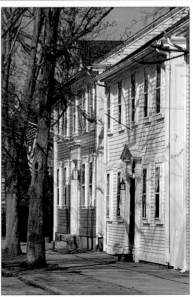

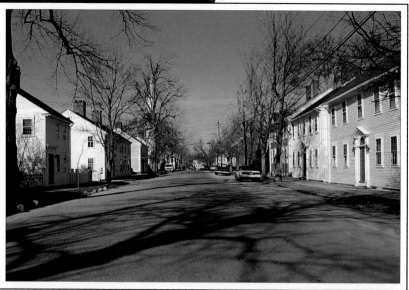

Today the residential section of Main Street looks much the same as it did in the late 1800s, with houses lining the wide tree-shaded street. Several of the homes significant to Wickford history contain prominent signs to identify them: the Narragansett House, formerly a bank; the Wickford House, once an inn. Many homes contain plaques with their names and dates by the front door. But as one recent account clearly states: "It's not a living museum, a historic re-creation, or a development with 'old New England flavor.' Real people live here, work here, and do their business here."

A short stroll down this section of Main is its own garden tour. Residents pride themselves on their well-tended gardens and yards.

The hurricane of 1938 is referred to as The Big One. People tend to date things by The Big One—as "before The Big One" or "after The Big One." So what remained untouched by destructive fires or the heedless assimilations of modernization did battle with nature. Here, trees have fallen on many fine homes (*right*), an outhouse has found its way to a more prestigious location (*above*), and the cleanup begins (*below*).

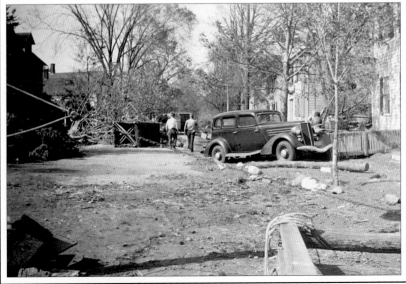

Scout rounded the bend, the honored leader of his troop. I watched as he struggled with the weight of a large parade flag and his awesome duty this day. As the local school band hit the high notes of patriotism, I was unexpectedly overwhelmed by the occasion, by the music, by the plain evidence that we are all Americans. But my responsibility called, too. I took a deep breath, focused as the valiant scout's flag gave a gentle salute to the breeze, and captured the moment.

A sign on the town green reads: "Updike's Newtown." This frequently confuses visitors, who worry that they've made a wrong turn. A brief knowledge of Wickford history clears things up. In 1709, two families—the Smiths and the Updikes—platted and laid out the streets, sold the land, and created the village much as it exists today. The town's many tidal pools and peninsular location on a protected harbor meant, in times past, that it was connected with the mainland only at low tide. Rising tides and the lack of bridges created daily challenges for residents. To leave Wickford, people had to ford the creek; children attending the Washington Academy around 1800 had to cross in boats to reach school. Today, the village dovetails seamlessly into the mainland, filled in or connected by bridges.

The bay shore and harbor have always been important to the success of Wickford and its residents. Although the harbor's functions have changed over the centuries and its fortunes have waxed and waned, in many ways the harbor still defines the town. Before the Revolutionary War, Wickford was a large commercial port. Local vessels were engaged in trade with "the Islands," and nearly all vessels were "launched," or built, in local shipyards. Exported Rhode Island products included horses and cattle, lumber, beef, dried fish, flour, wool, and butter. With nearby Newport under British occupation, the port of Wickford—still free from British control—flourished. Legend has it that a band of local patriots—calling themselves the "Newtown Rangers"—kept a marauding British ship at bay by firing week-old lobster bait at them from a cannon.

After the war, the town benefited from the port's commercial success, with taverns, silversmiths, and merchants of all descriptions springing up on Main Street. In 1804, the Narragansett Bank was incorporated into Benjamin Fowler's house; in 1820, the Wickford Savings Bank was established at the west end of Noel Freeborn's house. The bay also provided seaport industry to the town. An outgrowth of this industry, a fish works called the Menhaden, caused bitter feelings in the town. As one piqued resident is said to have stated in a characteristically straightforward Yankee way: "The stench

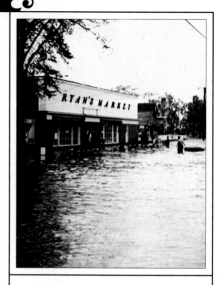

Not one but two hurricanes—Carol and Edna—wreaked havoc on Wickford in the fall of 1954—and on Ryan's Market (*above*), by then expanded to four times its original size. One can imagine the merchants at Ryan's piling goods high on shelves only to have them topple down as flood waters rushed through every crack and crevice. Hurricanes are a trying part of business life in Wickford.

Second-generation owner "EJ" (Edwin J.) Ryan, also known as "Steady Eddy," included a column of sorts in the Ryan's ads that appeared in *The Wickford Standard* from 1952 to 1957. In 1954, he had this to say: "Why they attach a woman's name to such a devastating thing as a hurricane I can't understand. Sounds like a man's work to me."

Ryan's Market *(below)*—a Wickford institution—celebrated its 100th birthday in 1992, having outlived and outlasted the competition from larger chains that tried to replace it. None was able to approach the honesty, reliability, and generosity of Ryan's, the choice of loyal residents. Third-generation owner Dave Ryan can be seen standing in the freight entrance. He's actually looking for me—to introduce me to Frank and Lois Tilley.

Frank Tilley, a former Ryan's employee, and his wife, Lois *(below, right)*, come in to Ryan's to shop once a week. The Tilleys, both eighty-eight years old, met many years ago at a dance hall in a nearby town. They were happy to sit for this picture, but eager to get on with their shopping.

was so strong it stopped a clock." Luckily, the fish works was a short-lived venture.

One late summer afternoon, I returned to Wickford, this time as an honored guest at the Wickford House. Formerly a popular inn, it is now a private residence and still one of the best places in town to meet friends or business associates. Violet and Charles Daniel invited four generations of the village's merchants and residents to a garden party in my honor to share their memories of life in Wickford. What began as a local event to help me in my research soon turned into a gathering of old friends who nodded and smiled as they reminisced over scrapbooks and photo albums, a satisfying mix of generations.

I had brought along the slides I took in the spring, the shots of the parade and some stores on Main and Brown. An interested group stood around the Daniels' spacious kitchen and we had a modest slide show. My parade shots passed inspection with honors, but a shot of Ryan's Market fell flat. "That's not a good picture of Ryan's," blurted out the first critic. (It seems that I'd taken it from too far away.) "You just have to do it over," declared another quite matter-of-factly. Brushing myself off, I found out that Ryan's Market is a village institution. Founded 102 years ago, it has outlasted several chain groceries that came and went. No one intended harsh criticism; it's just that everyone loves Ryan's.

During the Depression, Ryan's extended credit to anyone who needed groceries and couldn't pay. Up until World War II, the store's efficient ordering system consisted of a man named Clint Cooper, who traveled with an order form to homes in the village; deliveries were routine. The order form is extinct, but the house

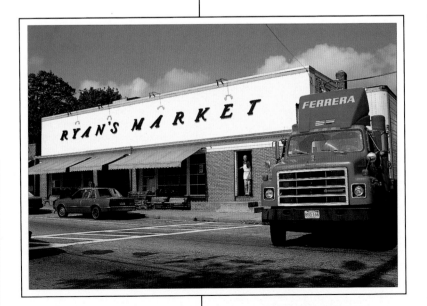

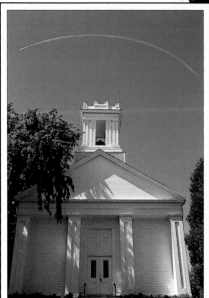

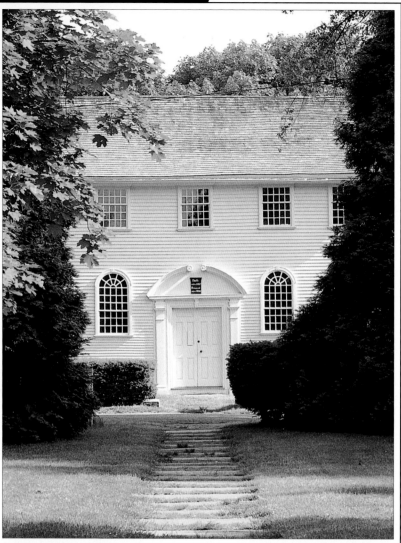

The presence of old churches on Main Street adds to the feeling that one has entered another era. The architectural details on the steeple of the First Baptist Church (*above*) carry out the building's simplified Greek Revival style that blends in with the church's country setting.

Just down the street, a peaceful walkway leads from Main Street to the Old Narragansett Church (*above, right*), the second oldest congregation in America, after Jamestown, Virginia. Today the unheated church, now painted white, is used mainly for weddings.

Erected in 1707, the Old Narragansett Church (*right*) was moved to its present location in 1800 by oxcart from several miles away. A simple frame church, it was based on the style of a traditional New England meetinghouse. Gilbert Stuart was baptized here on Palm Sunday of 1756.

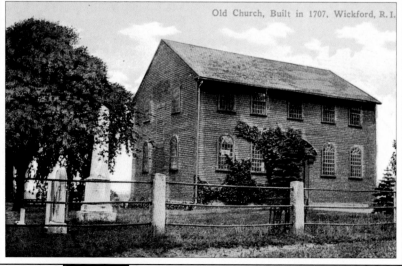

Old Church, Built in 1707, Wickford, R.I.

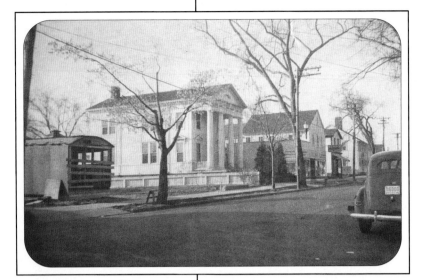

The old Wickford Diner (*above*) seems dwarfed by the former North Kingstown Library building. A popular spot for fishermen at the crack of dawn, the diner was eventually moved across the street to a new location to make room for Earnshaw's drugstore.

Its frame intact, the diner (*above, right*) now sits directly across Brown Street from its original location, placed on its own pedestal of sorts.

charges and the deliveries live on. The Daniels tell of being loaned a grocery cart from Ryan's to hold their many books while their library was painted. On Sundays, a line of carts will sit undisturbed on the sidewalk in front of Ryan's—a hopeful reminder that a few aspects of modern living have not yet found Wickford. The story of Ryan's is a rare one in Main Street history as the focus has shifted from the concerned local grocer to the indifferent food giant. I promised everyone I would reshoot Ryan's, and it was the first thing I did the next day.

Thomas J. Peirce, called Tommy Peirce by most of the people who know him, was for many years the trusted town banker. Now residents trust Tommy Peirce with their treasured souvenirs that depict life over time in Wickford. The photo collection of the local paper, *The Standard-Times,* was wiped out in the hurricanes that recklessly swept history away. Many private photographs and documents were victims of the same fate. Now Thomas Peirce, whose ancestors go back to founder Richard Smith, is the unofficial gatekeeper of an archive that documents the town's history.

Tommy and Erma Peirce live on a street that suits them well—Pleasant Street. For nearly five hours, they sat with me in their dining room, the formal table strewn with a tangle of paper memories. Together we went through Wickford's history in pictures, news clippings, postcards, letterheads, and personal letters. I listened to a story about a neighbor who was packing up albums of old news clippings to take to the dump when Tommy Peirce spot-

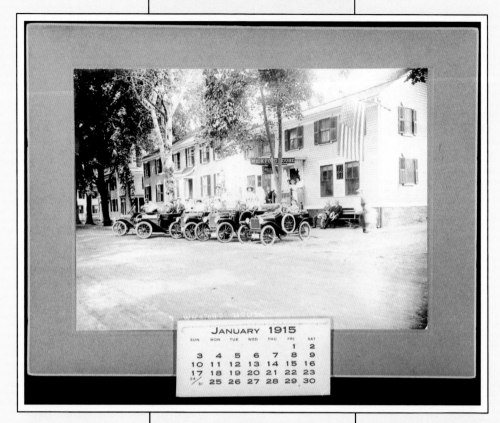

JANUARY 1915

SUN	MON	TUE	WED	THU	FRI	SAT
					1	2
3	4	5	6	7	8	9
10	11	12	13	14	15	16
17	18	19	20	21	22	23
24/31	25	26	27	28	29	30

This photo on a 1915 calendar helps confirm accounts that the Wickford House was popular among boarders for its gracious accommodations and among local townsfolk for its good food and amiable company. It had opened as a small country hotel and restaurant in 1882 (the building dates from 1769). Old-timers still remember that "somebody was always playing the piano," and that "there were always good smells coming from the windows," apple pie and strawberry shortcake plus local specialties such as johnny-cakes and quahog chowder.

Favored by local politicians, business travelers, and honeymooners, the Wickford House was run by the firm hand of Mother Prentice. One story has it that she used to leave two pitchers for the milkman: one for the milk and one for the manure.

It seems that the delivery horses were always kicking over the milk pitchers or stepping in them while the milkman was filling the order, mixing horse muck with the day's delivery. One hopes the milkman eventually took the hint.

Wickford House served as the location for a garden party at which I was the honored guest. In this lovely setting, Violet and Charles Daniel invited generations of Wickfordians to share their souvenirs and memories of village life with me. Seniors sat on the comfortable lawn furniture and reminisced while their grandchildren and great-grandchildren were more concerned with things like playing tag and finishing off the potato chips.

The Memorial Day parade has long been a heartening event in Wickford history. Today the uniforms and the groups are different from the parades of yesteryear, but as one enthusiastic onlooker put it: "We've got one of the nicest little parades you're ever going to see!" The tension mounts as the community's leading dignitaries round the bend at the intersection of Main and Brown. What follows is a long and spirited mix, from weathered veterans whose patriotism has been tested many times over to fledgling scouts in high gear, too young to comprehend the full significance of the day.

A break in the parade occurs when the oldest surviving widow of a local veteran casts a wreath of flowers over the railing of the town bridge into the cove below. The wreath drifts with the current out into Narragansett Bay.

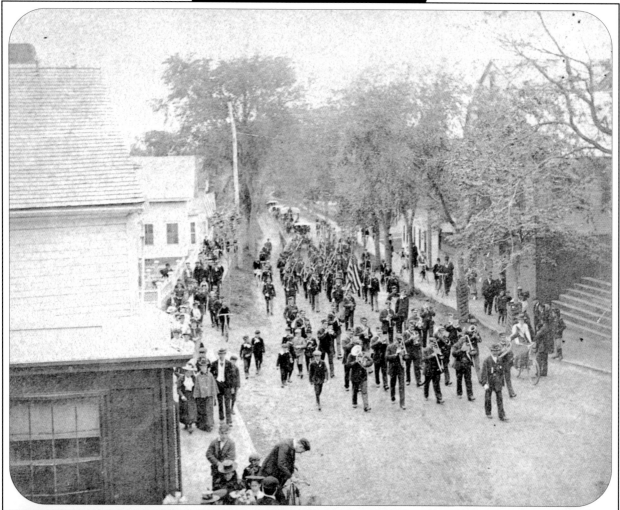

It is said that Harriet S. Smith "didn't act like anybody else and didn't dress like anybody else" because she wore pants and once walked all the way to Providence! At any rate, Harriet's overprotective brother, John S. Smith, once found a love letter written to Harriet by a suitor, John Sandhovel of New York. John Smith also found the daguerreotype Harriet's suitor sent to her. Angrily, he penned this letter (I've modernized the spelling):

March 24, 1857
Sir
If I hear anymore of your insolence thereafter I shall be under the painful necessity of introducing a pair of cowhides to your extremities. What the hell do you suppose that girl cares for your contemptible phisog, you pusillanimous. You and your damned old Christmas tree and your old cave you talk about so much in that insignificant letter you sent to her six or seven weeks since. You're a bird, you be [picture of bird here] without paint or whitewash. You are a fine-looking scam as I can see by your cursed old daguerreotype that you had the impudence to give to that girl, you damn fool. I have got the damned pretty thing in my trunk and the girl didn't want to lug around such trash and so she left it with me. I am going to have fifty or sixty of them taken and stuck up around town. They are so pretty. So don't let me hear of your sending any more letters that way or you may expect the consequences.
J. S. Smith

John Sandhovel sent the letter back to Harriet, marked *Strictly Confidential*, and that's the last that anyone knows. Except that Harriet became Harriet Davis. And no one knows about the whereabouts of the daguerreotype that started the to-do.

ted them in the nick of time. I heard about the people who send their postcards to Tommy Peirce for safekeeping; his collection of postcards once numbered more than 1,000. But I came away with more than the printed documents—I came away with a couple's warm personal recollections, their mirthful anecdotes, their steady sense of place.

In 1870, the Newport & Wickford Steamship Railroad Co. unloaded its well-heeled passengers at the steamship dock at Wickford Landing, where steamboats awaited boarders. Sometimes extra railway cars were added for "the season" for stylish Newport-bound New Yorkers, some of whom were said to have brought along as many as 300 suitcases! A four-foot-wide strip of plush Turkey carpet was laid down six times daily, reaching from the railroad car platform to the gangplank of the *General,* a steamship of renown that bore passengers to fashionable Newport to "summer." As I wandered through the charming streets one last time before driving back to New York, I was aware of other cameras, other curious eyes—the ever-present guests. Then it dawned on me that an appreciation of Wickford's unspoiled charm is not reserved for those who live here. It might be easy to think that the historic nature of Wickford would make it a static set piece; but that is actively not so. Wickford's time was then, but Main Street history lives on in the present.

Topiaries Unlimited (*above*) has set up a shop of the gardening variety in a house that once belonged to a Miss Gould, best remembered by children who attended school across the street in the early 1930s as "the woman who set herself on fire leaning over her stove." The owner, Ann Wallau—seen on the porch—has sufficient water on the premises today to dampen any such fate. Since the village is filled with avid gardeners, Topiaries Unlimited looks like a natural extension of the yards on Main Street (*above, left*).

Village life was gentle and well paced, and over the decades the stories of familiar events were tenderly inscribed in the diaries and journals of residents, some published and some not. Reading these gives one a sense of place. Seeing these snapshots, from the private collection of Wickford native Thomas Peirce, gives one a warm and full picture of the town.

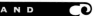

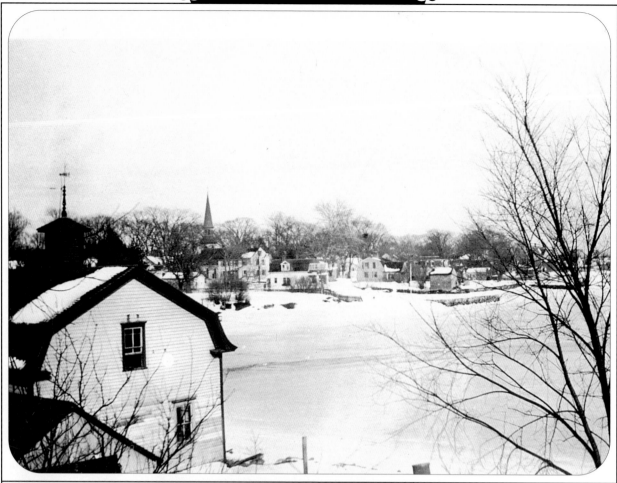

OBERLIN
OHIO

In the dead of last winter, when everyone was longing for a tropical vacation or some tangible reminder of spring, my morning mail was not filled with brochures for resorts on sandy sun-drenched beaches. Instead I was greeted by a dune of another sort: letters and brochures from small-town chambers of commerce and Main Street associations. Then, practically falling out of a manila envelope, was a picture of daffodils—thousands of them—in bloom on Tappan Square, the village green that joins Oberlin College and the town of the same name. Naturally, I took this as a sign.

Oberlin was merely the name of a college for me until I began my search for midwestern towns to include in this book. When I did some background reading on Oberlin—the daffodils included—it became clear why the town and the college are frequently mentioned in the same breath: They are, in fact, so closely linked that it is impossible to mention one without mentioning the other.

The town has been proclaimed "the real America" by S. Frederick Starr, twelfth president of Oberlin College. The college was attended by Thornton Wilder and Sinclair Lewis, writers who had a lot to say about small-town history. The college was described by close friends whose daughter attends school there as "unique," "congenial," "progressive," "principled," and "industrious." The town might well be described the very same way.

"Oberlin is peculiar in that which is good," principal founder John Shipherd is reported to have said. He meant the town as well as the college, for they were established by Shipherd and his small colony of followers as one and the same. When Shipherd, revival preacher and educator, rode into the nearly unbroken forest of Russia Township in 1832, he made his first appearance on

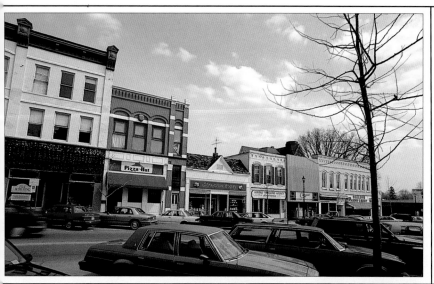

As the popularity of bicycling began to increase nationwide, this fast and accessible form of transportation was, for a short while, considered a threat to the horse and buggy. In 1890, C. W. Savage (*previous pages, bottom*) rode his high bicycle a half-mile in one minute and two-fifths of a second to win a race during his freshman year, the same year as the High Bicycle Club was formed at Oberlin. In an oft-repeated scenario of student turning into resident, Savage stayed on at the college to become athletic director.

Today, the bicycle is still a popular form of transportation among students and residents. An iron hitching post from Oberlin's past (*previous pages, top left*) is given an updated use.

Settled into an existing Main Street building, the signage of Pizza Hut (*previous pages, top center*) is tastefully subdued.

College rules once forbade the use of automobiles by students (*previous pages, top right*), giving Oberlin the title of "Bicycle City, USA."

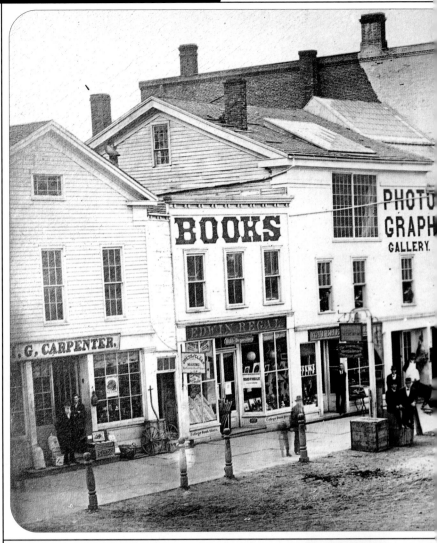

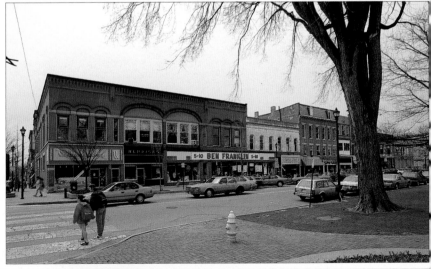

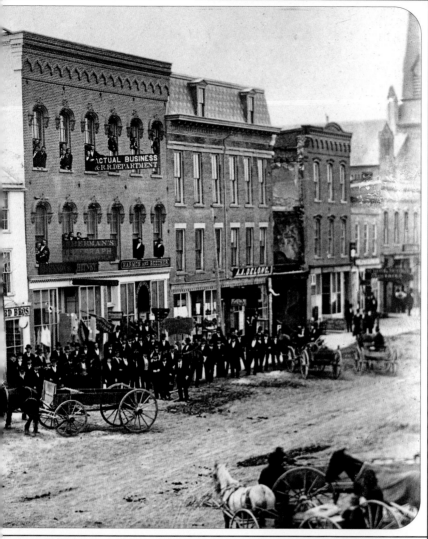

The south side of College Street (*left*) was the center of downtown in 1878. The building marked "Photograph Gallery" was formerly Oberlin Hall, and it once housed all of the Oberlin Collegiate Institute. When the college sold the building in 1854, the advance of the business district on this side of College was spurred, finding its way to Main Street, which runs perpendicular to College Street. In 1886, all of these frame buildings were lost to a fire.

In this contemporary view across College Street from the site of the historic elm (*opposite page, bottom*), one can see the evolution of the Carpenter building in the three tones of brick. The second-story bay was a novel feature. The Ben Franklin gives the block a cozy hometown feeling. Yet only doors away, the Foxgrape restaurant rates a four-star review for its superb haute cuisine. This block is a typical example of small-town extremes.

Awnings used to protect sidewalk merchandise displays from the sun and the rain (*below, left*). Most fabric awnings were removed or simply not replaced over the years because of their status as fire hazards in the business districts of most towns.

The decorative cornice of the Carpenter block rises high above Main Street (*above*). The new pharmacy billboard was inspired by the graphic symbolism of old town signs.

Oberlin's Main Street. He is said to have stopped to pray near an elm tree off the rough roadway, newly cleared by surveyors but already thick with fast-growing underbrush. Shipherd had found his way to this thickly forested land with a purpose: a place where his hoped-for Christian colony could be set apart to flourish.

Having procured the land, Shipherd gathered together a group of committed Christian families and students from the East and set about leading the new community in upholding the pledge of the Oberlin Covenant, which all had signed. The new Oberlinians committed themselves to an austere and pure life; above all, each would "strive to maintain deep-toned and elevated personal piety, to provoke each other to love and good works." The covenant directed most facets of life, including diet and habits. Women were to be trained or educated alongside their male counterparts at the Oberlin Collegiate Institute, so that they could stand side by side with their husbands in spreading the gospel. This coeducation was to be the first of many innovations for which the college would be known. Since all had signed the covenant, early settlers at Oberlin acted as if of one mind in most matters.

When Shipherd sought out the Oberlin site, he was perhaps not looking with a practical eye at the suitability of the land. He was looking for open space—insulated from any established society. He wanted room for public grounds for the school and for the center of the village. He had some notion of space for farms and gardens. Given the spiritual nature of Shipherd's quest, he may have neglected to concern himself with the dense forest and the wet, clayey soil beneath them.

"Mud, mud, mud," a visitor once complained in the mid-1800s of Oberlin's streets. "I had no idea of mud from New England roads," is an early comment documented by historian Nat Brandt, who goes on to note that the main thing early Oberlinians talked about endlessly was how muddy the ground was after rain.

While some of the streets had wooden sidewalks by the 1850s, the rain and mud made even these slippery. An editor of the *Lorain County News* in the spring of 1861 found the conditions "hardly navigable for cat." A 1950s excavation made by workers digging a new storm sewer under South Main Street revealed the strata of the road. Working from the bottom up, the excavation revealed: logs, clay, stone blocks, crushed stones, flagstone, a combination thereof, and brick paving. From the first corduroy road laid out in 1840 to the brick paving laid after 1898, the battle was always on to construct a road that could endure Oberlin's harsh winters and wet springs.

The most important business sections of town, as well as areas leading to and from the Collegiate Institute's buildings, were the first to get walks. During the rainy spring, a force of men was required to maintain the walks at busy street intersections. On the campus green, the walks were much used and were thought to be a real nuisance at times. One young woman named Almira, it is reported, caught her hoop in a nail on the plank walk across Tap-

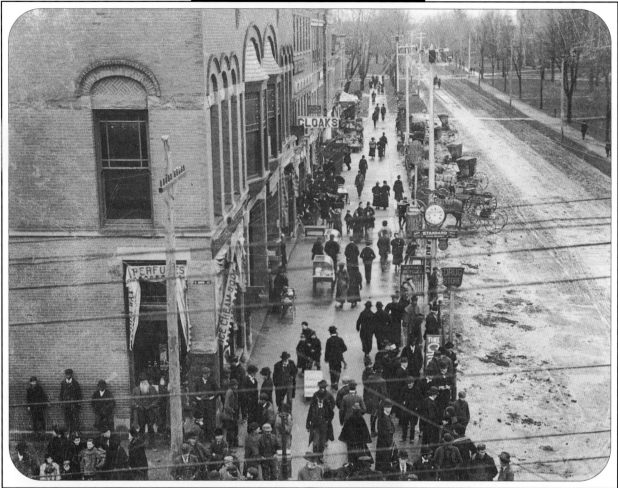

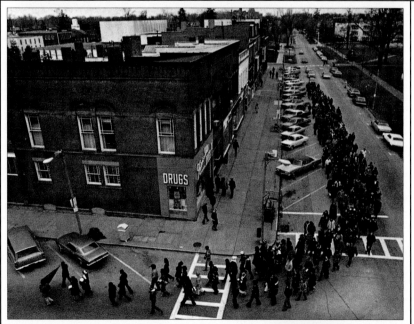

This corner view of the Carpenter block (*above*) shows no sign of the wooden structures that stood here in 1878. The Carpenter block went up in stages after the spectacular fire of 1886. Utility lines are obvious, as are the muddy, rutted streets.

In November 1972, black students at Oberlin College organized a march down College Avenue onto Main Street (*left*) in a "day of self-determination." Note the concrete sidewalks, marked crosswalks—and no mud at the busy intersection!

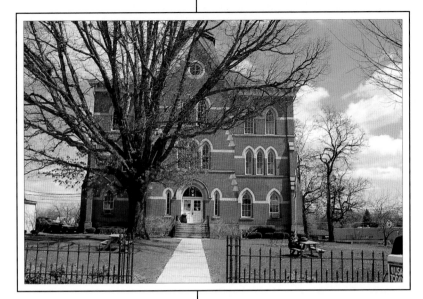

The old Union School building (*above*)—listed today on the National Register of Historic Places as Westervelt Hall—had an enrollment of 700 students in its heyday at the turn of the century (*above, right*). In 1923, Edward Westervelt bought it and gave it to the college, which used it for classes until 1961. It then stood empty, and many saw it as an eyesore until local contractor Kenny Clark launched a renovation in 1981, enabling the college to use the space as temporary quarters for their bookstore. Soon after my visit, the new college bookstore opened elsewhere, leaving the future of Westervelt Hall uncertain once again.

In the 1980s, Oberlin's downtown area underwent a $1 million renovation. The streetscape improvements (*opposite*) included brick-accented sidewalks and old-fashioned lampposts.

pan Square and had to cut off her hoop with a penknife in order to proceed. Flagstone walks eventually supplanted the mainte-nance-intensive plank walks in the busiest areas.

The first sidewalks tended to be whitewood plank, laid end to end lengthwise, excepting the curiosity known as the "coeduca-tion walk." Apparently laid out under the careful eye of the dean of women, it kept male and female students an appropriate dis-tance apart as its two planks of wood were laid endwise about two feet apart. The main walk across campus actually went *through* one of the halls of the college.

All over America, a break from sidewalks and roadways was offered by grassy stretches—some tree-lined, some fenced off, others rolling over many acres. Parks, greens, and squares—whatever their form or name—figured prominently in Main Street history. They restored much of the original terrain's natural beauty and added to a town's esteem and sense of community spirit. By the mid-1800s, Village Improvement Societies were looking beyond the useful to the beautiful as they promoted con-cerns such as tree-shaded roads and lanes, public flower beds, drinking troughs, lighted paths, clean streets, and purified air. Bandstands, benches, fountains, and monuments became gather-ing places and a focus for public ceremonies and community events.

In Oberlin, an impressive thirteen-acre green lies at the center of the town and the college. When we arrived, we circled Tappan Square twice to get our bearings. (It was April and the town was living up to its cold, wet reputation. The daffodils of the promo-tional photograph were still tight-fisted about their blooms.) Oberlin's basic layout is much as it was in its early years. The

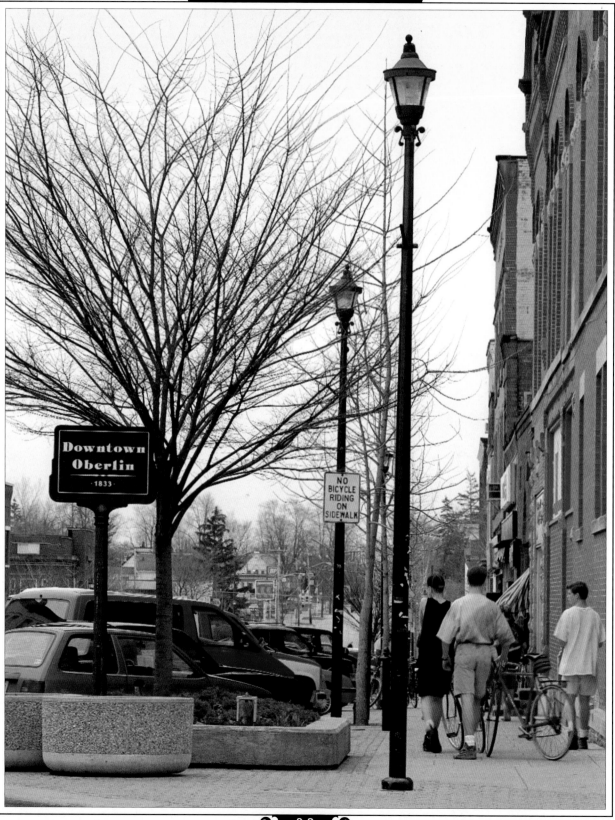

berlin presented a variety of facades from the late nineteenth century through the middle of this century. The brick buildings run the gamut from natural to whitewashed to softly colored pastels.

These painted pressed bricks with contrasting cornice trim (*left and below*) are typical of late-nineteenth-century commercial blocks.

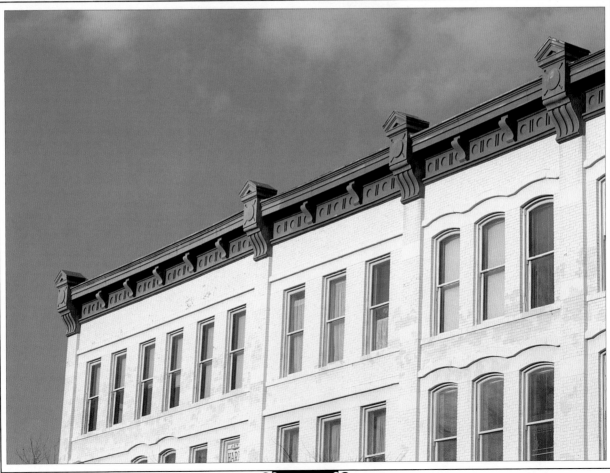

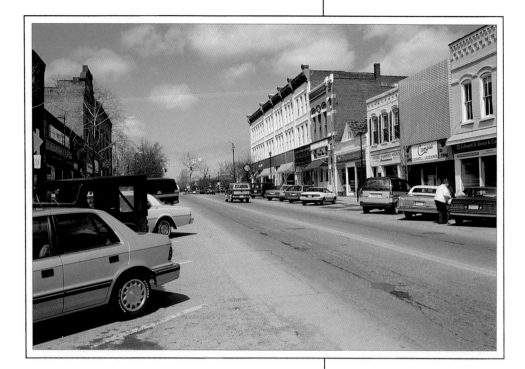

square was once the campus, and most college buildings were lo-cated on it with satellite structures surrounding it. Fires in the late nineteenth century destroyed some of the old college buildings, and others were taken down in 1927 to meet the conditions of a bequest requiring the square to be used exclusively as a park. The green was known as College Park or Campus Park until the 1940s, when it was renamed after an early college benefactor, Arthur Tappan.

The park area was heavily forested when the first Oberlin colonists arrived. Eager to clear the land for development, they are said to have stripped it down to two trees. By 1840, the plant-ing of trees in the park on Arbor Day had become an annual tra-dition—the beginning of a new era of environmental concern for Oberlinians. Today Tappan Square boasts of approximately sixty species of trees.

Still situated on the square are the Memorial Arch (1903), site of gatherings past and present, the flagpole, and the Clark Band-stand, which was erected in the 1980s. The new bandstand harks back to the days when the Citizens Brass Band played on Tappan Square. Events on the square continue to be shared and enjoyed by all townspeople, college-affiliated or not.

The pace of change in Oberlin has been gentle. There's an array of tidy stores refreshingly devoid of trendy trade names and urban glitz: a bicycle shop, several dress shops, an old-fashioned variety store, a stationers, a new drugstore, a relaxed restaurant

Modern commercial block buildings utilized important trends in architecture that had been developed after Chicago's 1871 fire, including iron skeleton support columns and crossbeams, use of smooth pressed "Chicago brick," and big plate-glass windows. This view of South Main (*above*) looks toward the intersection of College Street.

All along Main Street, one finds souvenirs from Oberlin's past. At John's Pizza (*above*), an old street sign sits unexpectedly in the window. In a nearby alley, an old billboard (*right*) is weathered by time.

A modest one-story building housing a local beauty shop (*above, left*) provides a break in the roofline along Main Street.

Just across the street, a vacant lot off Main (*above*) has been turned into a small parking area reserved for merchants only. Main Street has no meters, though vehicles are limited to two hours.

The ebullient message on the handmade sign at the Kimpton Jewelry store (*left*), about 1910, says it all.

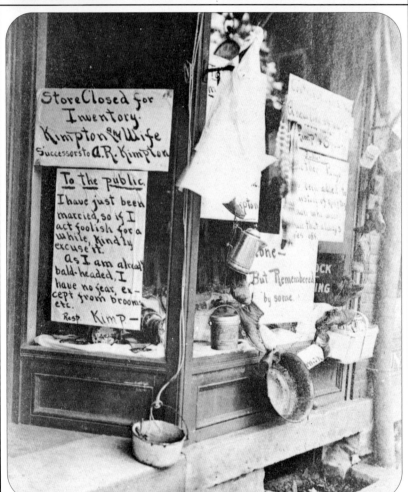

On the night of January 25, 1903, fire demolished the College Chapel on Tappan Square (*above*), an important center of activity at the college.

Blizzards and floods are the natural enemies of transportation (*opposite*), wreaking havoc on streets and buildings. Oberlin's worst flood is said to have been on June 28, 1924, when the water on Tappan Square was so high that children could swim in it. The various blizzards are also well remembered, especially the one in 1913, when passengers stranded on the Interurban slept in the cars till they could be rescued.

that has gone gourmet, and several college hangouts that serve nonstop cappuccino. A grocery store is going up on South Main. The town proper gives one an "as is" sense, the historic and the modern sitting side by side. And in a town like Oberlin, it's the socializing, not the shopping, that makes the difference.

From the corner of College and Main, I observed a local—a casually dressed senior—as he went about his morning errands. A morning paper was the obvious first stop. He then wended his way in and out of stores, accumulating a variety of items in small paper bags, which he shifted to one arm. What was remarkable about this ordinary morning trek was not the errand-running but the amount of time it took, as the man greeted and was greeted every few feet along the way.

From the very early years, independent stores had been established in Oberlin, and with population growth came further mercantile and business expansion. By 1850 the south and east sides of Tappan Square were established as predominantly "town" rather than "gown." Downtown was spreading, too. With the sale of Oberlin Hall by the college in 1854, the development of the western part of Main Street was hastened. Soon mercantile establishments expanded southward on South Main Street. In 1860 the *Lorain County News* reported that "all things to make a go-ahead Ohio village, excepting a grog shop, are found in Oberlin." (While the neighboring town boasted nineteen saloons, Oberlin had none.) After mid-century, Oberlin began to experience economic growth normal for a village of its size.

In 1855, the town had a population of 2,100, exclusive of students and fugitive slaves. An early center of the abolitionist movement, Oberlin today is a town where blacks and whites share in running the community. Renovations in the downtown area in the 1980s, financed by merchants, totaled more than $1 million, and included improvements to water and sewer mains as well as to streetscapes. Facade restorations were encouraged by a program of low-interest loans. The restorers of the 1980s had much to be grateful for in the wealth of mid- to late-nineteenth-century structures. Commercial blocks at major intersections set the tone, with smaller business buildings adding architectural and historical interest.

Today, many small-town walking tours hit the high spots, but few study the face of the town. A book devoted to the complex and sometimes quirky architectural history of individual buildings is rare. This is one of the reasons I was eager to meet Dr. Geoffrey Blodgett, who arrived for lunch at the inn where I was staying quite predictably on a bicycle. Bicycle riding is a long-standing tradition in the town, and Oberlinians bike everywhere.

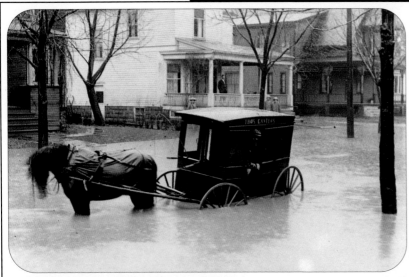

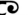

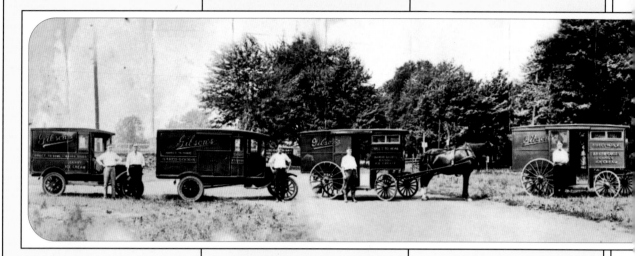

Gibson's, known for its intricately decorated cakes and cookies, has been fortifying Oberlinians for almost four generations. Here, three generations of Gibsons pose in front of the sleek black glass facade with its streamlined aluminum panels and lettering, which dates back to a remodeling in 1950.

Allyn Gibson and his son Dave work side by side in an atmosphere of small-town congeniality. Although Allyn insists he has retired, I saw no sign of this during the Easter weekend.

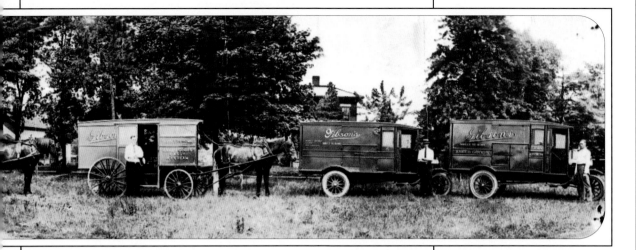

Dr. Blodgett, professor of American political history at Oberlin College and author of *Oberlin's Architecture — College and Town*, talks about "the freewheeling eclecticism of Oberlin today. . . ." He goes on to say that "you can stand in the middle of Tappan Square, turn in a full circle, and almost box the compass of the architectural history of the western world."

In his thoughtful book — and in typically direct Oberlin style — Dr. Blodgett outlines the history of every important building in town and the surrounding area: the date, the style, the changes. But beyond that, he places each building within the framework of its social history. Dr. Blodgett talks about how buildings do not materialize simply from plans on paper; they are products of a community's needs and hopes. "The local folk tradition is valuable both as hard evidence of historical reality and as a window on what is believed about the past. If one is lucky, the accumulation of clues from as many sources as possible will add up to pretty conclusive proof of what really happened." Taken from his book, which served as my most helpful guidebook, this philosophy is the way Dr. Blodgett views the history of people as well as buildings.

The weather had been so unpredictable that everyone was worried that the Easter Egg Hunt would be canceled. But on the Saturday morning of my visit, the sun was actually beginning to warm things up. Two older girls in cute pink bunny suits were already hard at work hiding Easter eggs in Tappan Square. I watched them from one of the picture windows of the Oberlin Inn, over a hot breakfast of oatmeal with fruit and nuts — a breakfast of which John Shipherd would surely have approved. In spite of the poor morning forecast, the sun had finally managed to break through the thick cloud cover. The Easter Egg Hunt was running according to plan.

Wearing a light parka and gloves, I set off for Tappan Square.

Gibson's lined up its impressive fleet of delivery carts and vans — a mix of horse-drawn and motorized — for this panoramic picture taken in the early 1920s (*above*). By this time, several thousand loaves of bread were being baked daily at Gibson's and delivered around town from door to door.

When I asked to borrow the only print of this scene in existence, the Gibson family took a deep breath. They thought about parting with their treasure — rolled and badly cracked from storage — and finally sent it along to me several months later. I was able to make a copy, but only after a careful professional restoration brought the photograph close to its original condition.

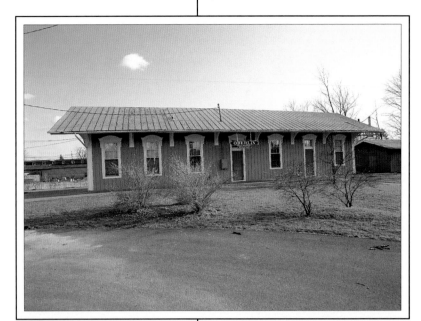

Today, the old railroad depot (*above*) is used as part of a Head Start program. The broad eaves of the depot, constructed in 1866, protected waiting passengers from inclement weather. The last passenger train ran in 1949.

Although Greyhound bus service had eclipsed the train as the most popular way to travel to Cleveland in the 1930s and 1940s, a bus strike in 1945 (*above, right*) brought a renewed interest in train travel.

Now I was planning how best to photograph a mob of eager children who, the pink bunnies warned me, rush the park for eggs and strip it fast. A hardy-looking group had begun to converge on the business end of the square. Although it was beginning to warm up, the dampness still made jackets and heavy sweaters a necessity. Several years ago, there was talk of discontinuing the Easter Egg Hunt, followed by a sizable protest. The hunt continues to be one of many events that still connect the town and the college.

In the spirit of fairness, sections of the park had been designated for different age groups. Everyone lined up along the pavement on the College Avenue end of the square. When the church bell rang out, every small mind was ready with a plan of attack. Dozens of bright little parkas flew by me, streaking a kaleidoscope of color across my field of vision. Picking up on the energy and the fun, I moved quickly from one child to the next to get my shots. As the cache of Easter eggs began to dwindle, the children hit their stride, zigzagging in a concentrated free flow across the green. Parents ran interference, holding out assorted baskets and bags for the youngest, scooping up eggs on the rebound for the overeager. I tried hard to match the rhythm of a small-town dance that comes, unfortunately, but once a year.

The crowd fanned out and disappeared into town as quickly as it had materialized. The day before Easter is also a time to line up for a picture at Bunny's Flowers and Gifts with two pet rabbits that are so gigantic and well behaved that I mistook them for stuffed animals. It's a time for pizza at the Main Street Pizza Hut, a franchise that has managed to blend nicely into its downtown

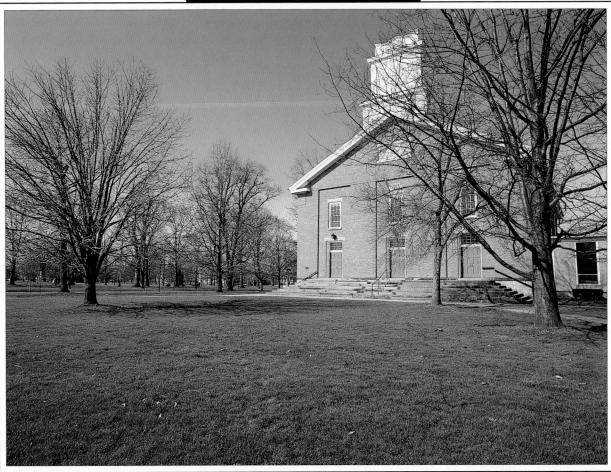

The grand orange brick meetinghouse (*right*) located just off Tappan Square, built with locally fired bricks, was constructed in 1842–44 as part of a massive community effort directed by the church deacon. The design for the tower—added in 1845—was taken from an Asher Benjamin pattern book. The imposing structure, which holds 1,200 comfortably, is now called First Church (*above*) and symbolizes Oberlin's idealistic and humanistic beginnings.

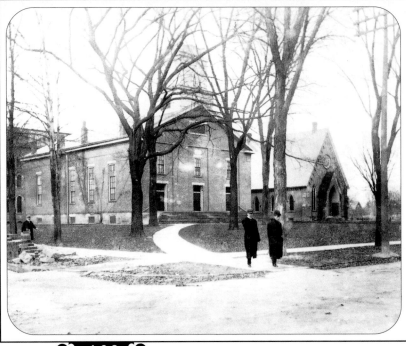

The wide expanse of Tappan Square divides the town geographically and unites it through beauty and shared use. Handsome brick walks have replaced the old cinder paths and plank walkways. The Easter Egg Hunt is but one of many events shared by town and gown on this splendid thirteen-acre green.

block. It's a time to buy Easter candy at Gibson's, an Oberlin landmark for four generations, with a fifth in training.

Gibson's is a bustling place year-round, but at Easter, I could hardly squeeze through the crowd for a closer look at the old-fashioned counter display of whimsically decorated cakes, cookies, and candies—a veritable canvas of Easter artwork! Bert Gibson and his brother, Cass, sons of the first generation of Gibsons, started with a peanut and popcorn stand at a prime location: the busy intersection of Main and College near the old trolley stop. Then they opened a three-story building in 1905 on the present site, which faces Tappan Square. Now Bert's son Allyn (who claims to be retired but was clearly evident behind the counter whenever I stopped by) is passing along the business responsibilities to his son, Dave. Dave's children are learning the ropes from the bottom up after school and on weekends, sweeping, refilling shelves, and waiting on customers.

All the baked goods, candies, and ice creams are made right on the premises. People come from as far away as Akron just for a Gibson cone. Their traditional specialty—a whole-wheat doughnut—is frequently shipped to Oberlin graduates throughout the country for sentimental reasons. "Sometimes the postage costs more than the order!" Allyn Gibson told me, amazed at the lengths people will go to for old times' sake. The recipes for the doughnuts as well as Gibson's other products remain closely guarded family secrets. While I was there, a customer selected a gaily decorated mini-egg-shaped cake from the shelves. I watched as Dave Gibson scrolled *Emily* on the tiny egg, squeezing and flourishing the letters perfectly across the gentle curve. In a world of mass production, Dave and Allyn Gibson are a rare breed of bakery artisans.

Easter Sunday seemed the perfect opportunity to photograph churchgoing on Main Street. And the First Church seemed the perfect traditional setting. I sat in the back pew of this magnificent meetinghouse building, its "one voice" of the past giving way to divergent voices and opinions within the community over the years. I tucked my camera bag out of view. After the benediction, I wasted no time in leaving. Out on the front lawn, I expected to capture worshipers as they descended the stately stairs from the front doors—a symbolic three in number—past a benevolent minister in flowing robes. I waited. A handful of churchgoers trickled out one door. Then no more. The penitent masses had either left by the back door nearest the parking lot or walked through a breezeway to coffee at the parish hall. So much for shepherds and their flock on Main Street!

On the way back to the inn, I spotted a bed of miniature daffodils, bright and bursting with news of spring. Oberlin had been true to its promise after all.

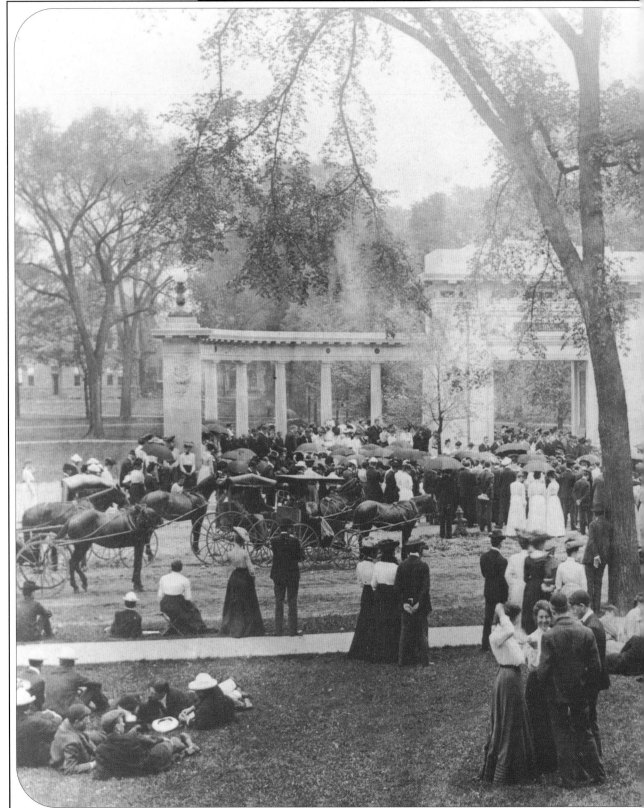

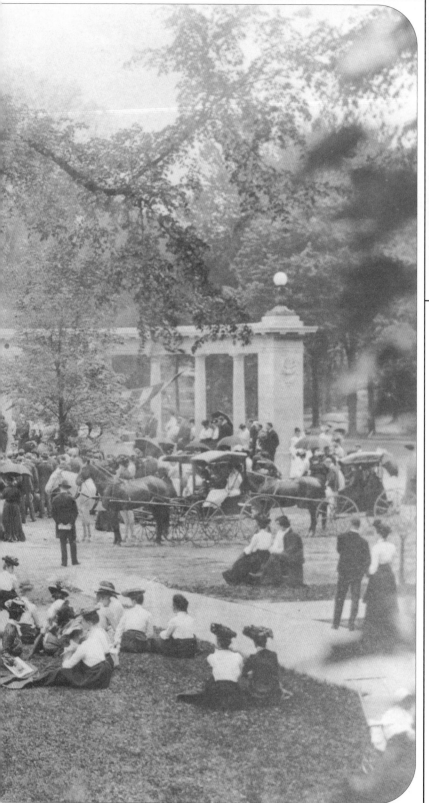

Conservatory students (*above*) shed their winter layers to play something joyful in Tappan Square on the first sunny spring day.

A light spring rain began to fall during the 1903 dedication of Memorial Arch in Tappan Square (*left*), commemorating the missionaries and their children who were murdered three years previously, in the Chinese Boxer Rebellion. All but four were Oberlin-affiliated. The formality of the arch reflects the popularity of the neoclassic design in American public architecture at the turn of the century. The crowd in the background appears to be bowed in prayer. A closer look reveals two couples in the foreground happily chatting away—celebrating the pleasures of coeducation!

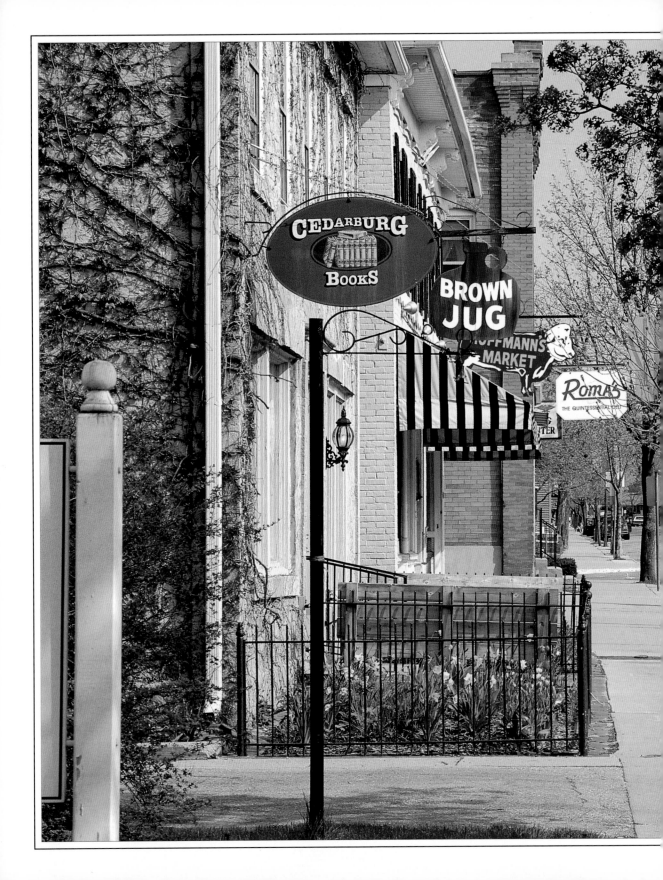

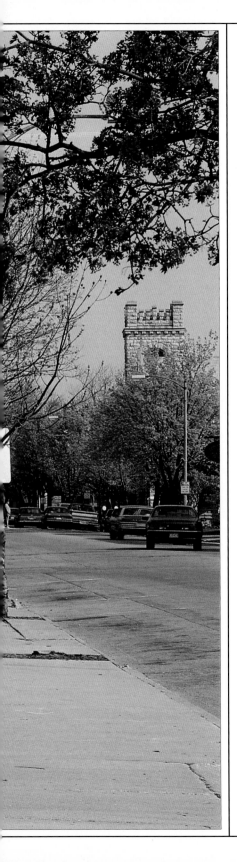

CEDARBURG
WISCONSIN

Bed-racing first attracted me to Cedarburg. I came across a brief notice of their upcoming Winter Festival in an airline in-flight magazine, sandwiched between ads for frequent fliers and reassuring diagrams of emergency procedures. I might have overlooked "bed-making," "bed-checking," or even "bed-wetting," but "bed-racing" got my attention. The other thing that got my attention was the apparent promotional savvy of this small Wisconsin town.

A month later, my suitcase was bulging with the weight of extra sweaters, ski underwear, a face mask, and thermal glove liners.

The way the scenery outside Milwaukee transforms itself from urban sprawl to rural isolation in just a few miles took me by surprise. The fields had been brushed by snow again, but Wisconsin had been spared its usual midwestern deep freeze.

There was farmland as far as the eye could see, fields fringed by woodlands relatively undisturbed by suburban Milwaukee's expansion. I tried to imagine what the road was like centuries ago, when a simple Indian footpath cut through the wilderness along the lines of Cedar Creek. This trail, part of a greater network that wound westward, was but a narrow seam in an unspoiled land of thick forests and pure streams. Then in 1836, a work crew began clearing the forests to build the new Green Bay Road, cut "2 rods wide" along the former Indian trail. Felled logs were laid across rushing rivers and streams. After centuries of use, and in violation of their rights, Native American ownership of the route was lost forever.

In 1859, when the first stagecoach line came through town, only a few businesses existed, and hand-carried lanterns lit the streets at night. A few years earlier, in 1848, the same year Wisconsin became a state, the legislature ordered the building of the

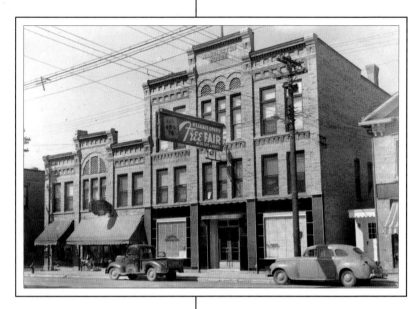

It's early morning in downtown Cedarburg (*previous pages*), and Washington Avenue is just beginning to fill with traffic. In 1846, Conrad Horneffer opened the first Washington House Hotel (*above*). A letter written by town founder Frederick Hilgen in December of 1846 relates: "Every evening we play cards or dominos at Conrad Horneffer's in the Washington House." A room could be gotten for $1.75 a week. By 1920 the hotel business had declined and the building was used for offices. This photograph was taken in 1948 by Harold Dobberpuhl, who has childhood memories of having his tonsils removed in a doctor's office there.

The *faux marbre* columns and rosette details of a building that used to be the Juergen Schroeder store (*above, right*), located only steps away from the Washington House Hotel, add a decorative touch to its lovely exterior.

Milwaukee to Fond du Lac plank road, which was laid through what is now downtown Cedarburg. Heavy loads—lumber and bricks—could only be carried when the roads were frozen, since the planks sank through the mud in warmer weather. Spring thaws made the roads nearly impassable. All along the way, rotted and weakened boards offered an uncertain fate for travelers braving this wilderness. In 1850, my forty-minute drive might have taken many days.

I slowed down to check for a speed trap at the top of the hill on Washington Avenue. It's the town's highest point, and I recalled an account from the early 1900s about a city constable who stood at the bottom of the hill with a whistle in his mouth and a stopwatch in his hand, timing riders as they came down the hill. If Constable Otto whistled and people stopped, he'd arrest them. However, if they didn't stop, he couldn't do a thing about it, since he had no car to pursue them. The city never gave him a car for the simple reason that Constable Otto didn't drive. Perhaps just the memory of Constable Otto is enough to keep traffic under control, at least at the edge of town.

Cedarburg has a remarkably homogeneous downtown. Its well-traveled main street—called Washington Avenue—is lined on both sides with dignified stone buildings, the majority constructed of local limestone. These lovely stones came into widespread use after the Civil War, due to a shortage of milled lumber. It is unusual to find such an unbroken architectural harmony in terms of age, scale, and color. Today the buildings seem remarkably well preserved, with little modern intrusion.

In one account from the 1850s, the town was referred to as a "thriving metropolis," certainly a relative term. Still, it's easy to

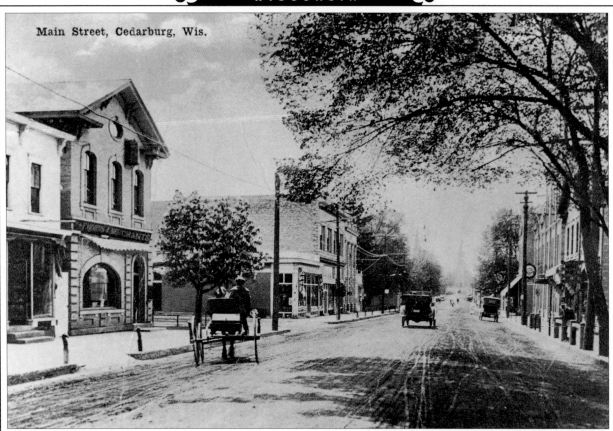

Main Street, Cedarburg, Wis.

Sometimes referred to in the past as Main or Sheboygan, Washington Avenue was still a dirt road in 1915 (*above*), partially shaded by chestnut trees. The hitching posts would soon disappear as automobiles took over the street. In the distance is St. Frances Borgia Church.

In 1984, a thoughtfully renovated Washington House Hotel (*right*) — identified by its distinctive roofline — was reopened by the Pape family, harking back to a time when the town boasted of fifteen hotels. The building next door has an ice-cream parlor where a five-and-dime used to be.

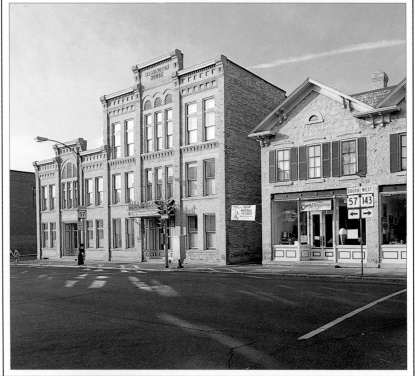

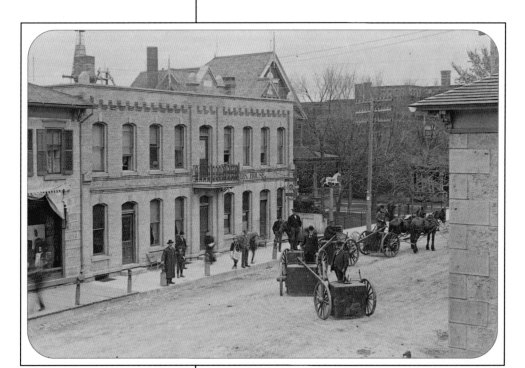

By present-day standards, the 1907 operators of this grading equipment (*above*) seem extremely well dressed for their job of preparing the road for paving, a road that in this instance will contain tracks for a stretch of the interurban railway. A newsboy with a double load is among the observers. Two benches sit on sidewalks beside entrances to the Union Hotel. Placed in front of the hotel, the horse-figure sign—true folk art today—clearly indicates that Mr. Kuhefuss, the hotel's owner, had a livery out back.

understand how visitors then as now might be impressed by the sight of the five-story grist mill in town, elevated high above the humble roofline. The power of Cedar Creek was an undeniable draw for the entrepreneurs who opened mills and for the settlers looking for a new way of life. Cedarburg grew rapidly, with mills opening in 1845, 1855, and 1865; it was incorporated as a city in 1885.

By the time I arose on the Saturday of my visit, gigantic blocks of ice for the Winter Festival's ice carving contest were already standing in front of many of the establishments along Washington Avenue. The early-morning mood at the Stagecoach Inn, where I was staying, seemed more like a pregame warm-up. The dress resembled something you'd see at a ski lodge during a snowstorm. Out-of-towners were signing up to carve alongside the seasoned hometown regulars. The theme was "Fairy Tales on Ice." Up and down Washington Avenue, all ages, stages, shapes, and sizes of individuals and groups were engaged in chipping, cutting, hacking, sawing, drilling, shaving, and even blowtorching their rock-solid ice masses into works of art.

It was hard to tell if a high school student I spoke to, working from a schematic drawing, was creating Rapunzel or the Little Mermaid. The young woman concentrated as she shaved and smoothed the ice without a break. When I asked in my most motherly voice if she shouldn't go in somewhere to warm up, she was almost too cold to answer. An older man on the other side of

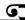

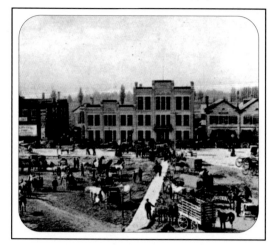

the street entertained a group of children who patted the bulbous nose of his developing ice character. The man said he does this every year, not for any prize, but for the pleasure it brings. A crew in front of the Washington House Inn wore goggles as they blow-torched their tall block of ice, a puddle rapidly forming on the sidewalk. Hours later, when I returned to see the results, they had torched the ice down to a fairy tale miniature.

Meanwhile, a crowd was gathering on the frozen Cedar Creek, which runs parallel to Cedarburg's main street, for the event we'd all been waiting for—the bed-racing. Contestants had rigged a madcap assortment of beds with runner blades to push and skate across the ice to victory. Two beds race at a time, circling barrels at the midpoint. A photographer for the local paper showed me where to walk out on the ice for the best shot. I was struggling with my camera, the flip-back fingertips of my new photographer's gloves, and my footing on the ice. It had been threatening rain all day, and I would have given anything for a ray of sunshine. Then the bed racers came flying across the ice. The crowd sent up cheers as wackily dressed storybook characters threw caution to the wind and skated like mad for victory, pushing a most bizarre assortment of wildly adorned beds across the frozen creek and over the finish line. Winter Festival was certainly in full swing!

The bed-racing took place on Cedar Creek just behind the Cedar Creek Settlement, a former mill and now a warren of crafts and antiques shops, restaurants, and related retail businesses. It is

A 1904 shot of Market Day on the village square (*above, left*) shows several buildings that still stand on Washington Avenue, including the Washington House Hotel in the middle and the L. E. Jochem General Store and Jacob Becker Tavern on the right. The dark building on the left was the Boerner Bros. Dry Goods Company, standing on the site now occupied by the Rivoli Theater.

There were traffic jams on Washington Avenue on Cattle Day (*above*)—also known as Market Day—when horses and cattle as well as agricultural products and implements were sold. A social happening as well as a street fair, this event endured through the 1940s.

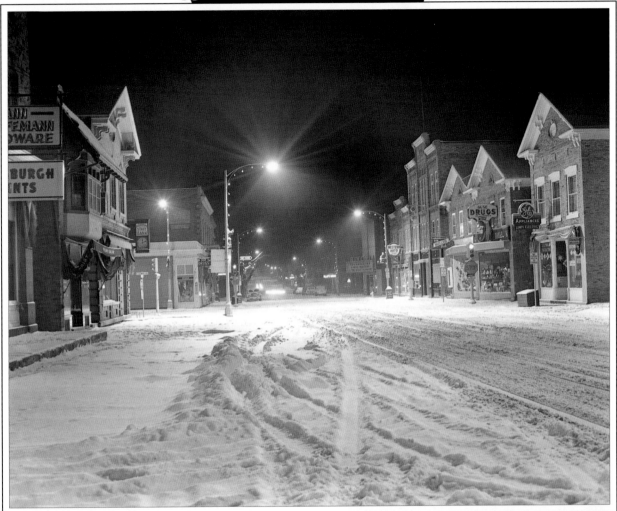

"the Settlement" that attracts visitors to Cedarburg year-round and the warmth of the ground-floor forge that attracted me. There, five men who might well have stepped out of the wilderness—or an L.L. Bean catalog—worked around a high orange blaze, hammering wrought iron into inspired furniture and objects. The blacksmiths were working for show that day, playing to the gathered crowd, who were sipping complimentary sherry out of small plastic cups to ward off the cold. Before I left the Settlement, I combed its astounding maze of shops, doing some financial damage in a vintage jewelry shop—my contribution to consumer confidence.

Although Cedarburg depends on the attendance of tourists at its weekend festivities and fairs—the Strawberry Festival, the Stone and Century House tours, and the Winter Festival among them—for much of its current economic survival, these events still attract a multitude of local residents. Cedarburg—undeniably one of the most popular bedroom communities of nearby Milwaukee—enjoys a long-standing tradition of community involvement. Liz Brown, who with her husband, Brook, owns the Stagecoach Inn, said in a local publication: "People are moving back towards the old downtown feeling . . . people need a center in their community—and Cedarburg is a great example of that."

Crowd scenes and excitement are hardly new to Cedarburg's downtown. Market Day—also called Cattle Day—was a long-time tradition that meant hustle and bustle downtown. Once a month before dawn, farmers would start rolling into town with a bevy of livestock, headed for the square across from the Washington House Hotel. The official function of Market Day was purely economic—the trading of livestock, agricultural products, and farm equipment. In 1883, potatoes brought 15 cents a bushel, pork sold for 4 cents a pound. But as the day progressed, Market Day would turn into a lively social event. According to one source, "The children played baseball for many years on a square of green in the center of town . . . Interestingly, early dentistry was conducted on the square also. A dentist came once a month to treat those that needed it, and sometimes those that didn't." Market Day was also a time for lively political debates, catching up on local gossip, and visiting with old friends. If you lived on Washington Avenue, you could sit right on your front porch and enjoy the view, protected from the hubbub by a neat picket fence. No doubt beer from the local Weber Brewery wet a few whistles during the day and into the night. Market Day continued until 1945, with farmers' trucks parked along Washington Avenue replacing the horse-drawn farm wagons on the square.

According to the Cedarburg State Bank clock, it was exactly 12:10 A.M. when twenty-four-year-old Harold Dobberpuhl, an aspiring news photographer, took this classic photograph of Cedarburg's main street shortly after a heavy snowfall on December 10, 1955 (*opposite, top*). The streetlamps continue to be decorated for the holidays.

Hoffman's (*above*) is the only one of four meat markets that remains in town today. Hoffman's has been making and selling Wisconsin summer sausage and bratwurst at this location since 1917.

The original sidewalk clock in front of Armbruster's Jewelry (*opposite, bottom left*) was knocked down in 1922 by a team of runaway horses pulling a wagon. It was replaced by this now-rare cast-iron clock.

The former Boerner Brothers dry goods store was refaced in the thirties, and the Rivoli Cinema (*opposite, bottom right*) was built.

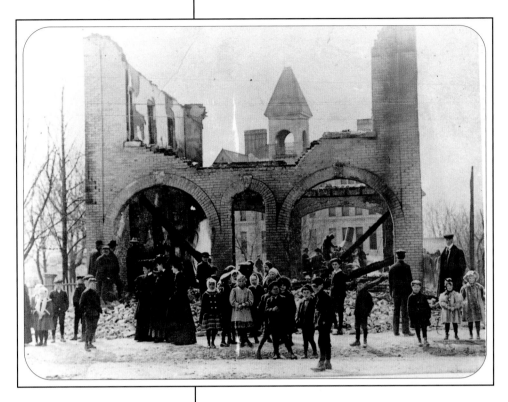

On April 1 of 1907, Easter Monday, a call for help was telegraphed to Cedarburg's adjoining villages and Milwaukee when fire ripped through Cedarburg's own firehouse. Local residents and volunteer firefighters watched helplessly as the flames, fanned by a high wind, destroyed the firehouse and all its equipment, plus schoolrooms on the second floor (*above*).

A Mr. Maas, a volunteer fireman from a neighboring town, is said to have hitched up his draft horses and raced to the scene, only to have his horses drop dead of complete exhaustion.

After the fire of 1907, the town obtained a spirited pair of horses known as the "Wild Ones."

It wasn't until my second evening in Cedarburg that I remembered it was my birthday. Not that I've ever made a big deal about birthdays, but being alone in a strange town without as much as a birthday card suddenly made me feel somewhat neglected. I decided that a good hot meal would make me feel better, so I walked two blocks to a tavern that someone recommended—a popular spot that was described as casual and old. Which was much the way I felt. Morton's was crowded and jumping when I arrived. I heard somebody say "Hey!", waving to me from the bar. It was the "Mountain Men" from the Cedar Forge, having a few cold ones at the end of a long day.

A few urban dwellers harbor a misconception about the ability to dine well outside of their city limits. If I ever had arrogant notions about New York cuisine, dining in small towns whose populations could actually fit into a complex of New York high rises certainly changed my point of view. Dinner at Morton's was one of those humbling experiences. If a meatloaf dinner sounds like a down-home basic, what arrived—served right at the bar—was a culinary revelation. The meatloaf had been stuffed with a fruit dressing; a squash had been baked whole in a honey sauce. The chardonnay was wonderfully dry and perfectly chilled. It was all just right for a birthday a thousand miles from home.

A good way to find out about a town is at the local bar. I quickly learned that the role of the blacksmith has changed dramatically

The new firehouse (*below*) was built on Mequon Street and dedicated in 1908. It was soon modernized with the addition of motorized vehicles, including this Pirsch hook-and-ladder truck, in the late twenties. By the 1930s, the city hall and offices were housed in this building, along with a small jail.

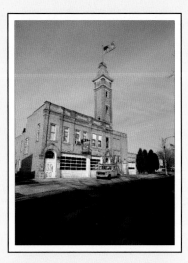

In 1964, the fire department moved from "Station No. 2" (*left*) to new quarters. It had simply outgrown the old station, despite dramatic alterations of the old arched doorways to accommodate the larger, up-to-date vehicles. In former days, the long canvas fire hose was hung up to dry in the five-story brick tower.

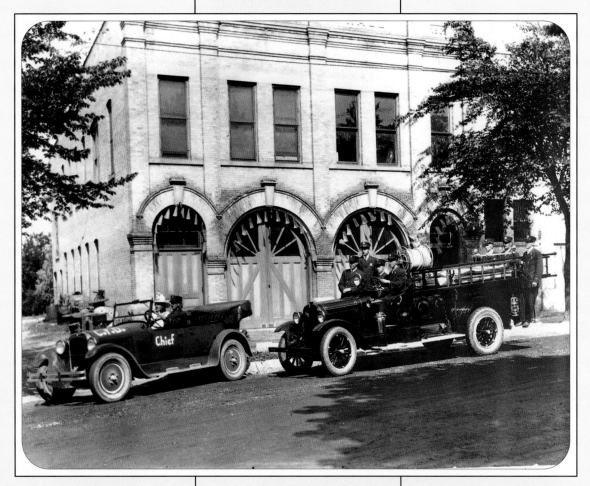

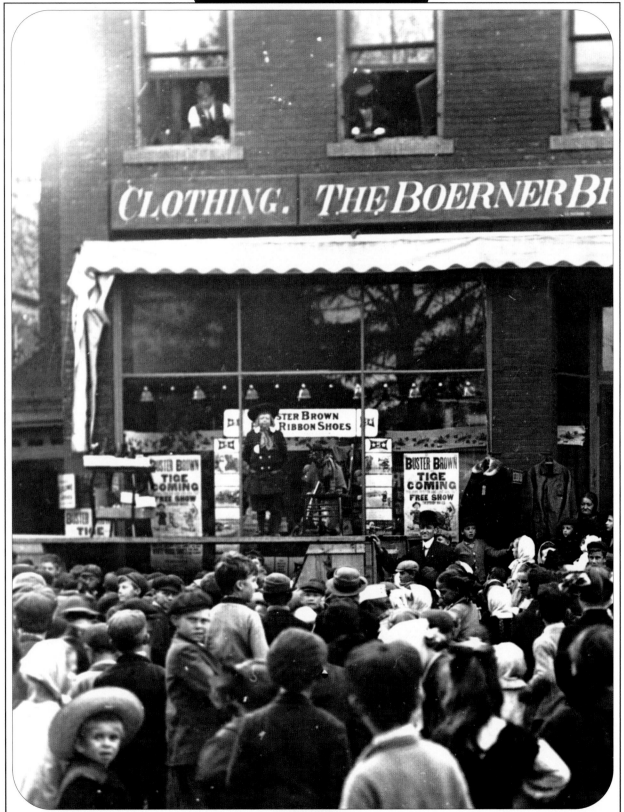

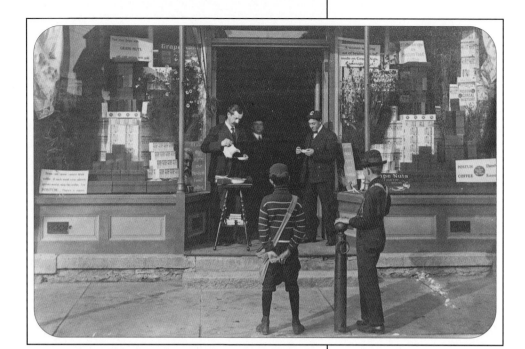

since the days of horseshoeing. Tom Wilson has studied the antique ironwork of the old masters and is helping change the image of the ironmonger. He's also helping to change the image of the town, having helped bring live jazz to Morton's weekly. When Tom was talking about Cedarburg's revival, the name James Pape came up. I didn't have to write down the name. I had heard it many times before. In order to understand how James Pape and people like him fit into current town history, it's necessary to go back to the mid-nineteenth century.

Frederick Hilgen, considered by many to be the founder of Cedarburg and often referred to as "Father Hilgen," wrote to a friend in February of 1847: "I think this will be a prosperous town . . . many are coming from Milwaukee!" His grand vision in the nineteenth century was the building of a town with industry as its linchpin. It's said in *Cedarburg History: Legend and Lore* that "Frederick Hilgen and William Schroeder arrived in Cedarburg in 1844, the Groths sold them the land, and the real history of Cedarburg began." Ludwig Groth was Cedarburg's first real estate developer, Hilgen and Schroeder the entrepreneurs and industrialists. Together they created an economic and social climate that would spawn an impressive mill industry. By the time of the Civil War, Cedarburg had five operating mills.

It was not until the 1920s that Cedarburg's water power—vital to the local industry—began to decline as a reliable source of energy. The advent of cheap electrical power signaled the end of the water-powered mills and the end of an era. There was little ex-

Customers at Jochem's store (*above*), accustomed to buying staples from barrels, are treated to a curbside tasting of prepackaged Grape Nuts and Postum in 1905, when the products were introduced in Cedarburg. A newsboy and his friend appear to be either the first or the only audience for this early form of sales promotion.

The crowds always turned out when Buster Brown and his dog, Tige, made an appearance at the Boerner Brothers store (*opposite*). A Buster Brown look-alike in the spectators is glancing back at the camera. Operated as early as the 1880s, Boerner Brothers was known for taking advantage of any photo opportunity that came along, sending workers and customers out to the street if a photographer was sighted.

In 1855, townsfolk accustomed to living and working in small log dwellings discovered a novel form of entertainment—watching the massive Greek Revival–style Cedarburg Mill (*right*) being constructed. Massive blocks of native blue-gray limestone were quarried from the floor of the Cedar Creek nearby—its water temporarily diverted—then pulled by donkeys up a 300-foot ramp that emptied into what was then Main Street. This amazing feat held a rapt audience.

In its heyday, the mill could produce 120 barrels of flour a day. It also served as a secure hiding place during the "great Indian scare of 1862," a tumultuous time when the area's original residents were being driven westward. In 1961, the mill was included in the National Register of Historic Places.

The Cedarburg Woolen Mill (*below, right*)—another of the town's vital mills—was opened in 1865 to meet the demand for woolen goods brought on by the Civil War. Powered by Cedar Creek and incorporating the latest in stone mill architecture and mill equipment, it grew at a steady rate. In 1893, the complex had twelve buildings and was considered the "most extensive woolen mill west of Philadelphia." Because of the mill industry, the town flourished.

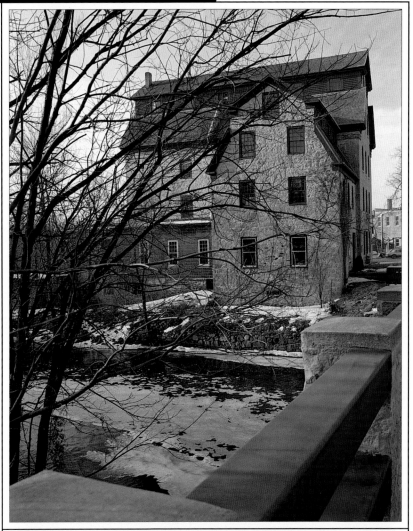

In 1969, the Cedarburg Woolen Mill (*left*) went up for sale and possible demolition. It narrowly escaped a fate as a convenience store and gas station, due, in great part, to the efforts of Mayor E. Stephan Fischer. In 1972, the mill complex was bought by James B. Pape, who launched an ambitious renovation and revitalization program, converting the space into attractive antiques and craft shops, artists' studios, a working forge, and restaurants, in addition to production facilities and a retail outlet for his own local winery. The Cedarburg Woolen Mill, renamed the Cedar Creek Settlement and given a second life, became the catalyst for re-establishing the town as a viable center of trade. Local blacksmith and artisan Tom Wilson, whose forge is in the Settlement, is shown at work (*below, second from bottom left*) and with his fellow blacksmith John O'Neill and his apprentice son, Alex (*below, bottom right*).

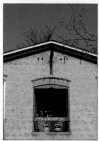
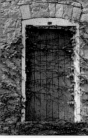
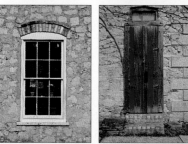

The old mill's exterior details (*left, center*) retain most of their impressive authority.

A pristine historic house (*above*) shares space on Washington Avenue with residences and businesses alike.

A Greek Revival two-story frame house built in 1849, with an addition in 1864, the Kuhefuss House (*opposite, bottom right*) was recently turned over to the Cedarburg Cultural Center to be used as an historic museum. The Kuhefuss House's decorative front porch (*opposite, bottom left*) was added when the 1864 stone and mortar wing was built.

pansion over the next several decades. The mills loomed as white elephants and empty reminders of the past. Although improved transportation gave Cedarburg a second wind and a population boost, the very existence of the downtown was threatened. With the old stone buildings deteriorating, they went up on the auction block, slated for demolition.

James Pape is credited by many in the town as starting the "domino effect" of Cedarburg's downtown revitalization. His grand vision in the twentieth century was preservation, and beginning with the Cedarburg Woolen Mill in 1971 he started a chain reaction. He not only saved the mill from the wrecking ball, he also started the first new business in the building—the Stone Mill Winery. With room for many more new businesses in the colossal old mill building, Pape helped restore and establish the Cedar Creek Settlement as an impressive and architecturally exciting retail complex. This was the catalyst that brought the downtown area its designation as a Historic District on the National Register of Historic Places.

With nearly 150 years separating them, Frederick Hilgen and James Pape made Cedarburg a vital place to call home. Hilgen, the nineteenth-century pioneer, was the builder of monumental edifices that fueled the new town's early prosperity; Pape, the twentieth century's new pioneer, fueled a revitalization of old downtown. No doubt both men would be quick to credit many others with the action and planning that brought Cedarburg its past and present prosperity, but it's clear that both are regarded as progressive movers and shakers in their own time.

Several months after my first visit, when the spring had unlocked Cedar Creek from its deep freeze, I returned with Leisa to explore the town's rich photographic archives. While many small towns struggle to assemble a modest collection, this town has two major collections documenting more than 100 years of the town's ebb and flow. Situated on Washington Avenue in the middle of things, the Cedarburg Cultural Center acts as the repository for the Edward A. Rappold Collection and the Harold Dobberpuhl Collection.

On the day we arrived, the center had been transformed into a wonderland of sorts for the local high school's senior prom. Here, new beginnings were of the moment, but we needed to turn our attention to the past. The Rappold Collection contains historical photography and postcards collected from the community over the many years when Edward Rappold had a photographic studio in town. It also contains some of Rappold's own work. The total collection numbers a staggering 1,400 images. Although Ed Rappold retired some years ago, he continues

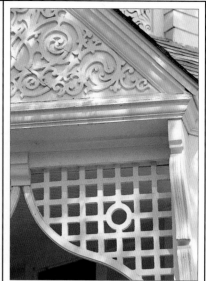

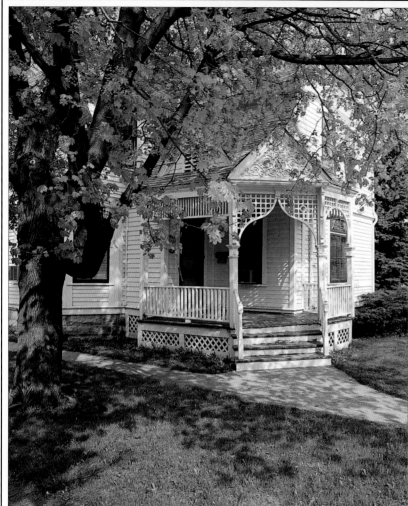

This 1885 frame Queen Anne–style former residence (*left*) is one of many period houses on the main street of Cedarburg that now serve as offices. The scroll-cut ornamentation (*above*) and the spindle- and latticework are typical of the style.

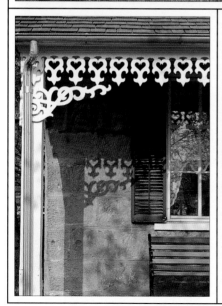

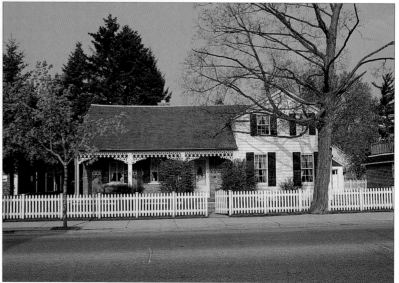

Over breakfast one morning, longtime local photographer and collector Edward Rappold beamed when I requested this particular photograph out of the nearly 1,400 historical photographs in the Rappold Collection, which documents Cedarburg from its early days. Since my photocopied reference had no photo credit, I didn't know Ed Rappold himself took this shot of his family's reunion picnic in 1938, when relatives had driven from Chicago. He immediately recalled that it was midsummer, times were tough, and they probably had his favorite—a berry pie.

BARRETTE'S BELGIAN PIE

Can be made ahead for a big party or a reunion.

Baking Powder Crust
2 eggs
½ teaspoon salt
½ cup sugar
¼ cup milk
½ cup vegetable shortening
4 teaspoons baking powder
Flour

Fruit Filling
Applesauce, prunes, cherries

Cottage Cheese Filling
2 16-ounce cartons small-curd cottage cheese
4 eggs
Pinch of salt
Sugar to taste
½ teaspoon vanilla
½ teaspoon cinnamon, if applesauce is used
2 tablespoons milk

Preheat oven to 350°. Mix first six ingredients of Baking Powder Crust. Sift in enough flour to make a soft dough. Divide dough into fourths and press into pie pan. Add ½ inch of fruit filling (see above suggestions). Mix all ingredients of Cottage Cheese Filling and pour on top of Fruit Filling. Bake approximately 1 hour, or until a custard consistency. Cool. Keep refrigerated.

Yields: 4–5 pies
Preparation: 45 minutes
—Mary Denis

From the
Cedarburg Cookbook
by Patti Hepburn

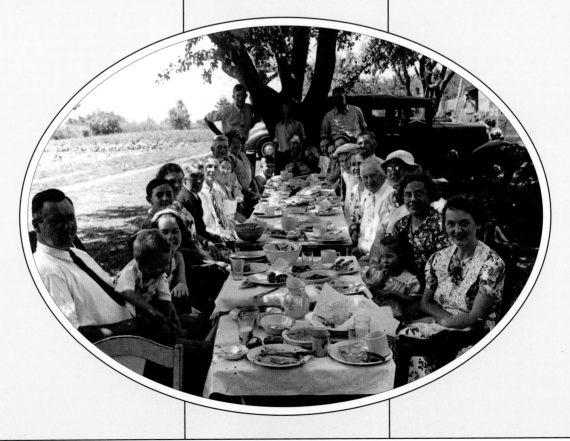

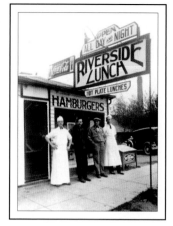

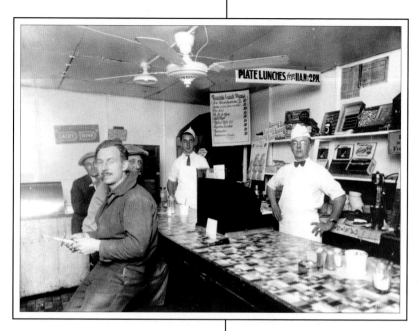

to oversee his collection. Over breakfast the next day, he gladly filled us in on the details of the photographs we selected and the wonderful anecdotes surrounding many of them.

The Dobberpuhl Collection, on the other hand, consists entirely of Harold Dobberpuhl's own photographs, beginning in the forties and continuing into the sixties. Today, Harold Dobberpuhl lives barely a stone's throw away from the house where he was born and where his father was born—a house that used to sit in the middle of planted fields. It now marks the intersection where I was instructed to take a left into an attractive new development. Harold and Joan Dobberpuhl had barely moved in, yet everything was in picture-perfect order.

Harold knew nothing about cameras or photography when he bought his first Brownie reflex at sixteen. He just knew that he had his sights set on becoming a newspaper photographer, and that he needed a camera for that. He laughed at his own youthful naïveté when he told us about his first experience with one of the grand old sheet-film cameras. It seems the still-green Harold didn't know he had to remove the cardboard that was sandwiched between sheets of film before loading the camera. It wasn't long, though, before Harold had figured things out, embarking on what was for many years a rewarding career and then an enduring hobby. His snow scene of Washington Avenue at 12:10 A.M. in December of 1955 is classic Main Street America and vintage Dobberpuhl.

Cedarburg is the sort of town that sponsors a contest each year to identify architectural details from a page of photographs in the

Riverside Lunch owner Mr. Nimitz, pictured here with customers and staff in 1929 (*above, left*), kept his small but thriving operation open day and night. During ruthless midwestern winters, his hot cocoa was always in demand. Both the menu and the prices (*above*) couldn't be beat.

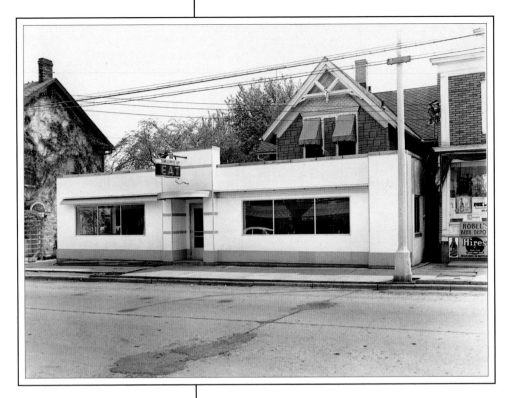

The Town Coffee Pot (*above*) was built in the late thirties, in a style that imitated the long, narrow lines of the well-loved diners that were springing up all over America. Local photographer Harold Dobberpuhl is uniquely connected to this photograph, which he took in 1950. As a child, Harold lived in the house just behind it, his second-floor bedroom looking out over the Town Coffee Pot's roofline. Today, the Cedarburg Coffee Pot has a new awning and a slight variation on its former name, but little else has changed. The house where Harold Dobberpuhl lived is still there.

local newspaper. Leisa and I were walking down the street working on the contest when a large group coming in the other direction made it difficult to pass. I took them for tourists, but as we passed shoulder to shoulder, I noticed the big buttons they were wearing: MAIN STREET. It seems that the National Trust's Main Street Center was holding its yearly meeting in Milwaukee and this group had come to Cedarburg to see a successful Main Street community in action. We were invited to tag along as representatives from small towns across the country toured the Washington House with Jim Pape, who began restoring the neglected building in 1983.

There's an unmistakable energy in the Cedarburg air. It continues to be fueled by people who share a common goal: a commitment to the evolving and enduring image that is Main Street. Ten years ago, Cedarburg's downtown was fast becoming a memory. Now it carries the standard for what Main Street can again become.

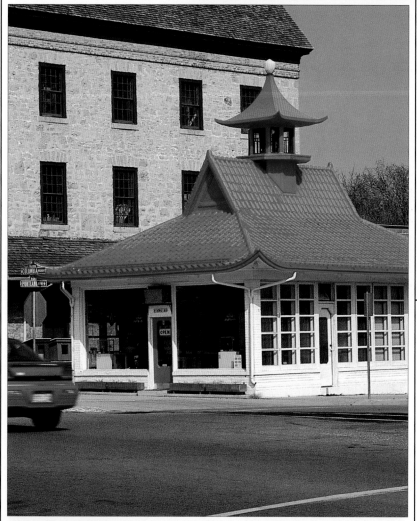

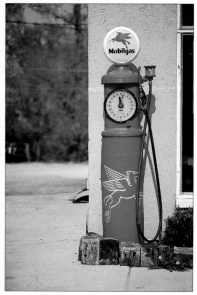

The structure that was Wadham's Pagoda filling station (*left*) is located on Columbia Road just off Washington Avenue. Its Japanese pagoda-style roof and cupola are typical of the nearly 100 tea-house filling stations that were built by Wadham's Oil and Grease Company of Milwaukee in the twenties. An antiques shop today, it is one of only a handful of such structures to survive.

A car repair service on Washington Avenue proudly displays an old gas pump (*above*), circa 1920. The globe on top is a reproduction and the pump itself has been repainted, although it was still used to pump gas as recently as 1989.

In Wisconsin, it's always been considered good form to order state-made brews like Blatz beer (*left*), once made in nearby Milwaukee.

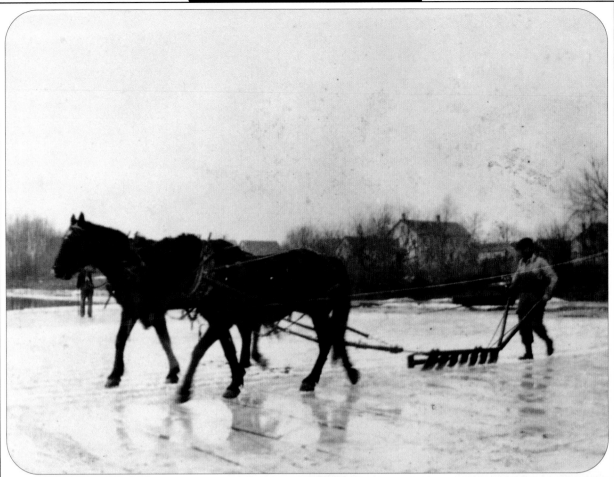

Aphotograph taken in 1915 shows ice harvesting on Cedar Creek (*above*). When the creek froze over, blocks of ice would be cut away and then floated to an elevator, where the massive blocks would be hoisted to an icehouse. There they were packed with sawdust for delivery to taverns and home iceboxes in town. Residents placed cards in their windows indicating how many pounds of ice they needed—a 50-, 75-, or 100-pound block.

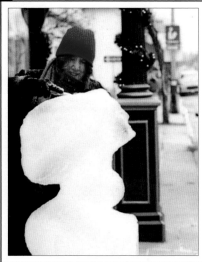

The annual Winter Festival brings hundreds of visitors to the small town of Cedarburg for the many festivities (*this page and opposite, bottom*) that take place during one weekend in February. On Saturday morning, tall blocks of ice are placed in front of many Washington Avenue establishments, awaiting transformation into sculptural works of art. During the morning, carvers young and old hammer, chisel, scrape, chip, and blowtorch the ice masses into shapes—from cartoon characters to mythic heros. Judges struggle to award prizes to the best entries. After a comical parade to Cedar Creek, the annual bed-racing contest is held on the ice. During the day, visitors take advantage of the steaming hot drinks served at makeshift sidewalk tables.

SHERIDAN WYOMING

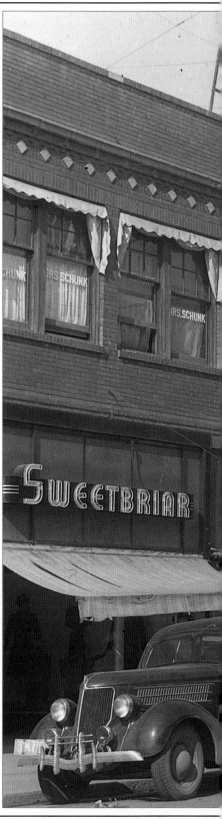

In years past, I'd been one of the dudes in Sheridan, a tenderfoot whose brand-new boots and stiff-brimmed hat were dead giveaways of big-city origins. Now I had come to Sheridan with business in mind, doing location scouting for this book. It certainly wasn't hard to decide on a place to stay. The HF Bar Ranch lies thirty minutes south of Sheridan. It's a vast spread at the foot of the majestic Big Horn Mountains where, for several vacations, our family had checked into a rustic cabin on a stream without phone or fax or TV. Signing up for the evening ride was just about all the pressure one had to deal with. Going to town, which meant driving into Sheridan, was a big event.

If Main Street is the face of a town, then Sheridan presents a straightforward, no-nonsense appearance. Broad enough for the wagon trains of the past and the horse trailers of the present, Main Street is where the action is. A network of parallel and side streets seems always to bring one back around to Main Street. The county courthouse sits at one end; a stretch of motels clusters at the other. In between, a still-thriving center of commerce for a ranching and farming community operates in buildings that date back to frontier days. It's business as usual, as it's been for more than a hundred years.

The pre-settlement saga of Sheridan is a story of Native Americans and herds of bison on a great treeless plain. By 1880, the surviving Native Americans were scattered on the plains, and so were the remaining bison. Although gold was never mined in Sheridan, it was the lure of gold—first found in southwest Montana in the 1860s and then in the Black Hills and Big Horn Mountains of Wyoming in the mid-1870s—that opened the area for settlement. As speculators and emigrant prospectors traveled

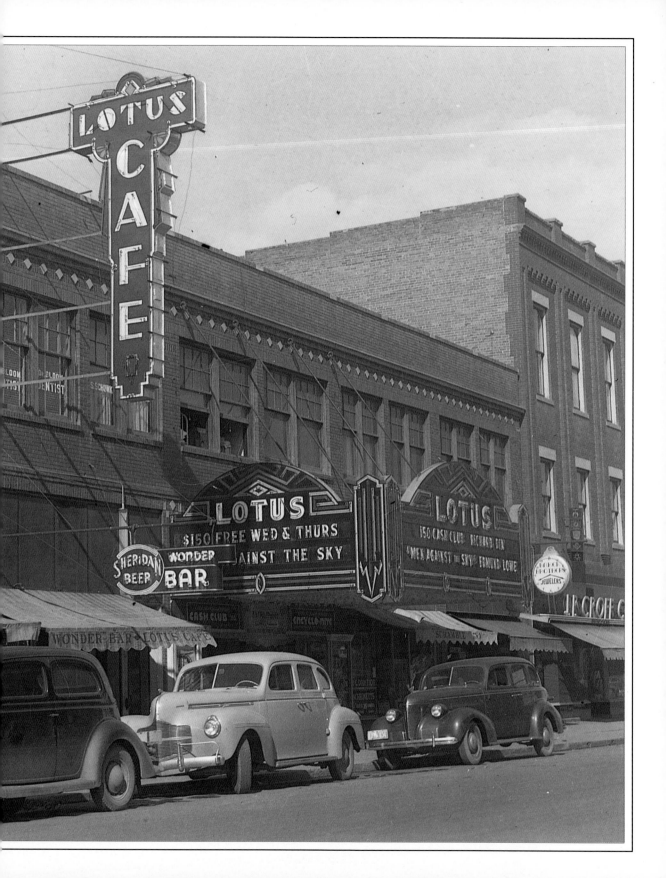

During her lifetime, Elsa Spear Byron amassed an astonishing collection of historical photographs documenting her home town of Sheridan, Wyoming—her own photography as well as the photographs taken by her mother, Virginia "Blue Belle" Benton Spear. A memorable shot of the Lotus theater (*previous pages*) is vintage Byron.

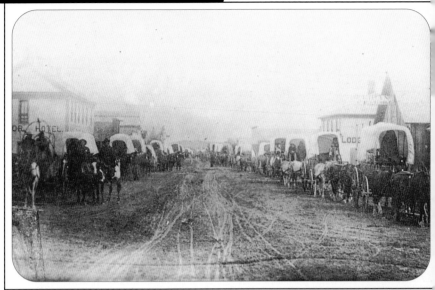

A photograph from the collection of Elsa Spear Byron (*above, right*) contains handwritten documentation on the back: "Sheridan—May 12—1889. Taken by Mr. Goff. Indians driving teams from Fort Custer—loaded with oats for the fort." Goff was a Montana photographer known for his shots of Western life.

As seen in this postcard view (*right*), Sheridan's Main Street—wide enough for wagon trains of the past and the automobile revolution of a more recent decade—has long butled with commercial success.

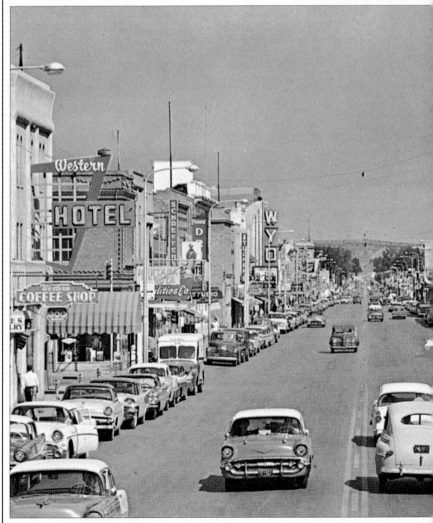

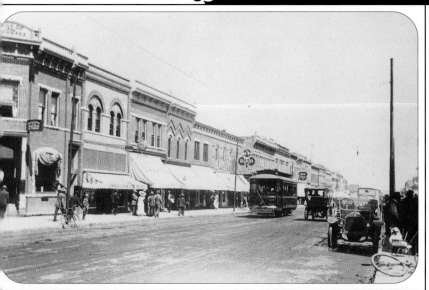

Another early photograph from a glass-plate negative by Virginia "Blue Belle" Benton Spear shows the electric streetcar system (*left*) that operated between 1911 and 1922 from the Western Hotel, traveling to the coal mines and Fort McKenzie as well as within Sheridan. The streetcar brought children from the mining camps into town for school; it also hauled sugar beets into the Holly Sugar factory when the roads were bad.

Horse trailers parked in town (*left, middle*) are still a familiar sight. Old cars and trucks (*left, bottom*) are never out of date here.

Virginia "Blue Belle" Benton Spear, mother of Elsa Spear Byron, rode by wagon with her family from Kansas to northern Wyoming in 1881. She started a diary at the age of seventeen, writing on split-open envelopes because paper was scarce. In one entry, she relates that she "kept the mules from straying and killed a rattlesnake."

Virginia Benton's desire to chronicle her life soon led to an interest in photography. She passed this interest on to Elsa, her daughter with her successful rancher and politician husband, Willis Spear. After they had moved into a twenty-three-room house in downtown Sheridan, Virginia and Willis gave Elsa a Brownie camera for her twelfth birthday. Elsa says in her diaries that her mother's work was her inspiration.

Photographs by this unusual mother and daughter constitute the lion's share of the photography in this chapter.

over Indian trails in the area, military protection was assigned. It was actually the military posts and forts that put the area on the map. And it was this new military force that—in a series of hostile skirmishes and bloody battles—drove the area's natives from their homeland onto reservations.

In the era of the great overland migration, land rushes, and boomtowns along the Bozeman Trail, few immigrants ventured south to Sheridan. But by the time John Loucks founded and platted the town in 1882, the rich pastureland of the nearby plains was a strong drawing card for this out of the way town. The area was settled lightly at first, by civilian employees and discharged soldiers from the military posts who took up good farmland near the creeks. Cattlemen from Texas and Oregon found themselves competing for land that they, too, had discovered to be suitable to their needs. Tales of great cattle drives and easy money sparked further new settlement.

Founder John Loucks had been in the Sheridan area in 1870 during the time of the Red Cloud uprising. He returned in 1880 to buy a cabin and to set up a store and a post office. By the spring of 1882, he had platted out the forty-acre townsite of Sheridan on a piece of wrapping paper. He named the town after his Civil War commander. By 1882, it is said that fifty buildings stood in town.

But Sheridan's big burst of growth would not commence until a decade later. Unlike the railroad-planned town of Cheyenne in southeastern Wyoming, laid out by the Union Pacific Railroad in 1867 and boasting a population of 6,000 people that very first year, Sheridan was much slower to grow. Left to its own devices, by 1888 it had a population of only 600. This, however, was enough to win the title of county seat when Sheridan County was created out of Johnson County that same year. The town now had a young cattle and ranching industry as well as a legal and civic base.

I arrived at the HF Bar wearing running shoes, no fair match for horses with intimidating names like Thunder and Sitting Bull. This was a good excuse to head into Sheridan and visit Dan's Western Wear, whose bold red signage stands out even on this expansive Main Street. I always find authentic boots at Dan's at half the New York prices. In the past, I had taken Dan's and the other Western-wear stores for granted. This time, I was more curious about their histories than their inventories.

Dan George is retired, which means that he no longer works seven days a week and spends a little more time fishing. He and Bessie George met me one morning at the local library, where we were able to talk without the constant interruption of customers and phone calls. The air-conditioned conference room at the local

By the time the above photo was taken, Elsa Spear would have already begun photographing with the Brownie camera given to her by her parents. For at least fourteen years, Elsa combined her avid interest in photography with helping out the family business, a mountain dude ranch. She started making money with her photography in 1923, when she documented the rescue of a group stranded in the mountains by a sudden September blizzard. That same year she started her business, "Fotocraft of the Big Horns," hand-coloring her photographs for application onto other objects, such as letter holders and lampshades. In the 1920s and 1930s, her

work was featured on magazine covers and was used in advertisements for the Burlington Railroad and the Northern Pacific Railroad. She took many of her pictures from horseback, carrying her Speed Graphic camera in the horse's nose

bag, fastened to the saddle horn, and a smaller camera in the saddlebag.

Elsa Spear Byron, a colorful and beloved personality throughout her lifetime, had five daughters, and they all spent time riding with her as she photographed the countryside. She died on January 1, 1992, at the age of 95. Her genius was to record the land and the legends as well as the everyday events in downtown Sheridan. She was a historian, a photographer, and a writer, roles that won her many accolades in her lifetime. Her writings and her photographs are actively promoted today by the generations that survive her.

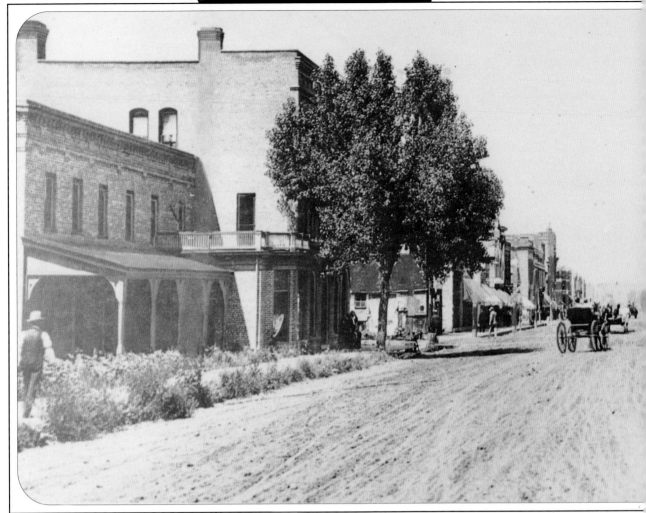

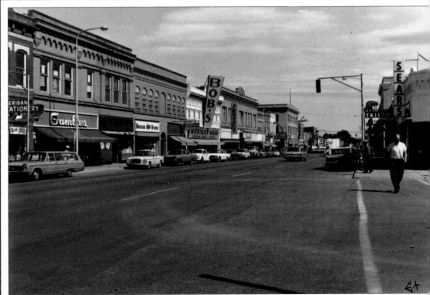

In 1891, a motion from the town council required all able-bodied men between the ages of twenty-one and fifty to give one day's work on the streets, alleys, crossings, and ditches, or pay $3 to the treasury. Then as now, there were only a few trees (*above*) to be found on Main Street.

public library, however, was a far cry from the smell of leather and flannel at Dan's Western Wear. We had only two hours to talk, yet in the first five minutes, I was made to feel like we were old friends.

Dan George is one of the successful Sheridan old-timers, and his family story is pure Horatio Alger, Western-style. Bessie George's independent spirit and business savvy—unusual for a woman who grew up in the '20s—make her a true partner. Dan's father emigrated alone from Greece in 1911, planning to bring his young family over as soon as he could provide for them. Desperate for a job, Tom George accepted an offer for work "out in the country a little ways." The "country" turned out to be Wyoming, 1,800 miles from New York Harbor.

Dan George related that his father—from a country half the size of the state he was headed to—felt a warped sense of time as his train rolled over vast unsettled lands, the promised "a little ways" turning into nearly a week's travel. Outside of Sheridan, Tom George lived in a boxcar on the side of the tracks with other workers. "When someone had to get supper," Dan said, "he took his rifle and went outside. They lived on bread mostly. Dug a hole on the side of the track, got a piece of tin and lined the bottom with rocks, built a fire and baked bread. It took my father five years to save $500 to send for us."

Dan's parents had no formal education. Together they worked odd jobs, managing to save $1,000 to start their own business—a cobbler's shop on Alger and Main. "Took my brother and me to work," said Dan. "I was ten years old." The miners were a ready market for the Georges' new business, which soon expanded to carry clothing.

In 1938, Dan George bought out his father, whose business had moved to a new location on Main Street. Then just four years later, with nine shops serving the Sheridan area, Dan was drafted. This was when Bessie, the mother of their two small children, stepped in to run the business until the war was over. When Dan returned home, he discovered that the country had "miles of surplus clothing." And before you knew it, both he and Bessie were buying up the surplus to sell in Sheridan. At one point, Bessie was actually competing with her husband, when she purchased a lot of women's clothing and opened up a shop across the street.

Dan George is probably one of only a handful of people who can tell Main Street stories regarding trade with the Native American residents, who, by this time, were living outside Sheridan on reservations. "When I was a kid," he said, "the Indians used to come into the store. The men wore blankets and their hair was braided, and they wore moccasins up to their knees. You

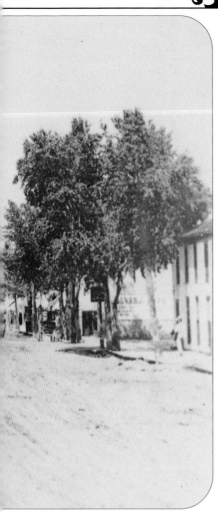

Most of the awnings still remained on storefronts in the 1950s, as seen in another of Elsa Spear Byron's photographs (*left*). Bob's Western Wear, so prominent on Main Street, later became the new location for Dan's Western Wear.

Before Dan's Western Wear moved to its present location on Main Street in 1923, it occupied the site and original building of the J. H. Conrad Trading Post, Sheridan's first general store, established in 1883 (*below, right*). According to Dan George, owner of Dan's Western Wear, a town official was making noises about having the old log cabin–style building torn down back in the 1930s, saying it was a fire hazard. This was before the mural was part of the building's facade.

In a cunning move for self-preservation as well as historic preservation, Dan George initiated a secret plan with a friend, artist and native son Bernard Thomas, to paint a mural that would fit neatly on the building's facade above the windows. The inspiration for the mural would be a photograph showing the activities at the old trading post in 1885. Bernard Thomas painted the mural in secret, using the garage of a friend who, conveniently enough, was a sign painter. The conspirators installed the mural before anyone could get wind of the scheme. From that time on, when anyone suggested that the town could do without the old building, Dan George would simply point to the mural and declare the building a historic and artistic landmark!

couldn't get a word out of them. They'd come in and point to something, take it to the register, and pay you for that one item. Then they looked around some more, and pointed to another item, took it to the register, and paid for that one. When I got to know one of them better, I said, 'Why do you do that?' He said, 'Because we can't count and don't want to be cheated.'

"The first generation of Indians were bitter. They had lived on *all* the land and were suddenly confined to small areas. The second generation was friendlier. We used to have signs here in town: NO INDIANS ALLOWED. Then we started having 'Indian Days' to pick out Miss Indian American. It was a town effort and caused friendship to begin."

Asking how a town has changed was one of my standard American small-town questions. Corny as it sounds, I always eagerly awaited the reply. "So how has Sheridan changed?" I asked.

"Sheridan hasn't changed that much," said Dan George. In a town where a number of residents' families have lived for three or four generations, change is regarded with a healthy skepticism. As I talked with Dan and Bessie at the library, the third generation of Georges was back at Dan's Western Wear, selling boots and clothing, made to last like the Georges themselves—through dusty summers and prairie winters, out in the country just a little ways.

The Georges' story is not unlike the story of the many settlers who came to the area. There are thousands of family stories around Sheridan, touching histories of brave immigrants and homesteaders who left everything they knew, arriving in town with little more than a good horse and a prayer. When the *Sheridan County Heritage Book* chose the following title for its history section, the authors surely had the homesteaders in mind: "Sheridan

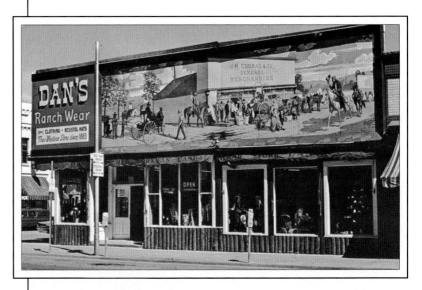

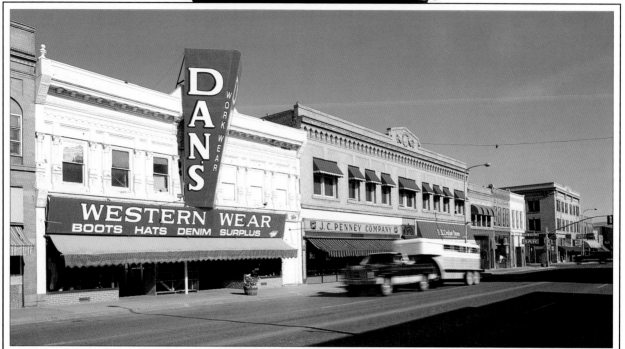

Dan's (*above*), now on the site formerly occupied by Bob's, carries much of the same merchandise. The contemporary awnings up and down Main Street are made of colorful and sometimes striped canvas, in contrast to the old street's monochrome awnings.

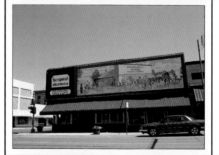

Today the former site of Dan's Western Wear is occupied by a pharmacy (*left*). The building is the only surviving wooden false-front structure on Main Street. The mural (*detail below*) remains, having earned a place in town history.

Otto F. Ernst was a Main Street merchant who understood the value of promotion. Always thinking up ways to advertise his products, Otto Ernst displayed his wares on a calendar in 1916. Sheridan's WYO rodeo queens wore Ernst leather vests and skirts, making them the envy

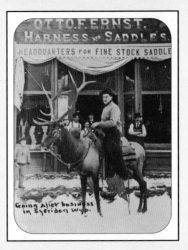

of many cowgirls. The model on the calendar was a good customer of the store's, too; she also just happened to be a local madam. This photograph shows Otto staging one of his legendary promotions. His mount is an elk, albeit a stuffed one, borrowed from one of the store's displays.

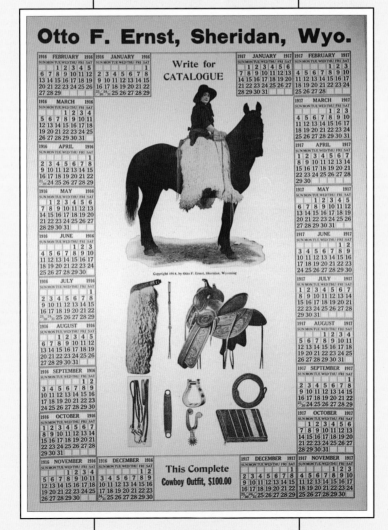

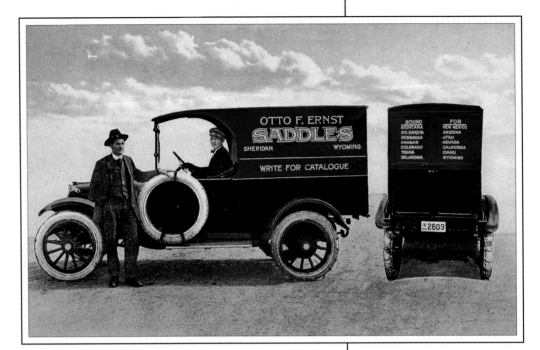

Otto F. Ernst's custom saddles and harnesses enjoyed widespread popularity in a fourteen-state area. Ernst traveled far and wide with a driver in an old Dodge car (*above*), selling and taking orders. In the early 1920s, Ernst came to believe that the days of the horse were numbered. He decided to diversify and devote part of his store to a vulcanizing and retreading plant—in short, to get into the tire business, the wave of the future. Soon he featured the largest stock of automobile tires and accessories in Wyoming. Unfortunately, Otto Ernst was about ten years ahead of his time. The venture was soon discontinued, but his original saddles—now valued collectors items—continue to make history when they come up for sale.

County: A Special Land and its Resourceful People." A compilation of written accounts by the descendants of the homesteaders, this book offers a moving and realistic look at the early settlement of the area.

The homesteaders were resourceful indeed. Many had moved several times to "new frontiers" as the young country's western border was expanding. They showed a willingness to start over and exemplified a belief in the future of the country. Many came with the specific purpose of filing a claim on the land, but were able and willing to do whatever it took to survive and prosper. This meant adapting to the local climate and taking advantage of the opportunities available. Men often changed jobs by season. Women moved into town for the school months so their children could be educated.

The loners—figures frequently romanticized in modern-day Western dramas—worked as trail hands, timber cutters, and railroaders. The inventiveness of the young wild west was evident as "Lonely Hearts Clubs" and "Heart and Hand Clubs" were formed to link men and women on this vast land. Whole families came in wagon trains or immigrant cars; the railroads encouraged homesteading by offering sleeping compartments for the family and boxcars for livestock, wagons, and

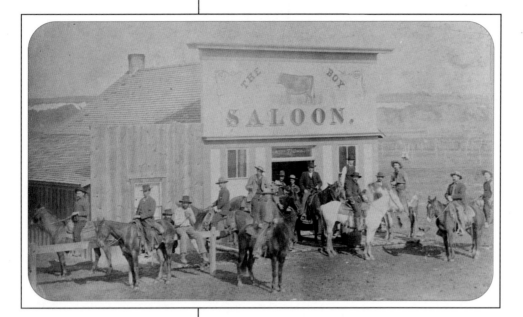

THE BOY SALOON.

Sheridan's Cowboy (*above*) was one of the first bars in town and was typical of saloons in the Old West that catered to a rough-and-ready bunch who went there to drink whiskey and beer, trade information, and revel in good times. Given the long bleak winters and the desolate wilderness, the saloon became an important social institution for men of the West. Generally, women were not allowed, unless they were bar girls or "ladies of the night," though some saloons did welcome women—generally through a back entrance marked LADIES ONLY.

household goods. One family recorded that they could not fit their "pretty new Easter hats or Edison Victrola" in their train car.

Some homesteaders came to join family members who had already made the move to Wyoming. Others stopped to rest or camp near or on the overland migration routes and simply stayed on, impressed by the open grazing land leading up to the foothills of the mountain ranges. One father was said to be so taken with the Sheridan area that he tried to convince his children that they were indeed in Oregon, the family's ultimate destination, so as not to disappoint them. The Homestead Acts of 1862, 1909, 1912, and 1916 made land deals attractive. The urge to "Go west, young man" continued in Wyoming well into the early twentieth century.

In the *Sheridan County Heritage Book*, the Warren-Austin family wrote: "As soon as the crops were in [during] the Spring of 1883, everyone started writing to the Land Patent Board so they could prove up on their homesteads. They had to send letters to Washington by horse, stagecoach, and train. It was 1889 before father got the papers." Early homesteaders found themselves in direct competition with the cattlemen, who felt proprietary about their uninterrupted open range. The cowmen were said to resent "nesters," and resorted to sabotaging fences by lassoing the corner posts and pulling them down.

Sheridan was fast growing as a vital market center, serving the vast open spaces beyond it. By the start of the twentieth century, you had to come to Sheridan to shop, trade, socialize, and to record birth, marriage, and death. The need for local transportation between the areas outlying Sheridan and the town itself was at first partially filled by a special car on the Burlington Railroad,

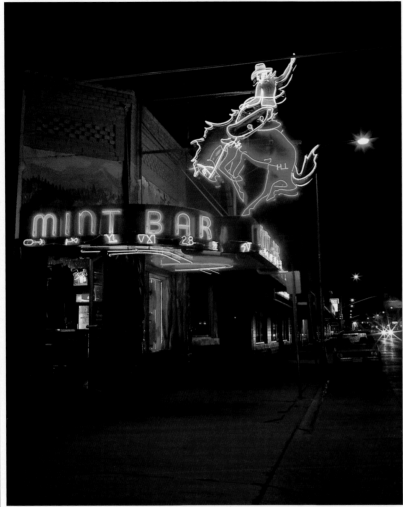

The broncobuster signals that things are pretty lively at the Mint Bar (*left*). Built in 1910, this one-story log-and-red-brick cabin-style building has a beautiful burled bar inside that stretches the length of the front room. The walls are blanketed with livestock brands from local ranches, antlers of all sizes, and Western photographs by Charles Belden; the oversized booths are made of genuine cowhide.

Today, the glare of neon welcomes visitors to Sheridan's Main Street bars (*below, left*). Now women are on equal footing, and both sexes might be heard ordering up a chardonnay instead of a shot.

The Sheridan Inn (*right*), located directly across from the depot (used at the time of this photograph as a freight house), was the first building of size and importance in the town, with 64 bedrooms on the second and third floors. Built at a cost of $25,000 by a joint effort of the Burlington & Missouri Railroad and the Sheridan Land Company, it has a remarkable 69 gables.

No longer in use as an inn, the building was designated a national landmark in January of 1964.

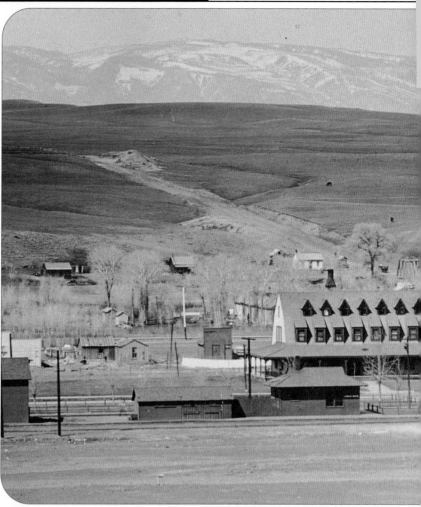

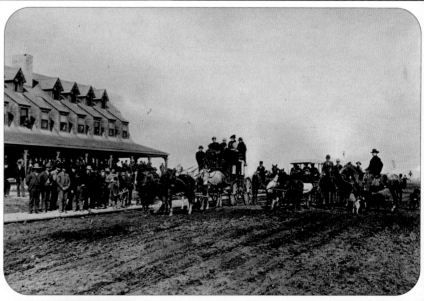

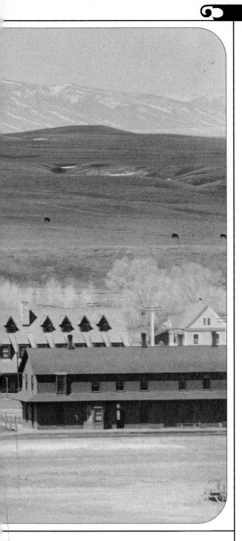

chartered to bring workers into town on payday. A more consistent solution came from the Sheridan Railway Company in 1911, when an electric streetcar, or interurban, ran within the town limits; a larger car capable of handling freight ran out to the camps and mines. The interurban provided special services by transporting the children of miners to school in town. When roads were impassable, the interurban even hauled sugar beets from the farms to the Holly Sugar factory in Sheridan.

In 1910, Wyoming had only 1.5 people per square mile. With long stretches of countryside mandating lonely physical separation, the saloon and gambling hall became places to gather and socialize. But these were all-male institutions, places respectable women had no desire to patronize. So as early as 1896, the women of Sheridan banded together to form the Sheridan Women's Club, consisting at one time of 232 members. This and other clubs became the alternative to the public recreation of the day, which did not suit women.

Ladies Aid Societies formed within churches, offering a needed sense of community as well as a chance to do good works. The LAS of the First Baptist Church in 1891 worked on an early project to erect hitching posts in town. The LAS of the First Methodist Church rescued most of the contents of a drugstore in town during a fire in 1890; the insurance company rewarded them with $50 toward the purchase of a bell for the church. It is moving to see pictures of these small clubs in the *Sheridan County Heritage Book.* Many of the groups have met for decades.

In town, the hotels and inns, theaters, and other establishments offered a range of entertainment. Ranchers were said to have kept good clothes in a trunk at the Sheridan Inn for weekend parties. A series of theaters provided live entertainment, vaudeville, and community concerts. One account states that "the whole town" attended a Christmas celebration at the Cady Opera House in 1897. Considering that the population at that time was close to 2,000, this seems a slight exaggeration of a very good time. When the Wyo Theater—formerly the Lotus Theater—was opened in 1941, the event was memorialized in a special edition of the *Sheridan Press.*

Much of the community-based entertainment today revolves around Western country life, such as the county fair, the annual Sheridan rodeo (since 1931), and the annual Cow Town Hoedown, a square-dancing event held since 1952. Sheridan has never lost its community spirit, which scales down the seemingly endless miles between its people.

The need for entertainment prompted a group of us from the

A coach ran from the Sheridan Inn (*left*) to town, about a mile away. A crowd of regulars that hung out at the inn—including Bill Cody, one of the owners—was known as "The Jolly Crowd." This shot was taken on opening day in July of 1893, shortly after the last spur of the railway was completed. Many fine parties were held at the inn. A favorite drink was the Wyoming Slug, a concoction of whiskey and champagne. Buffalo Bill is said to have auditioned acts for his Wild West show on its wide porches.

The Cady building—typically Romanesque in style—at the corner of Main and Alger was built by H. F. Cady of Omaha, Nebraska, in the late 1890s at a cost of $45,000. Stones for the building's construction were shipped in their raw state from Missouri and cut on site. The county courthouse was located on the first floor.

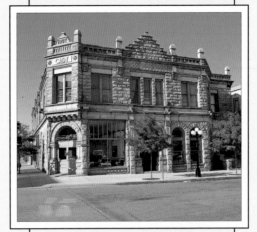

Originally a three-story structure, the Cady Opera House—which held live performances of many kinds—was located on the third floor. In 1906, the opera house and parts of the lower levels were destroyed by a fire. At the time of the fire, the opera house was featuring *The Runaway Match*.

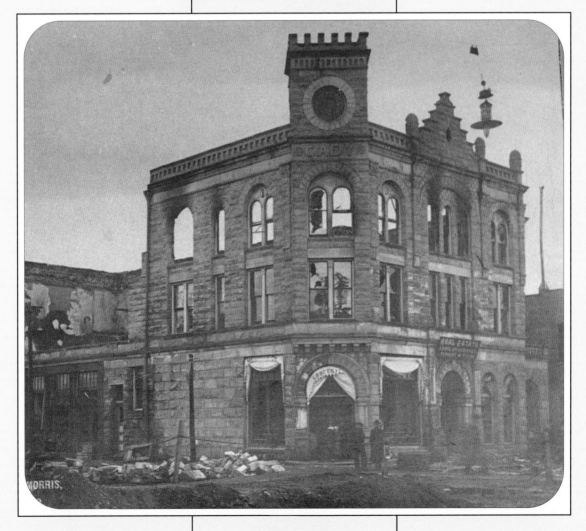

ranch to scrape off our boots for a drive into nearby Sheridan for a night on the town. Out west there's a saying: "You're in Wyoming if the bars are named Stockman, Cowboy, and Mint." We headed for the Mint on Main Street, a local watering hole with the sort of genuine Old West character that can't be copied by fashionable imitators.

The Mint's flashy neon sign—a rodeo rider bucking sky-ward—dominates the streetscape and proclaims that this is a town where ranch and horse are still king. Modern-day Sheridan's Main Street is not the archetypal old Western Main Street with false-fronted buildings. Although the false-front style predominated in Sheridan during the 1880s, there is only one such building surviving. Sophisticated local investors replaced the simple wooden structures with brick and stone buildings as monuments to prosperity, mixing elements from different classical styles. A local walking-tour book describes the result as "Plains Style." Elements represented in Sheridan's architecture include Georgian, Richardson Romanesque, Art Deco, and Pueblo. The elegance of the architecture juxtaposed against the western elements makes for a comfortable mix.

On my last day in Sheridan, I found several historical photographs credited to Elsa Spear Byron, a remarkable historian, writer, and photographer who died in 1992 at the age of ninety-five. I finally tracked down a daughter, Marilyn Byron Bilyeu, in Colorado, who had just inherited, along with relatives, her mother's archive but had as yet no idea of its total size and scope—a lifetime of Elsa Spear Byron's own work as well as the work of other photographers, stored in approximately fifty boxes containing pictures, negatives, and letters. Over the next year, I developed a long-term phone and fax friendship with Marilyn. I found out that the many boxes contained not only the work of her mother, but also of her grandmother. It seems that Virginia "Blue Belle" Benton Spear and her daughter, Elsa Spear Byron, chronicled life in Wyoming as far back as the turn of the century. My odds of finding historical photographs by mother and daughter photographers in the state of Wyoming were practically nonexistent, yet their stories and their work miraculously walked into the life of this book.

Marilyn went through the awesome amount of material for me, material that will take years to thoroughly sort, document, and catalog. Sometimes she actually sorted through negatives with me on the phone. "Now this is interesting," she said one day. I could hear the rustling of papers in the background. "Why, there's a whole bunch of shots of Indians

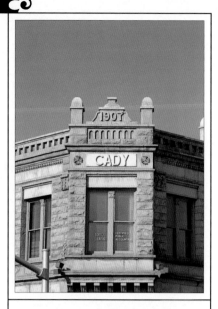

In 1907, a local resident named John Helvey rebuilt the first two floors of the old Cady Building to create the Helvey Hotel. The name on the stone slab was changed to Helvey, and the date—1907—was added to the pediment. Over the decades to follow, the building held a grocery store, saloon, barbershop, several business offices, a post office, and a community center. Yielding to changing functions, it lost much of its original character. Then, in the mid-1980s, a new owner invested $1.5 million and 10 months to renovate the building. More than 100 workers helped to bring the exquisite old building back to life. The name was restored to Cady, but the 1907 date from Helvey's time remains (*above*).

Today the building is listed on the National Register of Historic Places. A flash or two of neon announces a restaurant on the ground floor and playfully breaks the somber tone of the building's facade.

Behind every Main Street play there's a backstage—a rear view, a back door, an alleyway, or a thoroughfare for trade that is rarely noticed by the public, sought out mainly by delivery trucks and employees. In Sheridan, the largely unimproved look behind Main Street frequently gives one a hint of the earlier face of the town. Taking advantage of the early morning light on buildings behind the north side of Main Street, and, later, of the late evening glow behind the street's south side, I captured these quiet views.

in parades on Main Street. I think you might like these." I practically fainted. Again, the odds were in my favor.

It seems that Elsa Spear Byron had a special interest in the Native Americans of Wyoming. In fact, one of her most notable shots was taken in 1926 at the fiftieth anniversary of the battle between the Cheyenne Indians and Custer, now known as the Battle of Little Big Horn. In addition to her own shots, she collected many rare and remarkable photographs by other photographers that depict Native Americans as important and unsung players in Main Street history. While not as numerous, the notable early shots of Byron's mother, Virginia Spear, when viewed together with her daughter's, give us the inspirational perspective of a mother and daughter on small-town Wyoming life. Now a proud and diligent descendant is preserving that perspective.

In 1917, the Rapid Auto Line did a big business taking dudes back and forth from the railroad depot to the various ranches. The owner had a rate schedule for different kinds of trips, ranging from thirty cents an hour to quite a bit more for "joyriding." As I packed my bags to return to New York, I only wished that I could joyride in Wyoming for a little bit longer.

BOTS SOTS STAMPEDE
Parade Program

Maree Lee Nelson, Queen 1948 Bots Sots Stampede

10 A. M.
FRIDAY, JULY 16, 1948

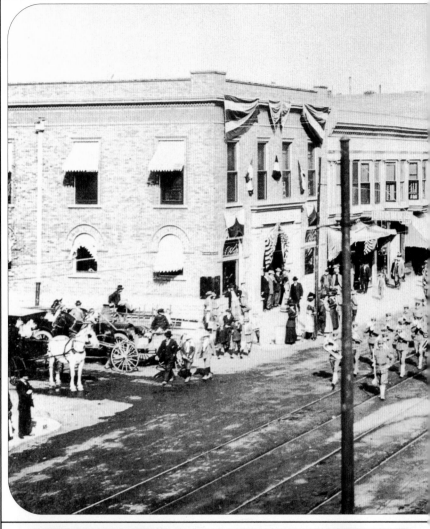

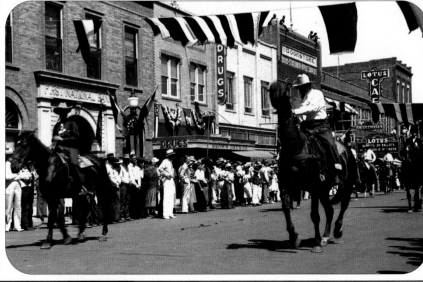

Sheridan's first annual rodeo took place in 1931. A souvenir program from a 1948 Stampede rodeo (*above*), named "Cowboy Days and Indian Nights," is considered a valuable collectible today. The rodeo celebration paraded down Main Street with its colorful Wild West show, one of many parades held in downtown Sheridan throughout the year.

Elsa Spear Byron captured a rodeo parade in 1936 (*right*). The man in the white hat on horseback was her father.

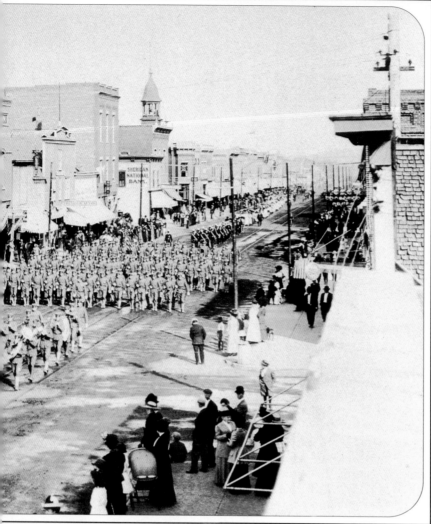

The circus always announced its arrival by parading down Main Street from the depot (*above*).

Troops from nearby Ft. McKenzie are seen parading down Main Street (*above, left*) in an elevated view taken about 1912.

Native Americans from the area, recognized for their vital role in both local and Western culture, participated in the town's many parades (*left*).

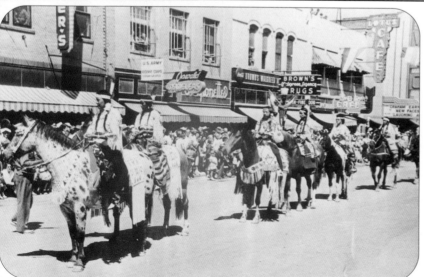

Railroad Ties

LIVINGSTON MONTANA

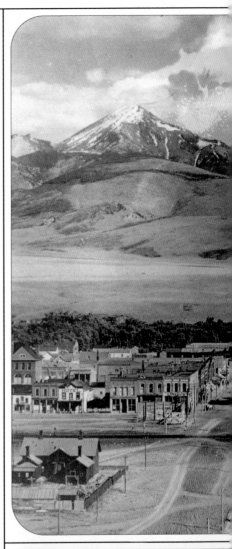

I opted to take the long way to Livingston from Denver, and left the shortcut through Yellowstone from Jackson to the mid-August tourists. Vast stretches of Western landscape are breathtaking in their rugged beauty, overwhelming in their desolation. It's possible to drive for a hundred miles between sleepy small towns, their dusty streetscapes wellworn flashbacks to the fifties.

Coming upon one of the big towns is cause for a hoot and a holler. Livingston, with its two traffic lights, is one of those big towns. (You'd have to go 150 miles to the south; 100 to the north; 110 to the east; and 26 to the west to get to the next set of traffic signals.) Its site at the base of Mt. Baldy establishes a respectful tone for the natural setting, with Main Street worshiping at its altar. After that bit of respect, everything else shouts.

At first, I suspected that this town is just a gussied-up version of the True West. A recent article in an upscale design magazine led me to believe that Livingston has gone chic. But if movie stars hang out in Livingston, their schedule is different from mine. There's talk of celebrities buying ranches just outside of town and expensive shops going in to cater to their needs. But my jeans had the only designer label in sight, and the hype seemed out of line with the true tone of the town. And, as one old-timer put it, "When those cold winds start in howlin', the hummers pack up and head home."

Livingston is still a town where riders break horses in rush-hour traffic, a wedding limousine is a red Jeep with the top removed, and the hurly-burly nights are spiked with neon. Main Street begins at the railroad depot and cuts a straightforward swath through several long blocks before it winds to the east toward the fairgrounds, where the rodeo comes to town. In its col-

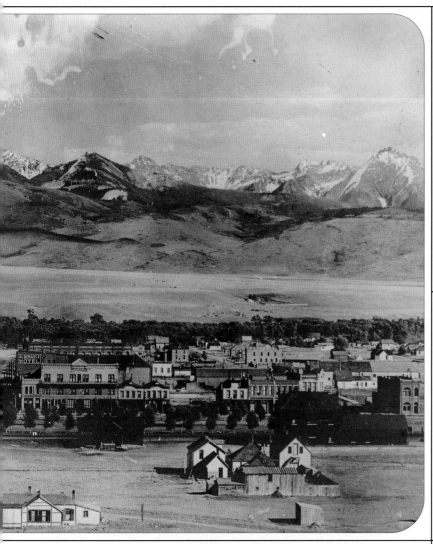

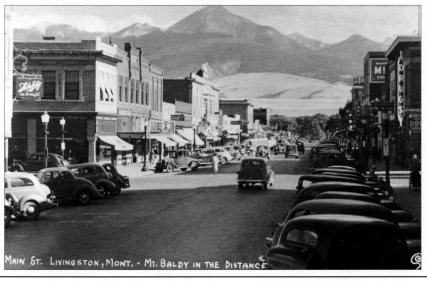

MAIN ST. LIVINGSTON, MONT. - MT. BALDY IN THE DISTANCE

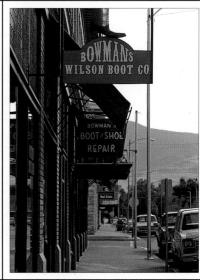

This photographic view of Livingston (*previous pages, top left*) appears to place as much importance on the town as on Mt. Baldy in the distance. In the latter part of the nineteenth century, bird's-eye views of towns—shown in skillful drawings as well as in panoramic photographs—contributed to a town's development as well as to its self-esteem. An 1883 article in the *Daily Enterprise* had this to say about these popular views: "We hope many of these views will be taken to send away to eastern points, as nothing could have so good an influence to bring our city into the favorable notice of those looking westward with capital to invest."

A 1937 postcard of a crowded Main Street (*preious pages, bottom center*) is signed "Sanborn" in the lower right-hand corner by the Montana photographer who was known for his postcard views of the town. It's a familiar sight today to see horse and rider (*previous pages, bottom left*) in the downtown area.

Grain elevators (*previous pages, top right*) loom large at the edge of town, monuments to a prairie past.

Kate Bean, a local resident, posed for this photograph (*previous pages, center right*) with her grandchild on July 4, 1910.

Lined up along a side street (*previous pages, bottom right*), these signs reveal a distinctly Western lifestyle.

orful past, Main Street boasted a bar every few doors, and the infamous Calamity Jane was known in every one of them. Today it's still easy to hoist a few without walking out of your way, but many of the old bars have taken on a gracious respectability. Lodging is located west of downtown, where most of the motel chains compete for the tourists in cars and assorted RVs. Known as the "Gateway to Yellowstone" because of its proximity to the northern part of that park, Livingston is no stranger to tourism and weekend guests.

At the beginning of the nineteenth century, Livingston was a small, undefined piece of a very large, unbroken, and unsettled territory—part of the "newly bought West," better known as the Louisiana Purchase. A detachment of the Lewis and Clark expedition—led by Captain William Clark—camped in what is now Livingston in July of 1806. The first published journals of the expedition—detailed in their description of this promising if rough terrain—didn't exactly bring about a wholesale rush of planned settlement. The ever-present threat of Indian attack, lack of any developed transportation and commerce, and the uncertain nature of land or mineral rights in the territory kept a rein on settlement. Fur and mining would bring a few intrepid individualists into the area, but it would be seventy-six years after Captain Clark's visit before any organized development began, ending the era of the open frontier.

An early omen to the future successful development of Livingston was the opening in 1872 of the country's first national park only fifty-six miles to the south. Yellowstone, with its spectacular display of unparalleled natural beauty, added an element of sure success. Later the county would be named Park, reflecting

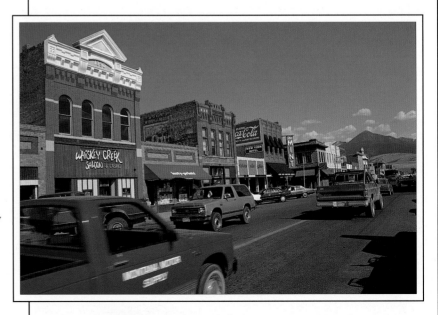

Exuberant architectural embellishments and attention-getting signage intermingle on the long corridor of a treeless Main Street as it stretches toward Mt. Baldy (*opposite page*). A stepping-stone rhythm was created with the alternation of one- and two-story structures downtown, perhaps echoing the lines of the landscape.

Often sponsored by groups — syndicates made up of local businessmen — commercial blocks were frequently named after the local entrepreneur who built them. It was customary for the name or the dedication data to be inscribed on the building's decorative cornice (*above and left*). The building labeled "Combination Block" was built by a group of five investors; the building features both commercial space and upstairs apartments. Commercial blocks, historic markers today, continue to be referred to by their original names.

the importance of Yellowstone to the area; Livingston would be named its county seat.

By the summer of 1882, nearly 20,000 visitors had passed through Livingston—a town still in its infancy—on their way to or from the national park. The lure is still there. In 1992, 6.5 million people visited Livingston; in August of 1992, most of them were looking for a motel room, too.

Most of the motels were familiar chain names—nothing in town that a magazine article could really call "trendy." In search of glamour, I headed for the Livingston Bar & Grille, where movie stars are said to hang out. I got a friendly welcome and efficient service even though the restaurant was packed. I liked the steady, muffled stomping of Western boots on old plank floors, the natural down-home ambience. When I scanned the crowd, however, I came up empty on the rich and the famous.

The promise of a constant tourist trade combined with the rumor of railway development in the late 1800s sent land speculators and developers scrambling to size up the Livingston area, plot it out, sell it off, and make a tidy profit. Many of us still believe the naive notion that our adventuresome ancestors rode into town, picked out a pleasant spot for a store or a house, and started clearing the land. The truth is that—in the typical spirit of American enterprise—the developer usually got there first. The land was indeed vast, but it was neither free nor accessible without the ubiquitous real estate broker.

The Daily Enterprise made its publishing debut in June of 1883, exactly a decade after Yellowstone was opened. Its first issue was filled with recurrent announcements that extolled the praises of owning and selling land.

Real estate is booming, and Allen Brothers and other real estate men have their hands full," the first enthusiastic announcement read. "We offer for a very few days the most desirable business lots in Livingston at prices which defy competition" another stated absolutely. Soon the liberal sprinkling of these early ads begins to sound as familiar as today's classified section: "The largest assortment of business and residence lots in the city can be seen at Allen Brothers." My favorite comes right to the point: "H. F. Ceperley has a bargain in some Main street lots."

Although, to my knowledge, John R. Hudecek has never been in real estate, he seems to have been in everything else. John met me for breakfast at the Best Western, where I was staying. When he tipped his feathered hat and pulled a business card out of the pocket of his wash-'n'-wear Western shirt, I wondered if this card routine was a throwback to old times, a courtly gesture. Then I

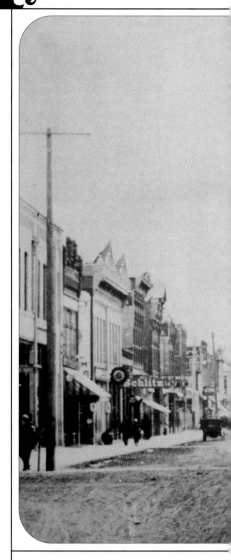

Main and Park (*above*) was one of the most desirable sites in early Livingston, and it was here that the National Park Bank and the Albemarle Hotel were erected in 1886. Note the wooden walkway from the railway underpass that came directly into Park Street; also the carbon arc lamp hanging over the street.

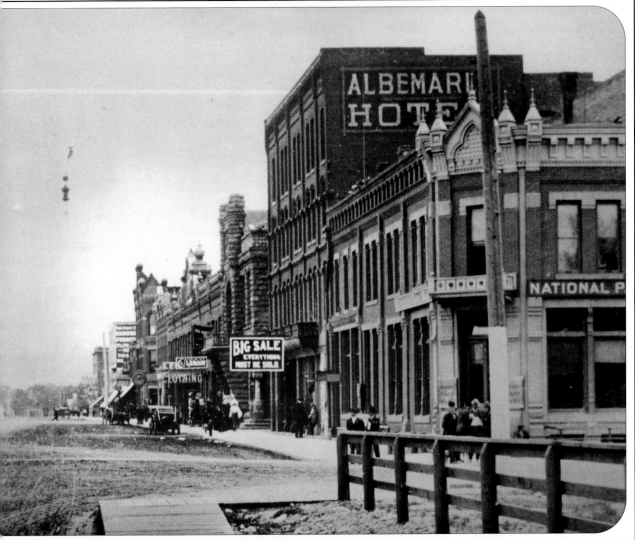

The Albemarle was built in an L-shape around the bank and had entrances on Park and Main, where, according to a newspaper account in 1902, the infamous Calamity Jane (*left*) showed some appreciation for the location: "She deposited herself & jug on one of the benches, where she was soon embraced by the living clasp of Morpheus. In a few minutes, Officer Skillin happened along . . ."

Rough drunkard, local eccentric, barroom brawler, indigent riffraff to some; Pony Express rider, talented performer, straight shooter, trailblazer, noble friend, and brave "Heroine of the Plains" to others—the real Calamity Jane remains a mystery, even to careful observers of her checkered life. Accounts of this frequent visitor and onetime resident range from glowing to glowering. Her activities made for instant copy. Here, a sober-looking, freshly scrubbed Calamity Jane poses in buckskins at Potter & Benjamin, a local photography studio, her trusty rifle at her side.

Calamity Jane claimed that the father of her daughter was the legendary Wild Bill Hickok. The secret diary that Calamity kept tells of a deep devotion to a daughter she never knew. At birth, Calamity gave up Jane for adoption to an English aristocrat, the ties with her only child severed by distance and breeding.

read the card: *John R. Hudecek, Retired: World Traveller, International Lover, Last of the Big Spenders, Friend of the Workin' Girl, Ex-Prize Fighter, Ex-Rodeo Rider, Exotic Cook, Ag-Consultant . . .* And it goes on.

I had been told to talk to John for a bit of local color. A few people had warned me that John Hudecek exaggerates; just look at his card. But gradually, I found out that everything on the card is true, to a degree. This also applies to what John told me about life in Livingston.

Over a breakfast that ran into lunch, John told me that people put up with Livingston's harsh winters because of its magnificent location in "Awe Country." John said he likes to walk along Main Street because you can look up and see the mountain right there in front of you. He said he used to know everyone downtown, "but then everybody died off." We talked about the Friday night shopping: "Yeah, we'd send the women in. Make 'em a list, give 'em the numbers off the parts we needed . . ." John was always looking for ways to get a rise. . . .

The subject inevitably got around to Calamity Jane, a frequent visitor to Main Street and a resident during her last years. John recreated the colorful history of Calamity and her cohorts, not because he's old enough to have run with that lot, but because he's lived with the legends all his life. Apparently a Madame Bull Dog ran a rough-and-ready watering hole called the Bloody Bucket and was one of the few people who could deal with the likes of Calamity Jane. There are several stories about the name of Calamity's favorite bar; all have to do with brawls and horrific acts by local desperadoes. "She was a mean dude, and she had the hots for Wild Bill Hickok. It was a wild town," John said flatly, in the understated way of someone who has grown used to the tale.

We talked about the railroad ("A mixed blessing. It brought the jobs in, but you never knew when they were going to pull out"), the bar at the Mint ("It was so long that they had to cut it in two 'cause the barmaids got tired runnin' up and down behind it"), the Depression ("If you were out of a job, you could go to Tecca's Grocery and get something to eat"), Main Street ("It used to be friendlier than it is now"), and John's range of knowledge ("I'm part Indian. I get all my messages through smoke signals").

I found out that John owns a picture of Bertha Gonder, the only one of the "Dirty Dozen" engine wipers for the railroad during the First World War who stayed on for the next thirty years. "Would you consider making me a copy?" I asked John, who didn't miss a beat: "I'd do anything for a buck." Then he made his exit with what I have come to recognize as Hudecek-speak: "Don't forget," he drawled, "around Livingston, you've gotta look out for blizzards in the winter, rattlesnakes in the summer, and Hudecek all the time." I promised I wouldn't forget, and we said good-bye.

A few minutes later, the desk clerk phoned my room to say that the mayor was in the lobby for me. I paused and wondered if

Through tales both tall and true, the memory of Calamity Jane lives on in Livingston. A downtown restaurant has been named after her (*above*); its charming decor would have appealed to Calamity's softer side.

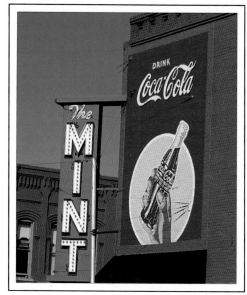

The Livingston Bar & Grille (*above*)—an inspired version of the old favorite— sits on the busy corner of Main and Park, originally the site of the George Carver general merchandise store in 1884. It serves Montana beef and trout as well as buffalo burgers and a delicacy called Rocky Mountain oysters.

Some of the old billboard advertising (*above, right*)— now vintage artwork— retains its bold appeal.

A rider breaks in his horse (*opposite*) along Park Street.

everyone in Livingston embroiders the truth. But sure enough, when I went downstairs, there was my old friend John Hudecek, who had brought Mayor Bill Dennis by to say hello. We stood by the elevators and talked about the town, about my work. It's the sort of small-town goodness that Livingston is known for. And I couldn't have been more pleased if the president himself had come to call.

When the newspapers of Livingston first took note of Calamity Jane's presence in March of 1884, the frontier she had grown up on was rapidly changing from a vast, open place teeming with action and danger to a string of newly settled Western towns. Calamity, who had seen and experienced as much raw frontier life as any man—as a cowpuncher, a scout, and a rider for the Pony Express—was left to fend for herself in the uncharted territory of a more genteel society. She spent her days promoting herself as a notable character of the frontier: playing engagements, selling twenty-five-cent photographic portraits and a pink pamphlet describing her adventures. The rest of the time she seems to have spent reliving the good old days in saloons, or sobering up in the town jail. Women were said to have led their children to the other side of the street to avoid her. By the time Calamity came to

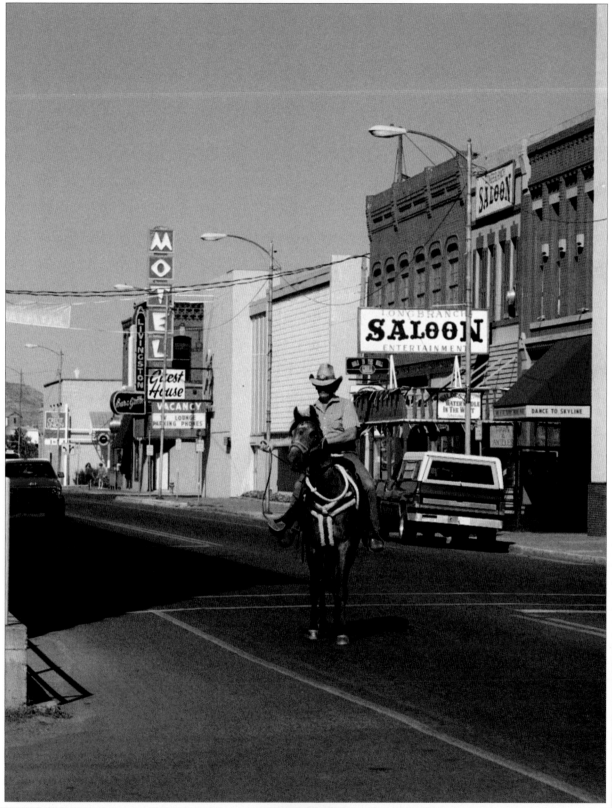

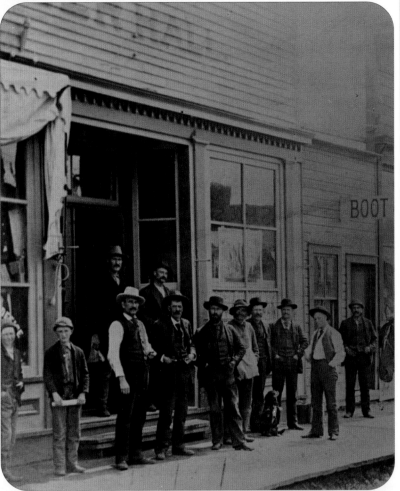

Today's Sport restaurant and bar (*above*)—the exterior now attractively renovated—is a far cry from the original The Sport (*above, right*), a beer hall and popular gathering place established in 1909 by Ben Smith. Some say the name came from Ben's love of outdoor sports. Others claim the name paid sly tribute to the shady indoor "sporting" establishments off Main Street. The original bar, which is still intact, is said to be the second longest in the state of Montana.

Nowadays, just like clockwork, a group of local businessmen—including a banker, mortician, and accountant, among others—a group nicknamed "The Coffee Klatch" (*right*)—take their break at the Sport five days a week at 10:00 A.M. and again at 2:00 P.M. They talk about "everything and anything," stay about twenty minutes, and decide who gets stuck with the tab by picking a number.

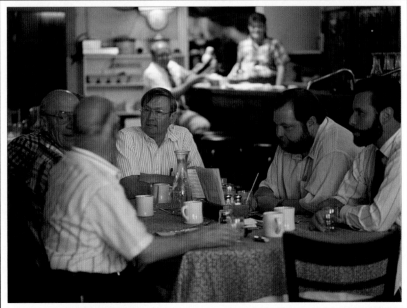

Livingston in 1884, the young town had a population of 1,500.

When the town site was chosen by the Northern Pacific Railroad supply store representative Joseph McBride two short years earlier, he found an undeveloped area of no more than 500 populated by an assortment of would-be frontier entrepreneurs, camped in 40 tents, waiting for his arrival. What had been untenable for development for nearly 80 years was to become a going concern almost overnight. As an early source put it, "For upon his judgement as to a natural location, hung the fate of their dreams of a future flourishing city that would offer equal advantages to capitalists or laborers who were interested in the building of any kind of enterprise that would secure the development of the country's vast resources."

When 30 freight wagons loaded with 140,000 pounds of supplies arrived at the site, stores were temporarily set up in tents and a road 100 feet wide was set out. By November of 1882, the town had been platted. By the time the first construction trains reached the town, Livingston had two hotels, one hardware store, two restaurants, and thirty saloons.

When the dust cleared, Livingston began developing its more genteel social side. The volunteer fire department held its first annual ball in 1898 at the Opera House. The firehouse itself boasted an unusual array of fine appointments, with a highly polished dance hall floor, a library and card room with leather upholstered chairs, and a billiard room with a soft Brussels carpet. Less refined, but equally entertaining, establishments included the town's many saloons, such as the Bucket of Blood (also known as the Bloody Bucket), which was allowed to move to its site at the corner of Main and Park in 1913 if the owner "promised to operate it in an orderly manner or close it on his own initiative." In Livingston, there was room for the raffish as well as the refined.

An announcement that the Northern Pacific Railroad would extend a branch of its system to Yellowstone spurred yet another optimistic surge of development in the town. As passengers would have to change trains in Livingston to get to the park, the town had sure reason to build new hotels and restaurants to accommodate the tourists. The advent of the rail system also spurred the development of the region's agriculture. Within trading distance of Livingston were 100,000 acres of arable land; a plentiful water supply for irrigation was another real asset. The *Livingston Enterprise Souvenir* of 1900 listed grain, hay, and vegetables, with experiments in domestic fruits, as examples of successful agricultural enterprises in the area. Ranching had long been a dominant pursuit in Park County, with pastoral lands far outnumbering tillable lands ten to one.

Women were not allowed in The Sport until the early 1940s, the exception being when they needed an extra for gin rummy and called in Ben's wife, Jeanette. Now Suzanne Schneider (*above*) owns the place. Montana boasts that 52 percent of its business owners are women, and Suzanne is doing her part in Livingston. She took a chance on the town in the mid-eighties, when Main Street had a high vacancy rate and a dim outlook. Today, her restaurant is a popular gathering spot for locals and tourists passing through.

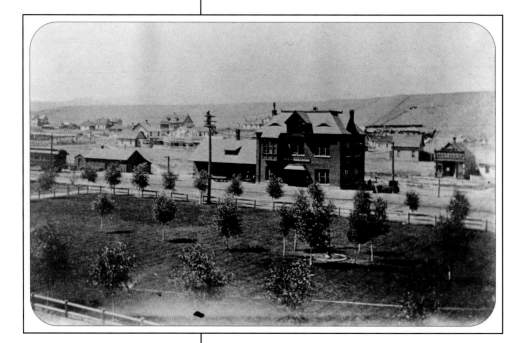

Livingston's character was determined by the railroad, with farmers, ranchers, miners, and tourists all passing through for trade or travel. The original railroad depot, built in 1897 (*above*), was located across the street from the Albemarle Hotel close to the town's center, signifying its importance.

Through a confluence of events—with the primary catalyst being the coming of the Northern Pacific rail line, supply store, and machine shop—the area found itself in the enviable position of having a fairly secure economic base from which to spring. A busy day on Main Street found ranchers, farmers, railway workers, and tourists using all the facilities of the rapidly growing downtown.

Although the railroad ceased to be a major player in Livingston's economy in the early 1980s, the trains still come and go throughout the day, their boxcars the colors of crayons. The passenger depot at the busy head of Main Street stood empty for several years until the Livingston Depot Foundation began a community-wide effort to raise the money to restore the grand old building to its original splendor. This classic stone structure was designed at the turn of the century by Reed and Stem of St. Paul, Minnesota, one of two firms that designed Grand Central Station in New York City, and built for $75,000. During the extensive remodeling in the late 1980s, at a cost of $800,000, the building was washed to remove the blackened soot left behind by thousands of passing locomotives.

My first trip to the depot was not to watch the trains go by but to see an exhibition in the relatively new Depot Center, a satellite museum of the Buffalo Bill Historical Center in Cody, Wyoming. Entitled "Women of the Wild West Shows," the exhibition reinforced all my girlhood fantasies about the daring Western women who wore cowhide culottes and shot as straight as the men. The exhibition—one of many held throughout the year—uses art,

Resembling an Italian villa, with its curved colonnade and rich terra-cotta ornamentation, the grand new depot was designed by the St. Paul architecture firm of Reed and Stem and built by the Northern Pacific Railroad at a cost of $75,000. It was dedicated on May 30, 1902.

Abandoned in the early 1980s when the railroad closed down many of its operations in Livingston and transferred or laid off its workers, the depot stood empty for several years until the Livingston Depot Foundation began a community-wide effort to raise money. Eventually, the grand old building was restored to its original splendor at a cost of $800,000—more than ten times its original cost! Now it houses a Depot Center, which sponsors such events as the "Evening at the Tracks" concert series and the Festival of the Arts. The Depot Center also houses a satellite museum of the Buffalo Bill Historic Center. The local chamber of commerce is located in the old baggage room.

The "Dirty Dozen" is the nickname for a group of women engine wipers who worked during World War I. Two of them, identified as Natali Parisi and Helen Cole, were just fifteen years old when their photograph was taken.

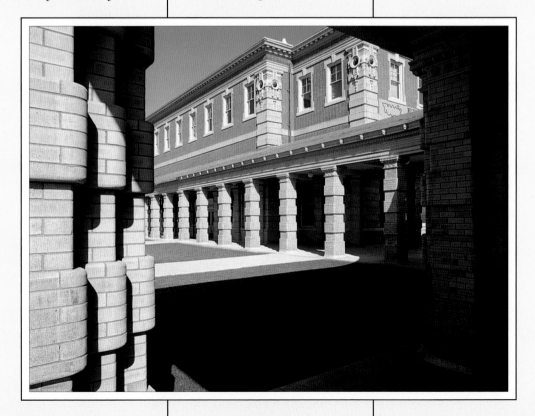

Doris Whithorn (*right*) has been entrusted with the archives of the town by the townspeople who know her. Here, she's seen in front of the 1898 Northern Pacific caboose, which occupies a spot of honor on the lawn in front of the Park County Museum, also called "The House of Memories"— Doris's brainchild and now her home as well. The museum contains the memories of Livingston: the photographs, the railroad memorabilia, the family quilts, the furniture, even the humble pots and pans. A genuine Yellowstone National Park stagecoach is also there.

photography, historical objects, and costumes to tell the story of these early performers—my hero, Annie Oakley, included. The second movie I ever saw was *Annie Get Your Gun.* The first was *Cinderella.* Early images die hard, but as I went through the show, I could feel Cinderella bite the dust.

When I sought out early photographs of the depot, the path inevitably led to Doris Whithorn, the one-woman band responsible for gathering under one roof—in this case a building with three stories—the historical photography, antique decorative arts, and related memorabilia of the town. Doris's late husband, a photographer, began copying old pictures during the fifties, and she soon developed a natural curiosity about their histories. In 1976, Doris Whithorn helped found the Park County Museum, and soon Doris was the town's unofficial gatekeeper.

Doris's desk on the third floor of the Park County Museum— a few blocks' drive from the depot—is piled high with treasures recently sent to Doris by local families for safekeeping. I spent hours with her, and hours on my own in the museum, studying the many photographs set in large wall-mounted displays that flip like a gigantic photo album. I found the "Dirty Dozen," the female locomotive wipers during World War I, a stalwart group of women at work at the depot in a man's world. I found Kate Bean, an early resident, challenging the camera, a pipe in her mouth and a baby on her lap. I found the tobacco-chewing, tough-talking Calamity Jane. I was in feminist heaven!

The old photography in the archives also aided the modern-day architects who restored some twenty Livingston building facades to their original designs. This was a cooperative effort between the state and local businesses. In addition to the architectural details that remain on many of the old business buildings, the names of early businessmen remain as well: Orschel, Danforth, Garner,

There's a new breed of rider on Main Street in Livingston (*left*).

Window displays (*center, left and right*) reflect the Western character of the place.

John Hudecek (*bottom*), who knows just about everything one needs to know about Livingston and is certainly one of the town's most colorful characters, claims to get his information through smoke signals. If this is true, then his system of communication beats my computer technology anyday.

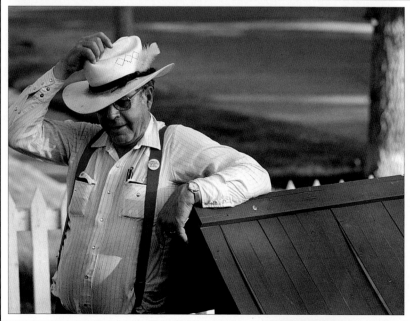

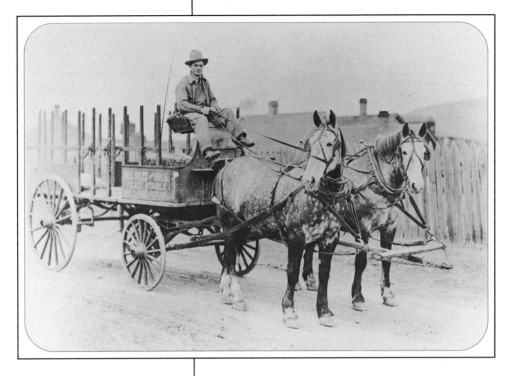

Red Moffield (*above*) is shown on the Bill Miles & Bros. Feed Stable wagon driving the matched bays to town.

and Frank. In 1979 the entire city of Livingston was surveyed for the National Register of Historic Places; 436 structures qualified in several districts.

When the Burlington Northern closed its repair and machine shops between 1983 and 1986 and transferred many of its employees to other states, local residents expressed concern that Livingston was in for some hard times. Although agriculture, ranching, and tourism contributed heavily to the area's economy, the town had depended on the railroad. Just when it seemed that Livingston had lost its center, Montana Rail Link brought in the southern branch of Burlington Northern, followed by the reopening of machine shops like the Livingston Rebuild Center, which was contracted to build and repair cars for, ironically, Burlington Northern. Still, by the time the railroad had reorganized in Livingston, more than 1,000 people had lost their jobs or left the area. Once again, Livingston was being affected by the ebb and flow of small-town events.

But the land was still plentiful and the soil was still rich. This attracted newcomers, such as the Church Universal and Triumphant, a New Age religious group seeking a place to settle. With a steady climb in tourism in the 1980s and into the 90s, and a newly fashionable interest in the beauty and charms of the West, Livingston was able to harness the tourist power that had been there since the opening of Yellowstone in 1873. Additional attractions such as annual rodeos, nearby dude ranches, excellent fish-

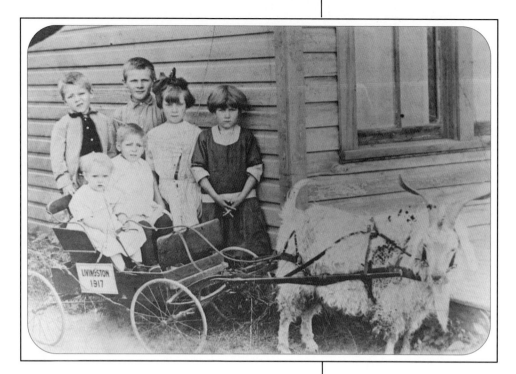

ing in the Yellowstone River, and recreational boating bring much-needed revenue to the town.

Business on Main Street is brisk. The empty shops, painfully obvious during the town's slump in the mid-80s, are not apparent now. In fact, the present vacancy rate is zero, with revitalization taking place up and down the street. Although the drugstores and hardware stores have moved out of town and into the strip malls, new businesses—galleries, bookstores, and restaurants—have moved in.

The mention of "galleries" brings up the chic thing with me again. I asked a local writer, a Colorado transplant, if he considers Livingston chic. "Aspen is chic. So are Taos and Jackson Hole. But not Livingston. Livingston still has a good base of *normal* people." He quickly corrected himself. "A regular community."

Okay, some big-budget movies are made here; movie stars hang out at The Sport between takes. And, yes, the out-of-staters are snapping up the surrounding land, making it difficult for local folks to own spreads the way they used to. But Livingston has too much heart and too expansive a spirit to be anything else than a town people still hanker to come home to. "It's just too damned bitter here in the winter for you Easterners to handle," I was told with good-natured candor. So I decided to head out while the sun was still shining.

Every year, the Goat Cart Man, an itinerant photographer, came to town to capture images on film. When he moved on to the next town, he simply changed the name and the date. Here, the Gonder children were gussied up for the event.

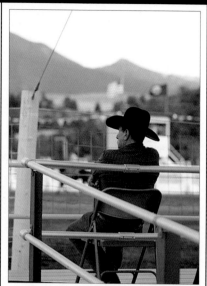

W̲estern is synonymous with rodeo. And in Livingston, the summer's two rodeos still bring out the rugged individualism, the color, the spills, and the daring of the past. In short, it's a traditional American celebration, Western style, in one arena.

I took Main Street to the far end, where it winds around until it connects with the fairgrounds, where the Calamity Jane Rodeo had come to town. The early evening's hair-raising events included barrel-racing, calf-roping, steer-wrestling, and bull-riding.

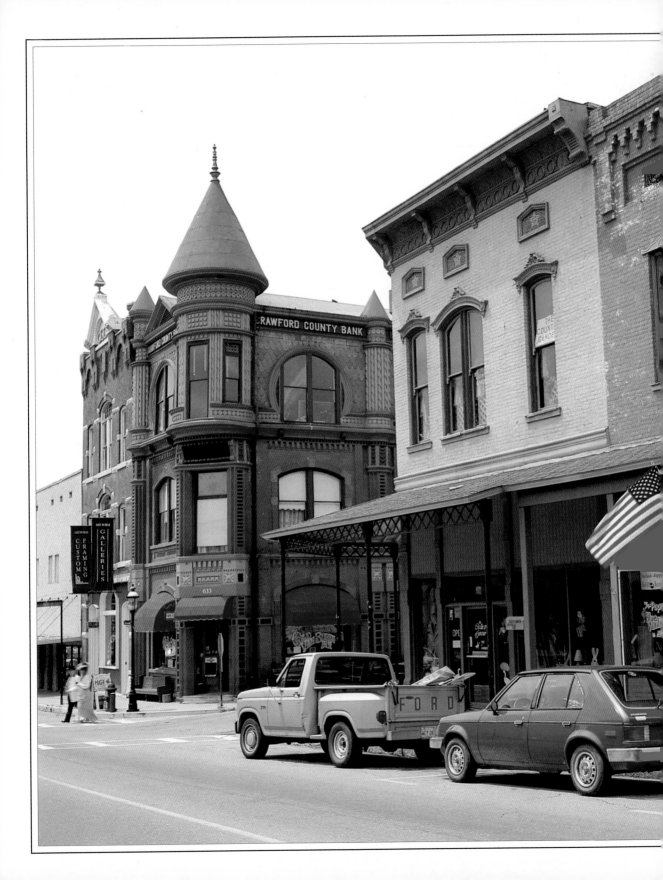

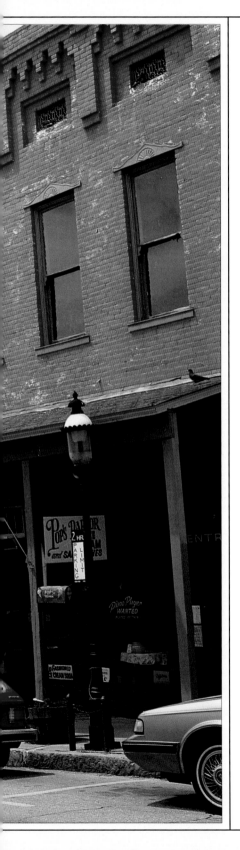

VAN BUREN ARKANSAS

It's hard to offend the good-hearted folks of Van Buren. But we managed to do just that by staying in nearby Fort Smith, an act that is considered downright disloyal. The lovely inns and historic bed-and-breakfasts in downtown Van Buren were all booked for the May Old-Timers Days festivities, so Leisa and I were exiled to a lackluster motel room on uncharming concrete grounds at the exact geographic center of a cluster of every imaginable fast-food chain known to humankind. Although Fort Smith is only a ten-minute drive away—"across the bridge"—the fiercely loyal Van Burenites seem to regard it as foreign territory. It's just not characteristic of these kind and gentle people to have been so disparaging of our accommodations. Then someone finally admits, "We're only joshing you." Still, I'm not so sure.

Modern-day Main Street in downtown Van Buren makes a long dash from the handsomely renovated "Frisco" depot at the top of a hill to Courthouse Square three blocks away, then on to the river. The historic origin of Main Street lies near the riverbank, where flat-bottomed steamboats once ruled the inland waterways, delivering an abundance of trade and travelers, plus a fair share of con men and cheats.

On the day I arrived, it was business as usual downtown. But as the weekday turned into the weekend, the town prepared to take a giant step back in time. Shopkeepers and local residents shook out their old boas and polished up their spats for the two-day event that turns merchants into nineteenth-century gentlemen and ladies, rogues and dance-hall girls—the weekend of Old-Timers Days.

Out on the street, barriers stood ready to stop anything motorized. Soon Main Street was lined with artisans selling hand-

The former Crawford County Bank building, now splendidly restored as the Van Buren Inn, has made the northwest corner of Seventh and Main (*previous pages*) a focal point on Main Street since 1889, when it became the town's first bank. On a street already laden with inventive use of architectural detail, the turret, windows, and other fancy work of this Queen Anne–style building make a bright and impressive statement. A cast-iron balcony over the door was removed by a previous owner. The third floor enjoyed a long tenure as a dance hall.

A view of Main Street looking toward the "Frisco" depot (*right*) shows a bustling streetscape whose buildings would remain intact over the next hundred years. A doctor's buggy and driver would sit on call in front of the doctor's office, and grocery delivery wagons were often parked outside stores as they waited for orders to be filled.

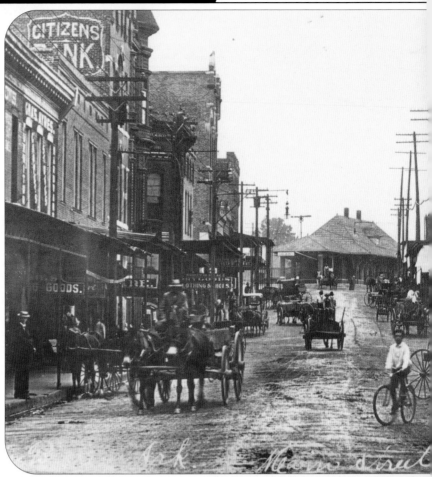

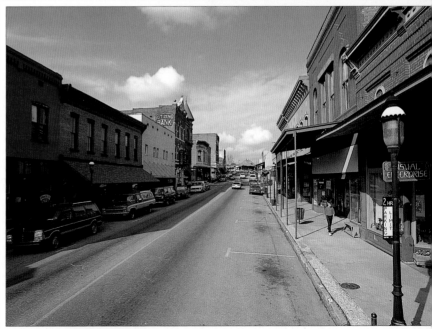

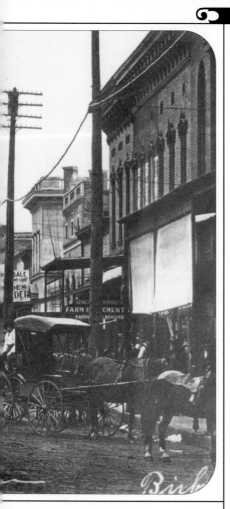

crafted goods and food vendors cooking up down-home specialties to warm a president's heart. It was just what I'd hoped for—local crafts, a little lore, and a lot of foot-stomping bluegrass. In short, a good time from a past time.

At first, the architecture up and down Main Street seemed almost too perfect to be authentic. I wanted to touch the cast-iron columns and the restored molding to make sure they weren't plastic. During my travels, I had gotten into the habit of looking above the street for honesty, for the original face of the town. But in Van Buren, even at street level—the level most frequently marred by "modernization"—buildings appear perfectly preserved.

Over a span of decades, the proud people of Van Buren constructed fine brick buildings with a feast of diverse styles and ornamentation. The Edmondson building, a handsome brick commercial block, features decorative ornamentation that the builder might have ordered by catalog from Sears, Roebuck & Company in Chicago. The 1889 Crawford County Bank building, the most ornate and colorful building in town, with its Michigan red sandstone trimming, reflects a sense of architectural exuberance. The appealing and rich earthy palette of other buildings—a bow to times past, when white paint was not durable—are a riot of historically correct colors.

It's hard to believe that in 1982, two-thirds of downtown Van Buren's buildings were vacant and run-down; some even had dirt floors and plumbing so antiquated that outdoor facilities were occasionally preferred. "We almost made a pretty nice ghost town," someone commented when we asked about the transformation. During the 1960s and 1970s, historic buildings along Main Street could be had for a song. "But who wanted them?" said one resident. The future of downtown Van Buren in the 1970s must have appeared pretty bleak, a far cry from Van Buren a hundred years before.

Nestled in the Arkansas River Valley, Van Buren's initial settlement occurred at the river—now the foot of Main Street—where early merchants provided steamboats with supplies and with wood for fuel. As a gateway to the West, the town played a part in the saga of the ever-expanding American frontier. Indian trade became big business. Commerce with the steamboat, the overland wagon, and the Butterfield Stagecoach Line put the town on the map as a supply and trading center. By 1836, mercantile trading firms in northwest Arkansas had established Van Buren as a wholesale trading center as well. Although the bulk of the buildings on Main Street today date from between 1880 and 1910, Van Buren enjoyed successful enterprise for a full

Utility lines, considered "modern improvements" in their day, were run underground during the preservation thrust of the 1970s and 1980s, and old-fashioned streetlights took their place (*left*). You can still see the Citizen's Bank sign painted on the exterior wall of its former site.

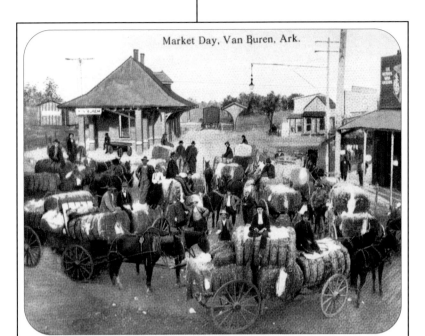

Market Day, Van Buren, Ark.

At harvest time, wagons would make the long drive from the countryside into Van Buren with produce to be weighed and freighted from the depot (*above*). Cotton, grown primarily between 1870 and 1930, was weighed on the public scales, then ginned across from the courthouse.

Today, the local chamber of commerce occupies the handsomely renovated railroad depot (*above, right*), whose roofline presents a commanding presence at the top of Main Street. The depot's former waiting area and baggage room have been converted into spacious public areas and private offices.

fifty years before this building boom took place. The river remained important to the town through the end of the Civil War.

By 1845, overland travel had done much to support the town, by then platted inland from the river's edge. Said then to be "a great thoroughfare already for emigration to Texas," Main Street merchants outfitted large wagon trains. By 1849, they were offering a refreshment stop as well as passenger and cargo pickup for the Butterfield Stagecoach Line. The early buildings that supported the various commercial and civic needs included the General Mercantile Store and the original courthouse, an Italianate-style building set on the public square in 1842. By 1852–53, a tax of $2 per foot was charged to put down pavement on the town's busy main corridor, emphasizing its growing importance.

At the start of the Civil War, the town was flourishing, set on an optimistic path of growth and development. But the war wreaked havoc on the entire country, and disaster came directly to Van Buren's doorstep. On December 28, 1862, after the Battle at Prairie Grove, a Union raid was made on the town. Steamboats were burned at the river, as were wharves and warehouses; stores were looted and demolished. Van Buren, which had been slow to join the rush to secession, suffered greatly. Today, a monument on the courthouse lawn to the Confederate dead stands as a reminder "to the price men paid for having had their time of life in the nineteenth century." During the Reconstruction period, the economy of the town was slow to right itself.

The 1876 arrival of a new transportation mode—the Little Rock and Fort Smith Railroad line into Van Buren—heralded a

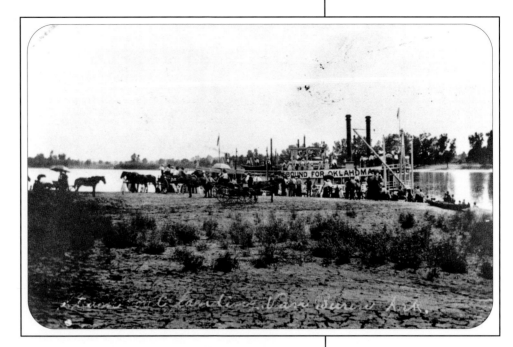

new beginning for the town. Now with the Arkansas River and the railroad as trade channels, cotton and grain came to be very important, opening up new markets such as New Orleans to the businessmen and farmers of Van Buren. In 1882, the coming of yet another rail line—the St. Louis & San Francisco Railroad Company (better known as the Frisco Line)—opened up additional markets in important distribution centers like St. Louis. Within a matter of years, Van Buren became a fruit and vegetable production center, signaling a new era of growth and prosperity in the town. A building boom was the direct result.

A crowd scene on Main Street a hundred years ago was a lively panorama. As the market and trade center for most of Crawford County, Van Buren was the place where farmers brought their goods to send by rail to distant markets or to peddle directly on Main Street. Open-air trading of tools and farm implements coexisted with genteel merchants whose shops were located inside fine commercial buildings. A cotton gin sat across from city hall, and public scales in town enabled pigs to be weighed. Cattle on the way to railroad cars occasionally wandered off the street onto the courthouse lawn. On a smaller, home-industry scale, market days for butter and eggs were held on Saturdays until the middle of this century.

As we sat in Pop's Parlor in the center of a revitalized town that shows no traces of Civil War battle scars, we puckered up with a glass of real lemonade. Richard Hodo, president of the Old Town Merchants Association and owner of an insurance business just down the street, joined us. Richard is one of the dedicated

A shot taken in 1908 of the steamboat landing at the foot of Main Street (*above*) shows passengers and goods traveling the waterways. At this time, many such steamboats were headed for what was called the Indian Territory, which would later become part of Oklahoma. Hollywood-style tall tales have glamorized the steamboat and blurred its historical importance.

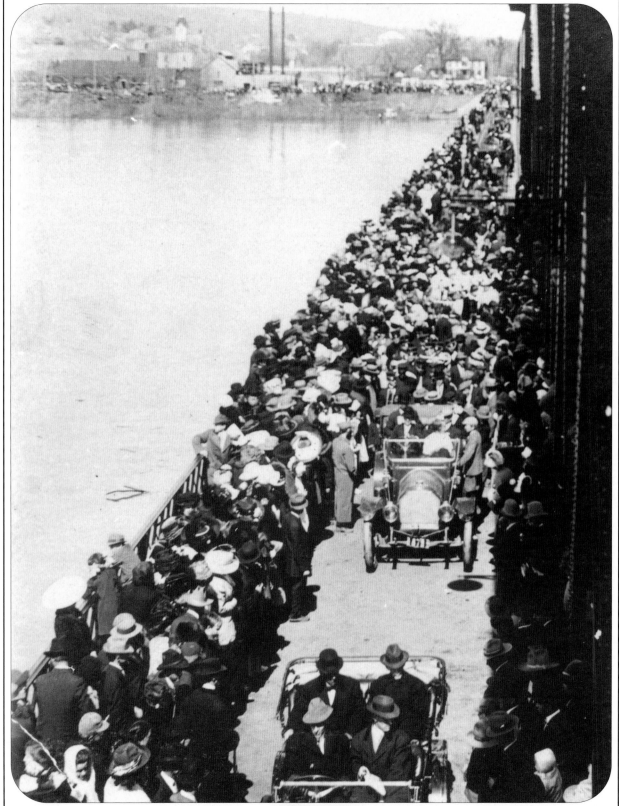

Such a large crowd turned out to celebrate the opening of the Fort Smith and Van Buren Free Bridge (*opposite page*) on April 1, 1912, that at one point in the day officials became fearful that the new span would fall. A joyful round of entertainment—including a frontier roundup, three baseball games, tight wire exhibitions, an air show, motor boat racing, music furnished by three bands, a carnival, and a well-known whistler—helped bring in a new era at the legendary gateway to the Western frontier at Van Buren. Although the bridge was known as the "free bridge," a five-cent toll was extracted both from motorists and from pedestrians.

Lee and Nellie Lloyd moved from Van Buren to Enid, Oklahoma, shortly after the opening of the new bridge. On a return trip to visit family and friends (*above, left*), they posed for a picture.

The arrival of the first railway line (*left*)—the Little Rock and Fort Smith Railroad—into Van Buren in June of 1876 was cause for celebration.

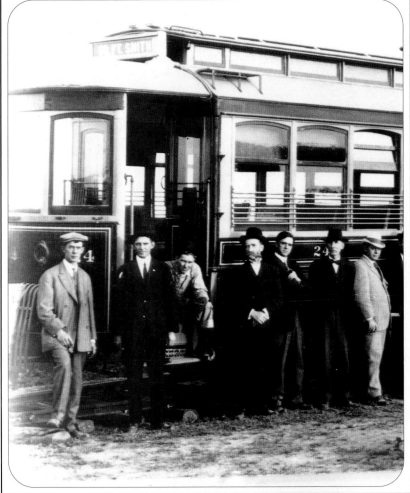

modern-day pioneers who bought his office building for the proverbial song and then renovated the long-neglected structure, joining with others on a mission to revitalize the downtown.

Van Buren's story of decline is one that we have heard before. Like so many others, its Main Street lost its long-standing importance as a commercial center for the community in the sixties, when the freeway came through and altered traffic patterns in Crawford County. Shopping strips in the outlying area sprang up conveniently off the freeway. Main Street struggled to keep up. Old meant obsolete. So downtown merchants modernized their buildings in an attempt to hide their historic architecture.

An account of Van Buren published as part of preservation case studies by the Heritage Conservation and Recreation Service states: "Between the 1930s and 1960s, Main Street storefronts underwent what seems now to be an almost predictable series of alterations. Many storefronts were replaced with inappropriate materials—brick, wood, metal-framed windows and infill. Several buildings were resurfaced with metal facades, thus obscuring some or all of the original details. In some cases, resurfacing also meant the destruction of any projecting brick, stone, or other decorative features. Newly installed signs were out of scale with the relatively small facades; and new canopies of inappropriate material and design detracted from store windows and entries. However, in spite of these changes, the significant features of many of the facades—elaborate brickwork, decorative columns and pressed metal cornices and parapets—remained virtually intact."

As businesses and customers soon abandoned this "made-up" modern Main Street, the old buildings were left to stand idle, thankfully untouched by further new "development." Unknowingly, they were ready for a rebirth in the decades ahead.

Many in town credit a film company with being an early catalyst for change. Ironically, it was a Civil War documentary, *The Blue and the Grey*, filmed in Van Buren, that inspired many merchants and residents to think: If a production crew could make so many surprising physical changes in such a short time, then why can't we take advantage of the possibilities for change that would call attention to our past?

No one could take away from Main Street the history that had occurred there. And as long as the old buildings still stood, no one could deny the architectural and social history that they represented. Who could forget that a battle was fought during the Civil War at the riverfront, or that children played on the courthouse lawn while their mothers sewed for the soldiers? What family didn't recall the importance of the depot as a market center, espe-

Dr. Louis Peer and his lawyer son, Steven, worked together to document many storefronts on Main Street before the revitalization of the street began. Many buildings had been "modernized" in the 1960s (*above and opposite, top left and right*) with inappropriate materials and designs that detracted from the buildings' original fine character. When these efforts to compete with the new shopping strips and malls failed, the made-up Main Street was left behind. Downtown, the buildings had deteriorated, but their good basic bones were still intact for the monumental preservation effort that would soon begin.

A two-story combination block (*opposite, bottom*) is a far cry from its ramshackle days. With close attention paid to historical accuracy, buildings such as this one have become Cinderella stories.

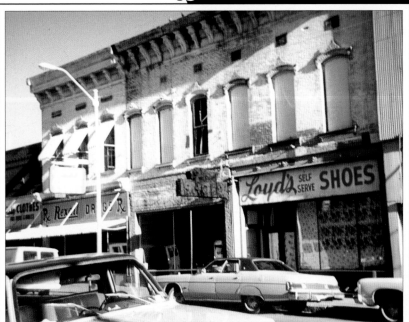

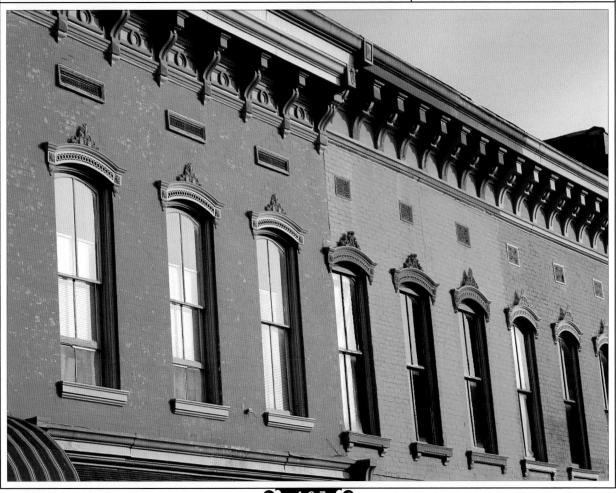

Local organizations working with state and federal support groups embarked on an ambitious program to restore Van Buren to its original architectural and economic luster. Present-day artisans were employed to work alongside local merchants and residents, who peeled, scraped, painted, replaced, and rebuilt throughout the downtown. Restoration efforts included replacing antique windows, (*above and opposite, bottom right*); preserving structural support caps, or "star" caps (*above, right*); restoring a railing (*opposite, top left*) that dates back to the Civil War; and uncovering decorative cornices (*opposite, top right and center right*), which were often made to order by popular catalog companies, such as Sears, Roebuck. Work on a magnificent Eastlake-style building on Main Street (*opposite, bottom left*) has involved a long-time commitment to its promising interior, with work on the third floor still in progress.

cially as strawberry season returned each year? And didn't Main Street have a more leisurely appeal too, as a place for entertainment, even if just to sit back and watch the comings and goings on the street? Didn't this beat the sameness of stores at the mall?

By 1968, concerned citizens had mobilized. The Van Buren Community Development Program and the Urban Renewal Commission were both founded that year. Local organizations brought about cooperative efforts, funded by state and federal programs that would be active for the next decade. By 1976, the country's bicentennial year, an important designation was given Van Buren—a designation that many communities have described as the linchpin of all their preservation efforts. An eight-block section of Van Buren's central business district was placed on the National Register of Historic Places and was declared a historic district.

Over the next several years, local organizations worked on an ambitious architectural and landscaping plan that went so far as to include actual renderings of individual restored storefronts. By 1979, it had been reviewed by a private design firm and worked on by federal, state, and local planners. This impressive "project document" enabled Van Buren to receive a sizable grant from the Heritage Conservation and Recreation Service. Dr. Louis Peer, one of the longtime movers and shakers in the preservation effort, documented the deteriorated downtown in a slide show that he now conducts for civic and school groups. "People who came to town could see the potential better than the people who were already there," he told us.

The 1980s saw a big leap for the commercial and mercantile aspects of Van Buren's Main Street. Businesspeople/merchants like

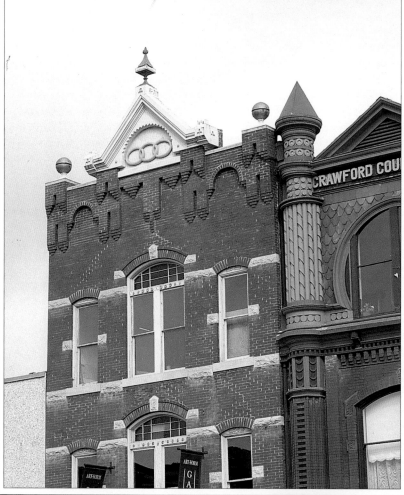

The Crawford County courthouse has been the seat of county government since 1841. The original courthouse dome was replaced with a clock tower when it was rebuilt after a fire in 1877. While the new courthouse was under construction, door-to-door solicitations raised $500 for the Seth Thomas clock in the tower.

A monument to the Confederate dead at the main walkway to the courthouse is a reminder of all the brave men from Van Buren who lost their lives in the Civil War. The monument is inscribed: "He wins the most who honour saves. Success is not the test."

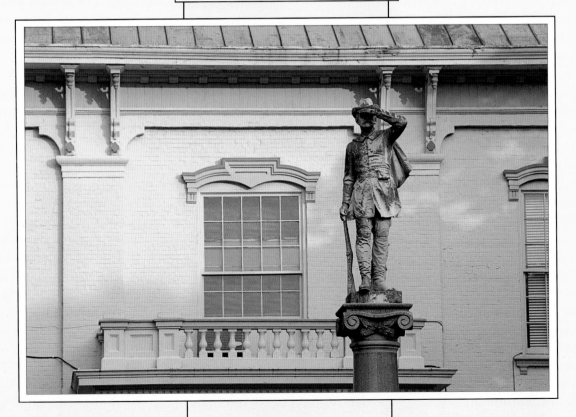

Jackie Henningsen of the Old Van Buren Inn bought properties at bargain prices, but then had to do massive renovations to reclaim their buildings' architectural integrity. Jackie had been vacationing in the Van Buren area when, in her own words, she "fell in love with the building. The rest is history." Another business merchant, Ralph Irwin, owner of Artform, bought his Eastlake-inspired building when its potential for elegance was buried beneath grit, grime, and misguided renovations of the past. His has been a painstaking yet rewarding floor-by-floor renewal.

In returning Main Street to its architectural roots, contemporary artisans were employed throughout the town to undo many decades of inappropriate change. They scraped off layers of paint, replaced broken stained-glass windows, matched and replaced many of the original details, and, like eager detectives, discovered jewels beneath the rubble.

With the pieces then in place for a physically reenergized Main Street, emphasizing the beauty and value of the architecture, the economy became of paramount importance. Van Buren had reinvented itself. Now it needed to attract the townspeople to its services and civic center, as well as travelers on the interstate. The town's organized and aggressive effort included the passage in the 1980s of the "A & P," a bill that imposes a 1 percent sales tax on hotels and restaurants within the city limits. The money is earmarked for advertising and promotion only. "Visit Historic Van Buren" is the theme of the lively and informative promotional brochures. Using the promise of well-placed advertising as a lure, the town was able to attract the Ozark Scenic Railway excursion train as well as the recreational *Frontier Belle* riverboat, bringing in an additional 15,000 visitors a year. These modes of transportation, so vital to Van Buren's economy in the past, have come full circle.

On the Saturday morning of our visit, a breakfast crowd congregated at the Cottage, a mix of locals and visitors turned out for the Old-Timers Days on Main Street. The homemade biscuits at the Cottage are hot and fluffy, just the way you'd imagine. You can order them with a bowl of gravy if you're inclined toward a breakfast that sticks to your ribs. I passed on the gravy and had my biscuits with whipped country butter.

The mournful strains of "Achy Breaky Heart" beckoned us into the street, where a group had gathered at the depot for live bands, impromptu street dancing, and a karaoke contest that would run all day. A sea of people swept down Main Street, tight blue jeans and loose overalls outnumbering vintage apparel. There's no time or tolerance here for the New York minute. Folks have come to stroll, to shop, to visit—or just to hang out and cog-

Adolphus Busch constructed this building (*above*) in 1901 on Main Street as an icehouse to keep his draft beer cold until it was shipped out. After 1918, the building was leased out by the Anheuser-Busch corporation as a beer parlor, restaurant, furniture store, warehouse, and community center. It now houses O'Malley's, one of the liveliest spots on the street, featuring a singing waiter, a storytelling cook, and dinner theater on weekends.

The company's famous trademark still caps the facade of a building that was basically a shell when the new owners began restoring it. Rooms on the top floor are rented as bed-and-breakfast accommodations. Lillie Aguilar, one of the present partners, lives here, "on the street."

H. P. King, a merchant in a nearby town, bought this circa 1891 building (*above*), then consisting of two commercial spaces, and removed the center wall to create the King Opera House. Opened in 1901, it was the only opera house in the state. Events such as traveling shows and Chautauquas were held here; Jenny Lind and William Jennings Bryan are said to have been showcased on the stage. Today, the King Opera House is nearing the end of a noteworthy renovation.

itate. Main Street offers the perfect setting, the way it used to be when people came to town to socialize.

A fair share of cogitation usually takes place across from the depot at Moon's, a water pump and filtration systems store referred to by insiders as the "Spit and Whittle Club." Dedicated to the gentle art of loafing in off times, the crowd at Moon's runs the gamut from seasoned old-timers to a faster-looking set. It's an all-male club as far as I could see, the sort of place where I might have demonstrated for equal rights back in the sixties. Now it's where I'm doing historical research!

The crowd inside Moon's arranged its chairs in a circle near the 7-Up machine. It reminded me of a friendly sewing circle or a chummy campfire gathering, depending on your sex. It didn't take much to see that this is a loyal and good-hearted bunch of friends who hold court on old car seats, respectfully defer to the senior members, and pull your leg about everything from hunting to world affairs. Everyone but me communicated in time-honored shorthand, with nods, shrugs, and few words. Then out of the blue, a designated spokesperson offered me the comforts of Moon's as a place to stash my extra gear, a place to hang out. Someone else patted the seat of a well-worn leather swivel chair. "Here," he said, and motioned for me to sit. "We're going to make this the Pat Ross chair." I wondered if I was dead wrong about this all-male stronghold. I wondered if this gesture made me an honorary member of the "Spit and Whittle Club," if only for a day.

Bought by a theater chain in the late 1930s, the King Opera House was renamed after Bob Burns, a nationally recognized humorist, radio celebrity, and native son. Burns was the inventor of the musical bazooka, and was known for his humorous tall tales about fictional Ozark kinfolk. Here, a crowd has gathered for the premiere of his new movie (*right*).

There were "cubbyhole" storefronts on both sides of the King Opera House, with Leonard's Café (*below*) at one side and an attorney's office at the other. In 1928, Joe T. Lloyd, Sr., at the age of 18, stands behind the counter at Leonard's.

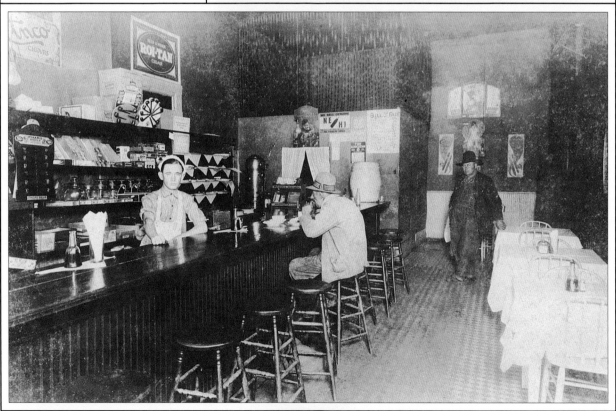

It takes T. J. Jones one hour and eight cans to make an airplane (*above and above, right*). He has perfected his design by making the propellers longer, to catch the wind better. His most popular "brands" of can planes are Coke and Budweiser. A folk artist in the truest sense, Mr. Jones says he has flown by plane only twice.

The good-humored crowd that gathers at Moon's (*opposite page*) calls itself the "Spit and Whittle Club." Dedicated to the gentle art of loafing, it's the sort of place where opinions about everything from hunting to world affairs flourish, and senior members receive the respect they deserve.

In restoring the turn-of-the-century architecture to Main Street, Van Buren has reclaimed its historic heritage. Anyone who mistakenly assumes that the town is merely a pretty "historic recreation" is in for some flak. Residents and merchants are quick to point out that their town is a working community, one that sticks together. It's a place where many merchants live on their premises; they call this "living on the street." As one restaurant owner told me: "If I run out of sugar packets, I can borrow a few from somebody on the street. Once when my young niece was visiting, the whole street looked after her. You don't get this in a big place."

The most important element in this hard-won heritage is the people, for without people there is no commerce, and, more importantly, no spirit.

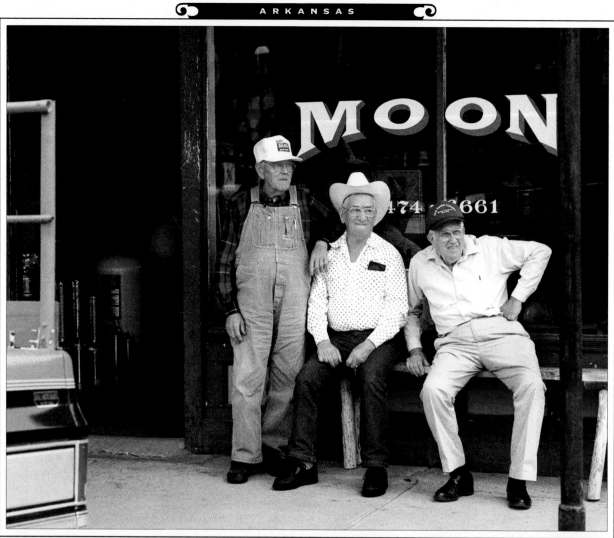

The authentic Civil War ironwork on buildings such as this one (*opposite page*) became part of the scenery when *The Blue and the Grey* was filmed in Van Buren.

In a time-honored tradition, many downtown merchants live in the same buildings where they have their businesses. This puts parking spaces at a premium, and vehicles are left to scramble for spots in alleyways and open lots (*above, left; and below, left*).

Forrest Ball, who with his brother Brian owns Rockabilly Music off Main (*above*), painted this sign six years ago as a replica two times the size of a 6120 Gretsch guitar, a model Chet Atkins played. This sign harks back to the pictorial signage of the past.

GRASS VALLEY CALIFORNIA

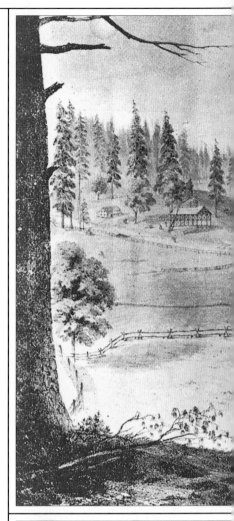

Following my own self-styled migration across the country, I reached the far Western frontier, the goal of so many before me. My scouting trip to the north of San Francisco through California wine country, then farther inland toward gold country, in a friend's reliable little car, stood in sharp contrast to the area's pioneering history. Occasionally, I was slowed to a crawl for miles of treacherous loops and curls by a lumber truck or a battered van.

For several hundred miles of my journey, Grass Valley had existed for me as only a small notation on my road map, a suggested stop by my California friend and still just one dot among many. Located in the Sierra Nevada foothills, approximately sixty miles northeast of Sacramento, it's one of the fastest growing communities on historic California State Highway 49. As soon as I looped off the freeway into downtown, the town started to click for me.

In 1845, when the term "Manifest Destiny" was coined by an editor of *New York Morning News*, there was a real nationalized feeling that expansion of the young country from its Atlantic coast border all the way to the still-foreign-controlled Pacific coast was imperative—in fact, it was destined. At the farthest end of this western land mass lay the coastal province of California, where complicated local politics were hampering governance by distant Mexicans. As early as 1805, the Spanish had fears of America's ambitions for their province. American overland migration began in earnest by 1840, and by 1845 there were approximately 700 Americans settled in the provinces.

It's not a huge place, Grass Valley: the heart of the town composed of just a hilly Main Street crossed by Mill and again by Auburn, the two vital secondary streets. The presence of mining as big business and big money in the 1870s contributed to the

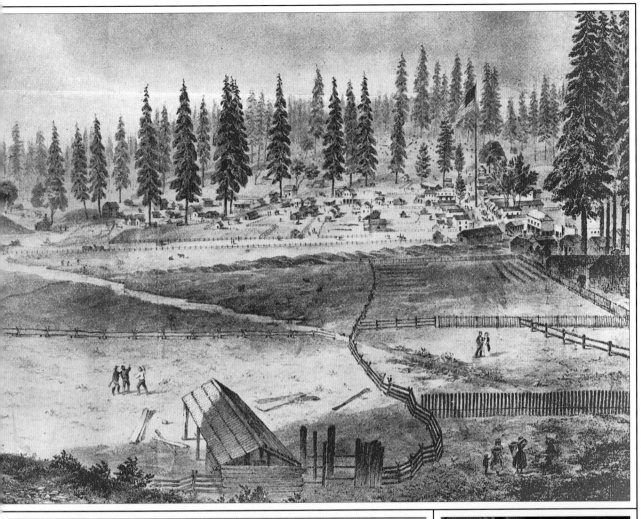

Early immigrants stopping to rest in the area off the Truckee Route are said to have found their cattle wandering off to graze in grassy pastureland, hence the name Grass Valley, shown during its early days in a bird's-eye view drawing (*previous pages, top*). At the time that gold-bearing quartz was discovered on Gold Hill in 1850, there were only 15 cabins in the town; the town hotel was a log structure built in September of that year. Less than a year later, the town contained approximately 150 buildings, including several hotels, stores, and saloons.

Larry Moore's Cafe on Mill Street (*previous pages, bottom left*) announces itself boldly during a 1930s blizzard.

A stretch of buildings along Main Street (*previous pages, bottom center*) remains much the same as it was in the nineteenth century.

This miner is always a crowd pleaser during the annual Fourth of July parade (*previous pages, bottom right*).

They even looked for gold on Main Street! In 1874, citizens dug through the waste rock that was used to pave the street (*opposite page*), which glittered with flecks of gold.

overall look of downtown, and typical late-nineteenth-century brick commercial buildings remain as testimony to its influence. Whereas the trees on Main Streets in the East often break the straight lines of building facades, the canopied sidewalks—also referred to as "balconies" by some and "wooden awnings" by others—do this in Grass Valley, giving the streets a certain frontier-style appeal. The recurrent use of iron shutters and masonry are characteristic of what is known as the area's "Mother Lode" architecture.

Thanks to the diverse backgrounds of the early miners and settlers, regional influences abound in Grass Valley. The many iron railings and porch balconies echo those in the southern United States. Other buildings are said to closely resemble structures in Cornwall, England, the original home of a large group of immigrant Cornish miners. The Victorian-era business buildings and fine Victorian homes indicate prosperity above and beyond the gold rush. Although the buildings also include a few contemporary civic archetypes—such as an impressive 1917 bank building and a 1916 Carnegie-Grant library—the town has never suffered from inept modernization. It has, somehow, maintained its unique sense of place.

It's hard to say how I found myself on the doorstep of the Holbrooke Hotel; perhaps it's the fact that this proud hotel, with its vernacular "Mother Lode" architecture, takes up the better part of a block. Or perhaps it's the Holbrooke's 114-year tradition of being at the center of activity. For weddings, banquets, reunions, honeymoons—or for simpler pleasures—people have been gathering at this grand hotel since Grass Valley's early days. It combines Western elegance and down-home friendliness with more than a touch of class. The guest book in the hallway has been signed by distinguished guests from President Grant to Black Bart. That was enough for me! I took a room for the night—the Mark Twain suite, which has a balcony overlooking Main Street—and settled in.

It's said that the bustling activity of today's downtown Grass Valley is truly more in keeping with the gold rush period than the feeling one gets when visiting a ghost town. From my balcony, I had a great view of this lively valley town surrounded by pine-covered hills. It was easy to picture the gold-hungry miners of Grass Valley's past setting out for the nearby countryside. A line from an 1875 paper shouted: "This town has plenty of gold right under it," which is no exaggeration. A network of 300 miles of tunnels ran beneath the busy streets and stores, and miners industriously dug and delved for the precious metal. Today, this gold-bearing network still exists, its riches

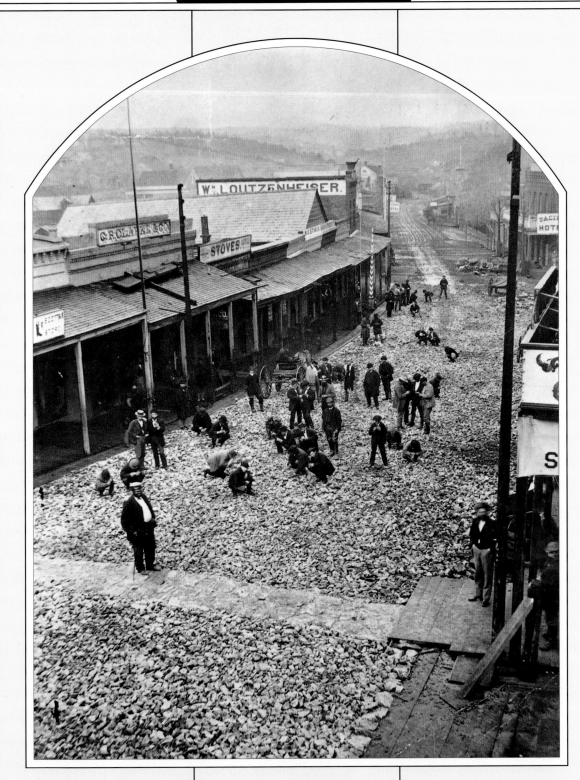

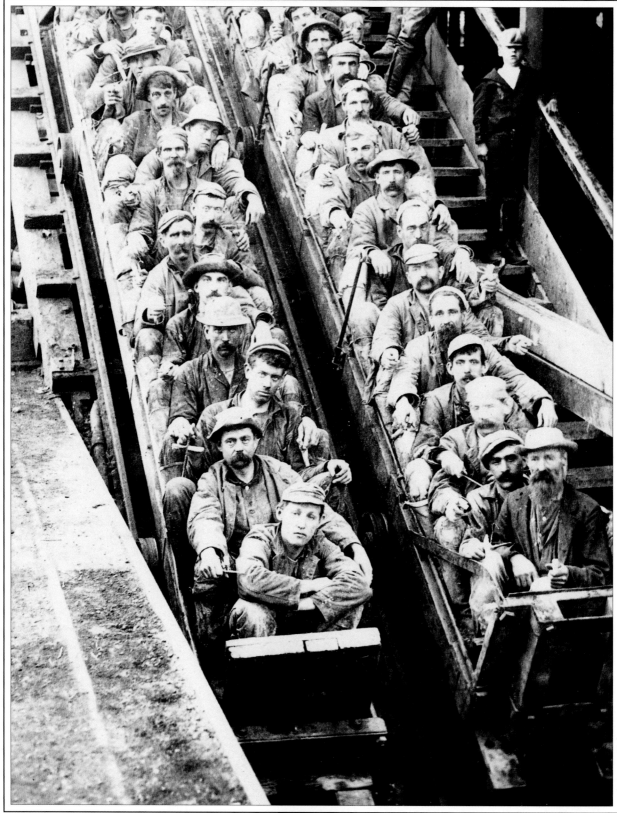

no longer mined and its heyday part of a glorious memory.

California was not yet a state when gold was discovered. In January of 1848, worker James Marshall spotted a glitter at the site of John Sutter's sawmill on The America River in Coloma. The rush was on! One source estimates that more than 500 gold rush towns were built in the years between 1848 and 1860 in the California Territory. At its peak, some 120,000 miners charged the California foothills looking for gold. The wild rush of excitement is described in a 1911 *Encyclopaedia Britannica:* "Settlements were completely deserted; homes, farms, and stores abandoned. Ships that were deserted by their sailors crowded the Bay at San Francisco; soldiers deserted wholesale, churches were emptied, town councils ceased to sit; merchants, clerks, lawyers and judges and criminals—everybody flocked to the foothills."

The second great discovery of gold was right in Grass Valley in 1850. A prospector at the edge of the Boston Ravine accidentally stumbled upon a shiny rock outcropping loaded with gold. That event precipitated a rush to Grass Valley and the beginning of hard-rock gold mining.

Many sought wealth only, unconcerned with any form of social order. There was little or no home life then, with women, the "civilizing influence," accounting for only 2 percent of the population. Disenfranchised from family life and growing chaotically as a result of the speculative nature of gold ventures, towns like Grass Valley appeared to be on a collision course. It was years before official governance—lynch laws, popular courts, vigilance committees—brought order to the area.

From its early days as a campsite with a tent store and 15 cabins, Grass Valley grew at a fast pace. The discovery of gold-

This graphic photograph offers a compelling look at the miners whose industry put Grass Valley on the map (*opposite page*). They pose in a manskip, a ladderlike structure that lowered 11 to 12 men at a time into the mine shaft. A vast network of more than 300 miles of mining tunnels was dug beneath the town.

By the 1890s, a horde of skilled Cornish miners had settled in Grass Valley to work in the mines. The frequently heard term "Cousin Jack" is derived from the Cornish immigrant's loyalty to fellow countrymen: "Do you have a job for my cousin Jack?"

In a grand gesture, Grass Valley announces its presence on the exterior rear wall of the Del Oro theater (*above, left*).

Mining artifacts, such as this ore car at the corner of Main and Auburn (*above, right*), are constant reminders throughout the downtown of Grass Valley's history.

The southwest corner of Main and Mill (*above*) is seen again and again in old and new photographs of the town. The corner building is Grass Valley's oldest—and first brick—building.

bearing quartz at Gold Hill in October of 1850 hastened the boom. In five years' time, Grass Valley accumulated 300 buildings, only to have them wiped out by the fire of 1855. A more cautious and perhaps better-grounded citizenry rapidly rebuilt businesses and homes with fire-resistance in mind.

As I pored over historical photographs from the town's archives, I kept seeing the same wonderful shot in newspaper articles and promotional brochures: it's of a group of people in 1874 looking for gold on Main Street. At first, I was not sure I was seeing it correctly. Perhaps the shot is just a trick. Then I learned that waste rocks, or tailings, from the mines were used to pave the streets, causing them to glitter in the sun. The streets were literally paved with gold! I was intent on finding a good print of that shot, preferably from the original negative—often an impossible dream. So before my second visit, I wanted to track down Richard Briggs, who is said to have a sizable collection of historical photographs.

Grass Valley is the kind of place where people leave their doors unlocked and their car keys in the ignition, keep up with old friends from high school, and know a string of local phone numbers by heart. I found Rich Briggs through one of his high school buddies.

Rich Briggs appears to have resisted urban stress. A souvenir that hangs from the rear view mirror of his van says: I REFUSE TO GROW UP! But by his own admission, he's willingly growing into early middle age. I attribute part of his youthfulness to the fact that he lives in a hilly and rustic outlying area and takes time to enjoy the benefits of a community like Grass Valley. Weeks before, when I called from New York to schedule "an appointment," Rich casually said, "Just give a call when you get in."

When we met, Rich pulled out the contents of every single file drawer in his basement office and, together, we looked through the many photographs he inherited when he became the owner of a photography business on Main Street. These photos, Rich told me, were passed down from the original owner—a man who went by the name of Maurice and took the shots that predate the mid-1940s—to the next owner, Tyler McHugh, the photographer of all the later photos in this collection.

As we sorted through this wealth of pictorial history, Rich's wife, Jane, was upstairs putting the finishing touches on the Annie Oakley costume that their teenage daughter would wear in the Fourth of July parade the next day. Among other things, we came upon an envelope of 5 × 7 negatives depicting the 1943 Fourth of July parade, negatives that Rich had not laid eyes on for years. When we held one negative up to the light, we could

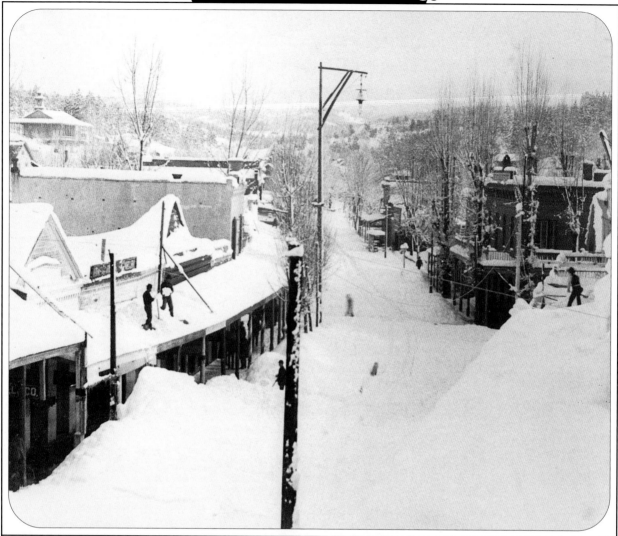

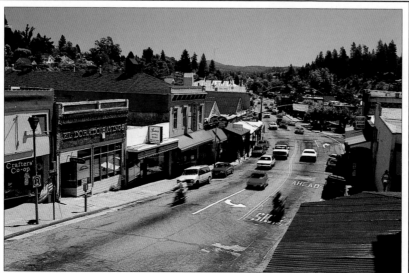

A heavy snowfall on building roofs often caused them to cave in. The 1890 snowstorm (*above*) found men shoveling to save their Main Street businesses and residences.

A view down Main Street today (*left*) shows businesses occupying the same sites and buildings where Grass Valley commerce and entertainment flourished in the late 1800s.

When Daniel and Ellen Holbrooke purchased the 1862 Exchange Hotel building in 1879, they advertised "a new, commodious first class hotel . . . with new furniture . . . situated in one of the finest climates and mountain towns in California."

The Holbrooke Hotel building—on the site where an 1851 wood-frame building existed until the fire of 1855—was built in 1862 to be fortified against fire in

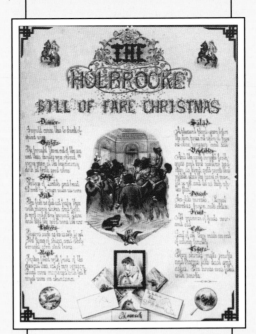

what has come to be called "Mother Lode" architecture, including heavy iron doors, abundant brick and/or masonry, and a foot-thick layer of dirt or broken bricks on the roof.

A Christmas bill of fare testifies to the graceful style of the Holbrooke Hotel, a focal point of the art community, attracting writers such as Mark Twain, dancer Lotta Crabtree, and internationally renowned actress-dancer Lola Montez.

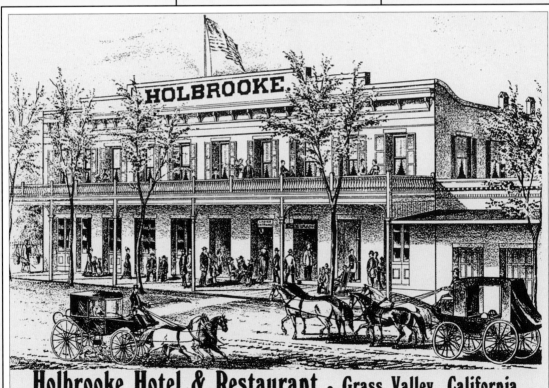

Holbrooke Hotel & Restaurant · Grass Valley, California

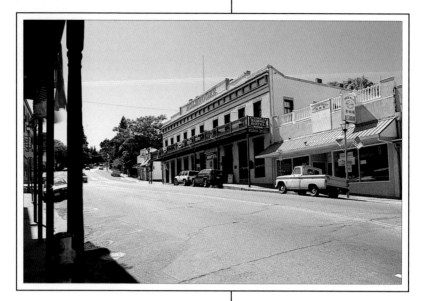

make out a group of Chinese girls from Grass Valley's old "Chinatown" on their own float. Rich no longer has a darkroom set up, so I packed up all the parade negatives to take back to New York—my unexpected treasure! Last but not least, we found a contact print of the celebrated Main Street gold-digging scene.

My search for historical photographs next took me to the Searls Historical Library, located in a charming small building in nearby Nevada City that looks as though it could be on a historic house tour. When I arrived for my appointment, I found a note tacked to the door from Edward Tyson, the historian in charge: *Back in twenty minutes.* Considering the number of years that Ed Tyson has served the community in this capacity, I felt I could allow him a mere twenty minutes.

From the shady porch, I soon spotted Ed Tyson trudging up the steep hill to the museum, waving a handful of papers in welcome. After he unlocked the door, I was greeted by two modest rooms crammed floor to ceiling and wall to wall with books, papers, and photographs. In typical fashion, the one or two dedicated people who work here wear many hats and handle the jobs of a dozen. Ed Tyson was soon helping me, a grateful genealogist who had just unearthed an ancestor's death certificate, a local history writer who collects vintage photography, and the various other folks who "just stopped by to say hello." Soon the congenial group was chatting up a storm while Ed Tyson, the proverbial one-armed paperhanger, dealt with our individual requests as well as a ringing phone that wouldn't quit. I had a feeling that this was a typical day, and that Ed Tyson wouldn't have it any other way. I left with yet another print of the town's treasured image of gold on Main Street, plus a stack of other gems.

At eighty-four, Don Hutchinson (*above, left*) says he "walks a mile to town three hundred and sixty-five days a year." I spotted him early one morning on a sunny bench in front of the Holbrooke "thawing out." After a brief chat, he rose and said, "Gotta get the stage now." Wondering if this could be a reminiscence of his early days in the West, I watched as Don Hutchinson crossed Main Street. In short order, the Gold Country Stage, the local shuttle bus, stopped for him. Don Hutchinson did indeed have a stage to catch.

Today, the Holbrooke Hotel (*above*) has been brought back to its former elegance after a lengthy process of exterior and interior renovation. The ensuing work included facade and balcony restoration, new sewer and water lines, electrical wiring, and street improvements—in short, a major overhaul.

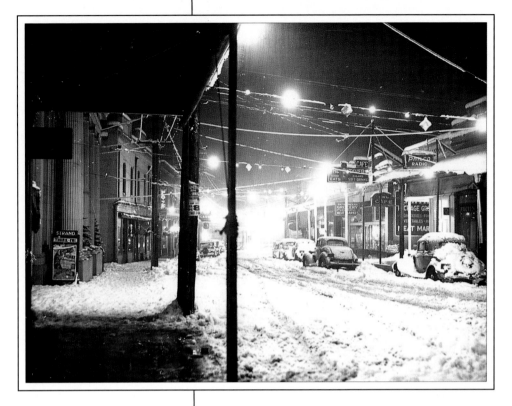

Sidewalks covered by wooden balconies (*above*) protected merchandise and shoppers from the blazing sun, the blowing rain, and the winter snowstorms.

Wooden sidewalk covers (*opposite*) still offer protection and give the street a distinctive appearance. Their presence alters the line of the building facades and influences the use of signage.

While Grass Valley did not go boom and then bust like so many other gold rush towns, and while the boom period matured into a long-term industry, the town's economy did suffer some interruptions in its prosperity. A lack of knowledge about techniques and equipment for dealing with the twisted lodes beneath the surface is said to have frustrated many miners and mine owners alike. The Cornish miners who arrived in town in the 1860s, however, brought with them their expertise in the art of deep mining. These Cornish workers, called "Cousin Jacks" and "Cousin Jennies," continued to flow into Grass Valley for decades thereafter. An editor for the Grass Valley *Union* in around 1910 had this to say: "It then almost seemed that I had stepped into an unknown foreign country. Fully three-fourths of the people were of Cornish birth or descent."

Suppliers and other peripheral businesses set up shop in Grass Valley to support the mining industry, establishing the town as a commercial center for western Nevada County and bringing a continuing vitality to Main Street. The area's big mines included the Empire, North Star, Golden Center, Pennsylvania, and the Idaho-Maryland.

The Empire Mine operated for 106 years—from 1850 to 1956. Today the Empire State Historic Park helps the visiting public understand the history of hard-rock mining. Despite the cessation

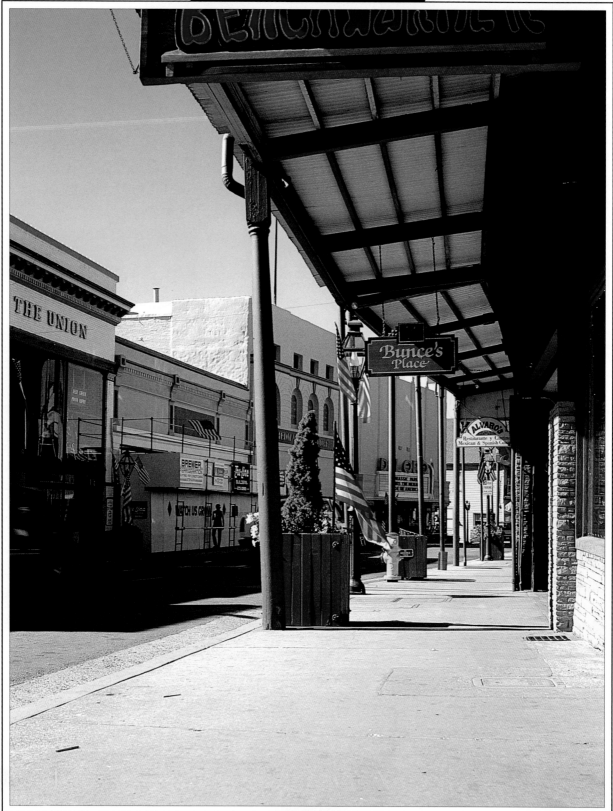

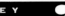

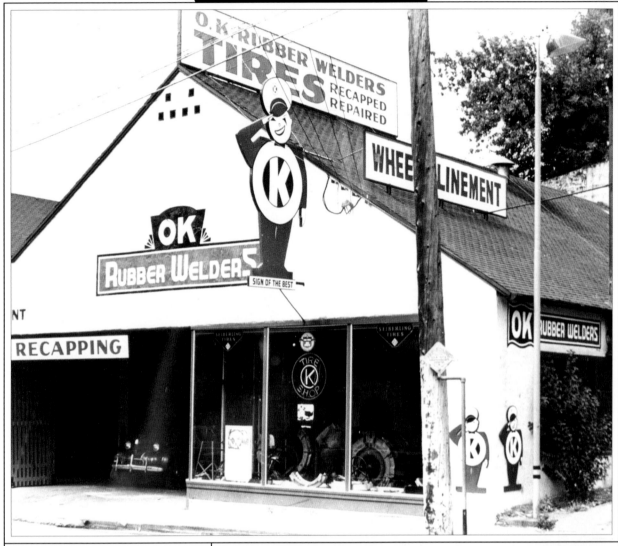

An old Packard sign (*right*) brings back memories of a time when the automobile was used for touring, and roads outside Grass Valley were a playground for drivers and passengers alike.

A car-crazy population meant steady business for garages and automobile service businesses in Grass Valley (*above*).

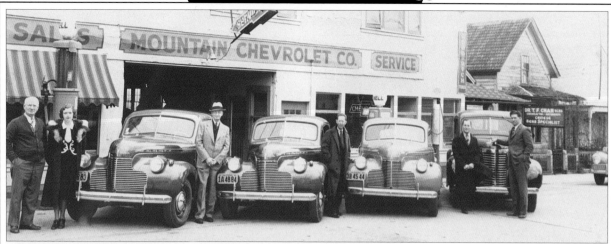

As travel patterns changed, livery stables began to give way to gas stations and car dealerships. Two hotels lost their positions at the busy corner of South Auburn and Main and filling stations took their place. Car dealerships such as this one (*above*) became highly visible on Main Street.

The Western Auto Supply store (*below, left*) was a once-thriving town business.

Main Street sale! And the dealerships are still located along the same stretch (*left*).

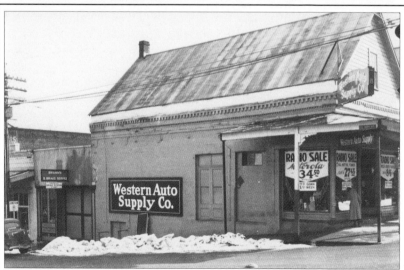

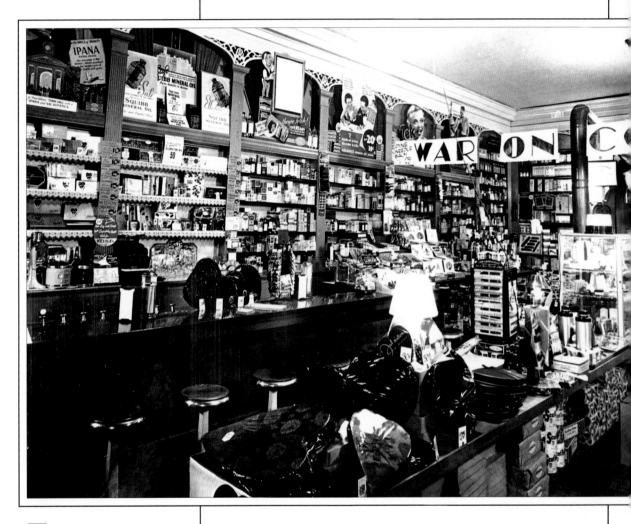

The exuberant display of goods at the 1947 grand opening of the new Auburn Street location of Grass Valley Drug indicates that it is winter, with its "War on Colds" banner and its heart-shaped boxes for Valentine's Day. There seems hardly an inch of space left on wall or counter.

of the mining industry as a strong presence, Grass Valley is still a fully functioning community whose mining tradition serves as its proud backdrop. In spirit, it has not forsaken the romance of the gold rush days.

Grass Valley could never be accused of not respecting its elders. If anything, it goes out of its way to preserve their memories. "Looking Back in Time" is a series of radio interviews with seniors, tapes of which KNCO "Two-Way Radio" host Carol Scofield dropped off at my hotel. As part of a special show celebrating the one hundredth birthday of the incorporation of Grass Valley, Carol interviewed people who grew up in the area, including her mother-in-law. I popped the cassette into my Walkman and listened as Vivian Scofield recounted her memories of the Depression, when men who hitched rides on the railroad invariably wound up looking for breakfast at her family's front door. "My mother was such a good-hearted person," she said, "that she'd

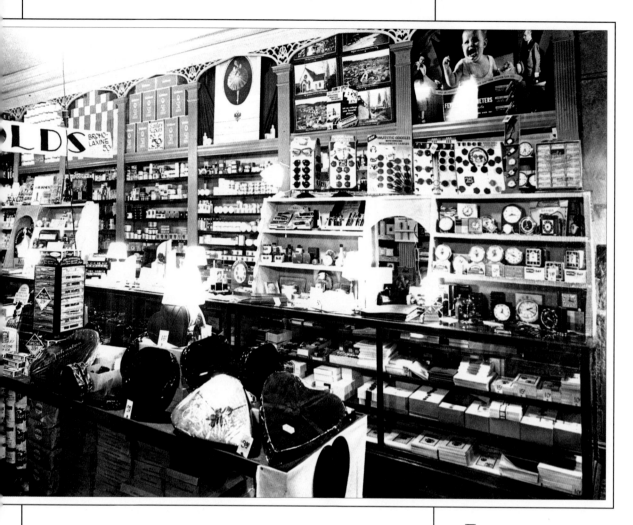

fix them up a real nice breakfast and they'd eat outside. And one day . . . someone said, 'Why, they've probably got a mark around your house so they know where to come.' So we went down and looked all around our fence, and we did find a mark which we erased off, and then my mother didn't have many more for breakfast."

In another interview, Hanabelle Daley, fourth-generation Grass Valley native, remembers the great joys of going to town: "Years ago, everybody went to town on Saturday night. The elderly women would sit in their cars. You knew everyone and you'd go and visit with them. All the older ones who couldn't get out of their cars . . . everybody would go and visit with them. It used to be so nice. The Salvation Army band played. And when Penney's was here, you'd do all your shopping on Saturday night."

One senior remembers that the newspaper occupied a building

In April of 1993, Grass Valley Drug, in business for more than 100 years, closed its doors and moved its services into nearby K-Mart.

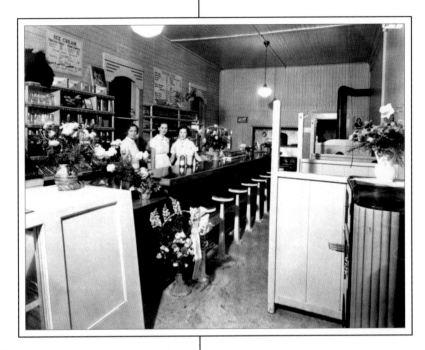

Local resident Jack Clark was able to trace ads for the Golden Poppy luncheonette (*above*) back to 1931. When the dance area in the back was remodeled in 1936 and lined with knotty pine, the name was changed to the Knotty Poppy. Jack remembers the soda fountain in the front, where Ernie Hocking sold his own homemade ice cream, and the jukebox in the back, where students from both Nevada City and Grass Valley would meet and dance. Jack has fond memories of the place; perhaps because it's where he met Emily, his wife. Sometime after 1950, the owners changed the Knotty Poppy into a gift shop named Tess's.

Today, Johnnie's Restaurant and Donuts (*above, right*) offers an authentic diner atmosphere in the heart of downtown.

on Main Street and "when they used to get AP releases by telegraph, they'd read them off the balcony and solicit subscriptions at the same time. It was the only fresh information on the coast, read off verbatim." Another senior talks about the typical payment for a house in town back then: "$500 gold in hand" written right on the deed. One of my favorite comments came from a senior who remembered how they used to play Kick the Can and Paper Chase on Main Street: "Now you'd get picked up for littering."

One senior I interviewed made the comment that "Television takes everybody's time." But on the Fourth of July in downtown Grass Valley, it's hard to believe that anyone would be home watching TV. At 7:30 A.M., I found a woman already staking out a spot on the corner of Main and Mill with an aluminum beach chair. It's the prime spot, where many of the pranks and much of the folly take place, where the horses are given a wide berth for showing off, where the old-time firemen give the crowd a good squirt. I could see that the parking lot at the foot of Main—once the site of a hotel from early mining days—was already filling up. A spirited, fun-loving community turned out in force, welcoming strangers into its midst. I was offered a place on the judge's platform and ice-cold sodas from big coolers to curb the effects of the blazing sun. When the parade was in high gear, I couldn't imagine being anyplace else.

The spire of the Del Oro theater, a landmark that can't be missed at the curve of Mill Street, punctuates the horizontal two-story lines of the street.

Glass slides containing advertising for Kramm the Jeweler—a Mill Street store that closed in 1944—were projected on the screen of the Del Oro before the feature and during inter-

mission. Today, the fragile hand-painted 3 1/2-inch glass slides are considered cherished collector's items. These and dozens like them are housed in Grass Valley's new Video & Pictorial History Library, where director Ron Sturgell has edited literally miles of early film depicting life in Grass Valley for viewing on video.

The Fourth of July parade has long been held on alternate years in neighboring Nevada City. Shots from a 1943 parade include a pagoda-style float of Chinese immigrant children from the town's "Chinatown" and the ever-present Miners Protective League float (*top row, far left and right*).

The Golden Gate Saloon (*top row, center*) in the Holbrooke Hotel, said to be the longest continually operating bar west of the Mississippi, has been at this site since 1852. On this day, the bar was decked out for the Fourth of July.

In 1923, Helen Vincent wore a big bow in her hair when she rode on the Volunteer Fire Department float (*opposite, bottom right*). Today she is Helen Williams, owner of Williams Stationery, in business since 1949.

Grass Valley commemorated the centennial of its city charter during the Fourth of July in 1993 in a sweeping celebration that rocked the town. The replica of a giant cake (*opposite, center right*), the original of which had been made up of seventy-two sheet cakes and baked by members of the community for an earlier (March 13th) celebration of the exact date of the charter's signing, traveled down the Fourth of July parade route on its own "Happy Birthday, Grass Valley" float. Uncle Sam (*opposite, center left*) led the way.

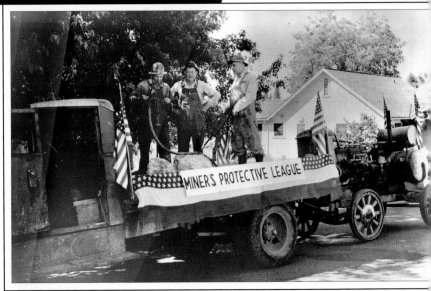

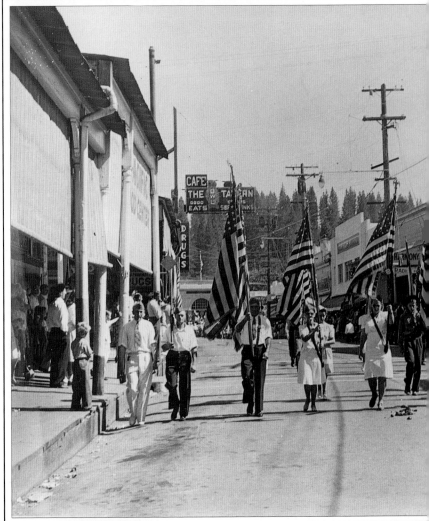

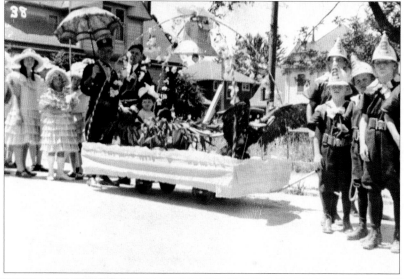

An anonymous photographer has captured the well-dressed citizenry of Grass Valley at the turn of the century during a day of leisure and celebration. In this view down Mill Street from Main, flags decorate many of the buildings, offering some clue to the event. The camera's long exposure time has added an element of grace and movement to this pleasing shot.

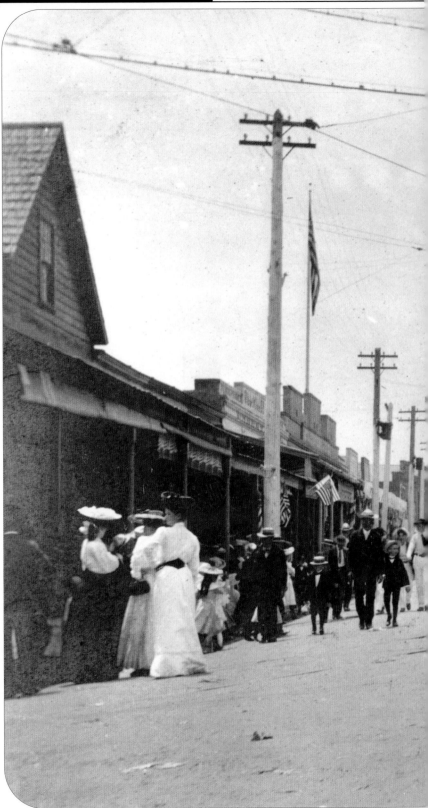

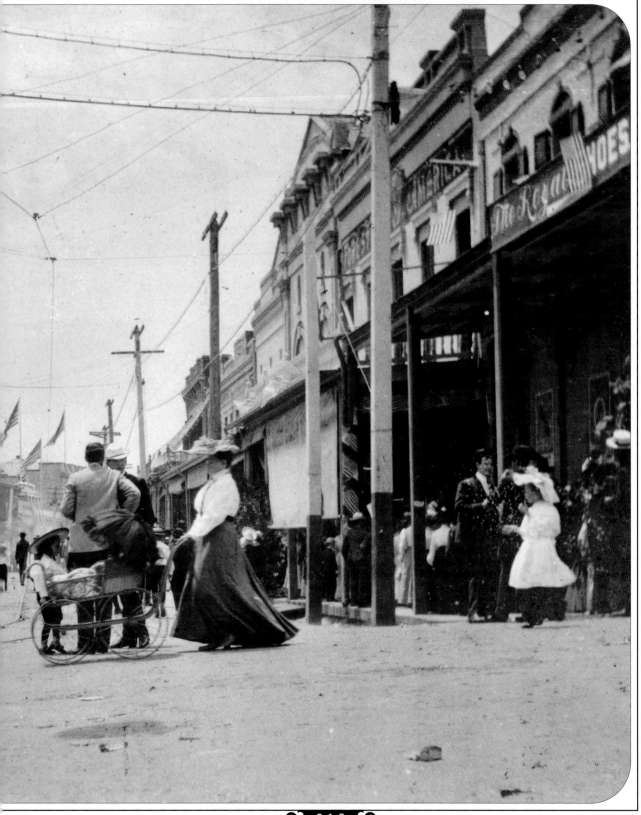

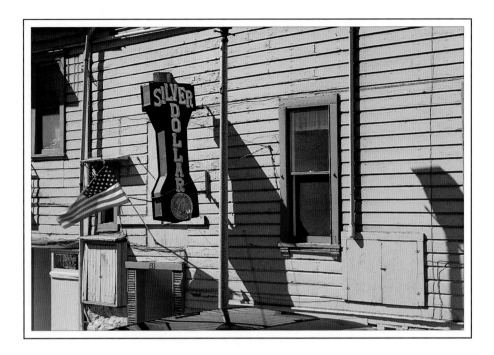

Humble Beginnings

There's no computer program that prints out a balanced list of ten towns for a book on Main Street America. Even if there were, the possible combinations would be daunting, and the benefits of the search would be diminished.

In October of 1991, I dug out my Christmas card list and began sending inquiry letters disguised as Christmas cards to friends and acquaintances. Many grew up in small towns; some still live there. Others inevitably had an emotional connection to small-town life—through their grandparents' hometown, their camp town, their favorite ski resort in some country village . . . I knew this was just scratching the surface, but personal networking was a place to start. Soon the phone began to ring; I ran out of places to put all the Christmas cards that came back with enthusiastic, supportive, and, yes, helpful letters, making me realize that everyone has his or her own picture of Main Street. It can mean a winding road through a hamlet in Vermont or a busy thoroughfare through a suburb of Cleveland.

Having the cooperation of an involved histori-cal society, Chamber of Commerce, preservation group, or Main Street program in any town soon became an essential prerequisite. Towns sent brochures, booklets, pamphlets, maps, posters, postcards, photographs, videos. One sent the local phone book. Printed material soon spilled out of cardboard cartons in my office. We even mailed out a disposable panoramic camera with a self-addressed and stamped return mailer to anyone who'd snap a few pictures for us. Towns whose archives were complete enough to offer a lively documentation of Main Street's history, progress, evolution, and change were essential to enrich these pages.

Then I read everything I could get my hands on in a struggle to define the population parameters for the other towns in the book. After the first few scouting trips, I realized that I lost that small-town familiarity in towns of more than certain population. Finally, I decided that when I could no longer walk the length of Main Street comfortably with my heavy camera bag, then the town was too big. My criterion was not just a number; it was also a feeling.

I always made a few friends by phone before my first visit to any community. But as Charles Kuralt says in his *A Life on the Road*, "when I finally shook off the tempo of daily journalism and fell into the rhythms of the countryside, I didn't have to worry about finding stories any longer. They found me."

Most of the accounts of travels through Main Street America have been written by men, who seem content to throw a few things in a duffel bag, a six-pack in a cooler, and take off cross-country in a battered pickup truck, generally one that breaks down with some regularity. This means they get to hang out at gas stations and body shops all across America—places where most women still feel like aliens. Some of the resulting accounts are warm, humorous, and casual; some are solemn chronicles of self-discovery. I have enjoyed both. But their way was not my way.

When I headed out to explore small-town America, my choice of travel was fly-and-drive. Camping off some unmarked road or wheeling around hairpin mountain turns in an RV may be a joy to many but it was not for me. I chalked up frequent-flyer miles and checked into a local bed-and-breakfast if one existed. If not, I learned to appreciate the down-home basics of budget motels along the highway. Their showers suited me better than a dip in an icy stream.

This is not to say, traveling as I did in this less-than-rugged way, that I didn't have a chance to see the country. On a three-week trip through Colorado, Wyoming, and Montana, I put more than 2,000 miles on a rented mid-size sedan. (Of course, this isn't hard to do in Montana, where eighty's the slow lane.) In other states I visited, the towns were rarely so far apart. I pulled off the superhighways as soon as possible and wound through the back roads that used to be the only route into town.

I'm no stranger to back country roads. I learned to drive on dirt roads outside Chestertown, Maryland. Back then the law required a road test in a stick-shift vehicle. So as soon as I turned sixteen, I got my driver's license in a pickup borrowed from my father's business. Chances are I could still raise some dust in a pickup on a back country road. Although I've lived in a city all my adult life, my childhood roots are firmly planted in rural America. I've never needed an excuse to flee the fast lane of cosmopolitan living, at least temporarily. Whether it's a classic New England village prim and fair, or some hurly-burly Western town decked out in neon, I'm at home.

At the time I undertook *Remembering Main Street*, I assumed that a professional photographer would do the photography. Then I tried to work out a plan and a budget for an entourage of people to travel America. My requirements went something like this: WANTED: *Photographer willing to hunker down in small towns for two years, national holidays included, sometimes on short notice. Accommodations from humble to charming, food from home-style to haute. Good people, interesting places, rewarding work. Satisfaction guaranteed.*

Why don't *you* do it?" suggested my daughter, Erica, one day as I struggled with the logistics and practicality of such a plan. A number of years ago, I had dusted off my old camera, a 35-millimeter Minolta, and loaned it to Erica for a high school photography course, wondering if I would ever again have the time or the energy to give to photography.

The idea of doing the contemporary photography for the book continued to pull at my sleeve. A few months later, I devised my own crash course in color photography, hired a coach, and bought two new cameras and a variety of lenses. My new medium-format Pentax 645 is well suited to landscape and architecture. My 35-millimeter Contax is lighter and faster than the Pentax, essential for more spontaneous work. At first, I felt conspicuous setting up my tripod in the middle of town. But as the flow of work fell into a more natural rhythm, I began to feel comfortable in my new role.

In the beginning, I traveled alone for much of the book, staying in towns for anywhere from several days to a week, often returning many times over. Then, mid-project, I was suddenly overwhelmed by the prospect of locating the historical photographs, taking new shots, doing the interviews, and tracking down research material as well. Enter Leisa Crane.

Leisa and I have worked together on the research aspects of most of my books. A graduate of Columbia University's School of Library Science, Leisa has the fine-tuned research skills needed for a project of this magnitude and duration. She's also an avid traveler whose meticulous attention to detail makes her an excellent tour guide. From the project's inception, Leisa had been doing back-

ground research. Later, I needed her active involvement as well as her good company. As a result she traveled with me to eight of the ten towns in this book on at least one of my visits there.

The search for historical photographs to include in this book warrants a special—and more personal—comment, not only because of the book's visual concept, but also because of the uncommon challenge it posed. Assuming that I would simply request the town's archives from the local historical society, I was in for a few surprises when the search for historical photography often turned into an endless scavenger hunt! It was a hunt that often stumped both Leisa and me, but always enriched us as we met the many photographic gatekeepers and scrapbook-tenders across America.

Starting with a town's local historical society or Chamber of Commerce, the hunt fanned out in every conceivable direction. As we collected any illustrated information we could lay our hands on—centennial publications, local histories, brochures, advertising, and even restaurant menus—our wish list of photographs grew to huge proportions. While the Library of Congress and other national repositories, state historical societies among them, would gladly search their files for us, the best possible source for the bulk of any town's photography was always the town itself. And every town was different. In many cases, the local historical society kept its collection under lock and key. We often found we needed an appointment and an escort to gain access to it.

On one of the hottest days of the summer of 1993, James Parrish of the Great Barrington Historical Commission picked up a key from the front desk of the Housatonic Public Library and led me two flights up to a small auditorium in a fine old building, lacking the comfort of air conditioning in true nineteenth-century fashion. As James and I went through a very impressive permanent collection, I gazed longingly at yet another collection in the process of being sorted and cataloged—an overwhelming number of photographs and negatives recently donated and still sitting in packing boxes. Unfortunately, I was about a year too early. Eventually I learned to appreciate the fine catch in my net and to resist lamenting the one that got away.

On a chilly fall morning, Nancy Nunn managed to fit me into her busy schedule as historian of the Historical Society of Kent County in Chester-

town, Maryland. I climbed the central stairway to the society's third-floor office at the handsome landmark Piper Geddes House, where volunteers have been engaged in an ambitious program to organize and catalog the Reed Collection, containing many years of photography from the *Kent County News*. I sat on the floor—grateful for a space heater nearby—and thumbed through boxes of as-yet-uncataloged photographs. I actually found several photographs of my parents posing with local civic groups. How young they looked! Then I realized that they *were* young—younger than I am today. I started searching for a shot of myself, proof that I, too, made a small dent in town history—my Brownie troop, my 4-H Club—and came away with a memory or two. It's a curious feeling to discover your own life in an archive!

A town like Oberlin, Ohio, offers a relief from historic uncertainty in the area of early photographic images. The Oberlin College Archives houses carefully indexed and meticulously documented photographs of the town. Leisa and I found most of the Oberlin photographs by just sitting at a library table and filling out request forms; nearly all of the historic shots used in the Oberlin chapter were preserved there.

In Van Buren, Arkansas, lacking any substantial single source for historical photography, we often convinced merchants to take framed photography of their walls so that we might make a copy. Saying you're a writer from New York either opens doors or politely and firmly shuts them. All those other writers who "borrowed" treasured photographs and documents, never to return them, frequently made my job more difficult. But when we were accompanied by Doug Gibson, our ally from the local photo shop, we took on sudden credibility. One morning we were able to do a quick sweep of the barber shop, the candy store, and several antique shops.

In tiny Wickford, Rhode Island, I worried when I learned that most of the town's archives had been wiped out by the indiscriminate destruction of two hurricanes. Then I met Tom Peirce—native, pillar of the community, and gatekeeper of the town's few remaining private archives. For nearly five hours I pored over photo albums, scrapbooks, a gigantic postcard album, and untold ephemera with Tom and his wife, Erma, at their dining-room table. Tom

Peirce shares a tradition with avid collectors of the Victorian era, who kept their hometown memorabilia safe in treasured albums.

Indeed, even today, efforts on the part of both individuals and groups account for a rapidly growing movement to preserve the photography, printed history, and memorabilia and ephemera of small towns across this country. Perhaps we have confronted the reality that pictorial representation of our town histories is disintegrating in damp basements, has been accidentally tossed into recycling bins, or has been mislabeled and thus is lost forever.

Some of the approximately 250 historical shots in *Remembering Main Street* were printed from the original negatives, usually film or celluloid. On occasion I was fortunate enough to find prints made from the original glass-plate negatives. More often, though, it was necessary to make a new negative from existing prints. Although it's most desirable to reproduce pictures from the first-generation, original print, many of the second-, third-, and even fourth-generation prints in this book retain amazing definition and clarity.

The bittersweet last word about the photographs concerns the anonymity of many of the early photographers. That their work has survived is the good news; that many of the chroniclers' names have not is regrettable. Whenever a photographer's name is known, however, I've provided credit, along with any other surviving information.

Over the course of the years I have been constantly surprised by the unexpected turns, the fortuitous encounters, and abiding good cheer—the sheer serendipity—that this book has brought me. My original view of Main Street was derived from a childhood memory. My adult view includes a greatly expanded panorama. The complex history of Main Street shows me that towns, like people, have the ability to shift, change, modify, and rally. The valiant histories of the towns have become metaphors for human survival. The countless stories of people, from the noble to the outlandish, have become the threads that bind together that crazy-quilt called Main Street America.

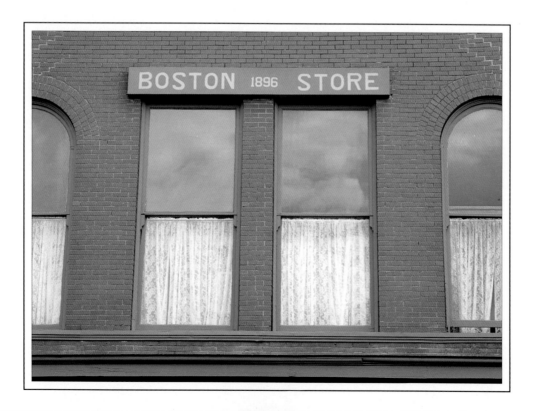

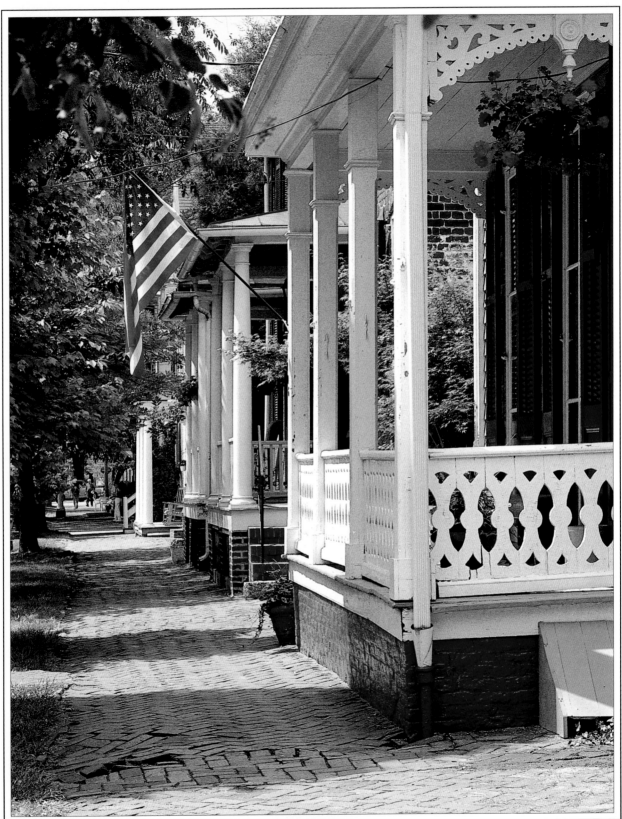

Gazetteer

CHESTERTOWN, MARYLAND

Population:
4000

Location:
On Maryland's Eastern Shore, on Maryland Route 213. An 80-mile drive across the Chesapeake Bay Bridge from Baltimore; approximately 2 hours from Washington, D.C.

Information:
Kent County Chamber of Commerce
1118 N. Cross Street
Chestertown, MD 21620
410-778-0416

Historical Society of Kent County
P.O. Box 665
Chestertown, MD 21620
410-778-3499

LEXINGTON, VIRGINIA

Population:
7000 (7500 when college is in session)

Location:
In the Shenandoah Valley of Central Virginia. Accessible by Interstate Highways 81 (North and South) and 64 (East and West). Or "you can wade in gently" by way of Route 11.

Information:
Historic Lexington Visitor Center
102 E. Washington Street
Lexington, VA 24450
703-463-3777

Lexington-Rockbridge County Chamber of Commerce
312 S. Main Street
Lexington, VA 24450
703-463-5375

GREAT BARRINGTON, MASSACHUSETTS

Population:
7000

Location:
In the foothills of the Berkshires, just minutes from Tanglewood. From New York City, proceed north on the Taconic State Parkway. From NJ, PA, and the south, take NY Route 22. From CT/NYC metro area, take Route 7 north.

Information:
Southern Berkshire Chamber of Commerce
362 Main Street
Great Barrington, MA 01230
413-528-1410

WICKFORD, RHODE ISLAND

Population:
circa 2000 (a part of greater North Kingstown)

Location:
South County region of the state. Off Route 95 N (the fast route); or state Routes 1 and 1A (the scenic routes)

Information:
North Kingstown Chamber of Commerce
245 Tower Hill Road
North Kingstown, RI 02852
401-295-5566

OBERLIN,
OHIO

Population:
8000

Location:
Thirty minutes' drive
northeast of Cleveland and
12 miles due south of Lake
Erie. Freeway accesses:
I-480; I-9; Ohio Turnpike

Information:
Oberlin Area Chamber of
 Commerce
20 East College Street
Oberlin, OH 44074
216-774-6262

CEDARBURG,
WISCONSIN

Population:
10,000

Location:
Approximately 17 miles
north of Milwaukee on I-4
North to exit 89; west
3 miles to Hwy. 57, then
north one mile to down-
town Cedarburg

Information:
Cedarburg Visitor
 Information Center
P.O. Box 204
Cedarburg City Hall
W63
N645 Washington Avenue
Cedarburg, WI 53012
414-377-9620

Cedarburg Cultural Center
W62 N546 Washington
Avenue
P.O. Box 84
Cedarburg, WI 53012
414-375-3676

SHERIDAN,
WYOMING

Population:
15,000

Location:
At the base of the Big Horn
Mountains in the NE section
of the state. Take I-29 from
the south; I-90 from the east
or west

Information:
Sheridan County Chamber
 of Commerce
P.O. Box 707
Sheridan, WY 82801
800-453-3650
307-672-2485

LIVINGSTON,
MONTANA

Population:
6700

Location:
50 miles north of Yellow-
stone National Park, located
at the crossroads of I-90 and
US Highway 89

Information:
Livingston Area Chamber of
 Commerce
Depot Center Baggage Room
212 West Park Street
Livingston, MT 59047
406-222-0850

Park County Museum
118 West Chinook
Livingston, MT 59047
406-222-3506

VAN BUREN,
ARKANSAS

Population:
15,000 (greater area)

Location:
The Arkansas Valley, in the
foothills of the Ozark Mou
tains at the state's western
edge on I-40

Information:
Van Buren Chamber of
 Commerce
P.O. Box 652
Van Buren, AR 72956
800-332-5889
501-474-2761

GRASS VALLEY,
CALIFORNIA

Population:
9000

Location:
In California's Sierra foot-
hills, approximately 60 miles
east of Sacramento in
Nevada County. Grass
Valley and Nevada City are
located 3 miles apart on
Hwy. 49

Information:
Grass Valley and Nevada
 County Chamber of
 Commerce
248 Mill Street
Grass Valley, CA 95945
916-273-4665

Recommended Reading

The research for this book led us to many scholarly, regional, and local references that are difficult to access and frequently out of print. This Recommended Reading section includes general sources, from fascinating chronicles to pictorial art books—the most interesting, useful, and memorable titles that we feel will hold the widest appeal. Most are currently available through local bookstores and public libraries.

Baeder, John. *Gas, Food and Lodging*. Abbeville Press, New York, 1982.

Crampton, Norman. *The 100 Best Small Towns in America*. Prentice Hall, New York, 1993.

Kuralt, Charles. *On the Road with Charles Kuralt*. Ballantine Books (paperback), New York, 1985. (And other books by Charles Kuralt).

Liebs, Chester H. *Main Street to Miracle Mile: American Roadside Architecture*. A New York Graphic Society Books/Little, Brown and Company, Boston, 1985.

Longstreth, Richard. *The Buildings of Main Street: A Guide to American Commercial Architecture*. The Preservation Press, Washington, D.C., 1987.

Malcolm, Andrew. *U.S. 1: America's Original Main Street*. St. Martin's Press, New York, 1991.

Moon, William Least Heat. *Blue Highways: A Journey into America*. Ballantine Books (paperback), New York, 1982.

Plowden, David, *Small Town America*. Harry N. Abrams, New York, 1994.

Reps, John W. *The Forgotten Frontier: Urban Planning in the American West Before 1890*. University of Missouri Press, Columbia, 1981.

Reps, John W. *The Making of Urban America*. Princeton University Press, Princeton, New Jersey, 1965.

Rifkind, Carole. *Main Street, The Face of Urban America*. Harper & Row, New York, 1977.

Sears, Stephen W., Belsky, Murray, and Tunstell, Douglas. *Hometown U.S.A.: America at the Turn of the Century*. Barnes & Noble Books, New York, 1975.

Wallis, Michael. *Route 66: the Mother Road*. St. Martin's Press, New York (paperback), 1990.

Index

Photo Credits

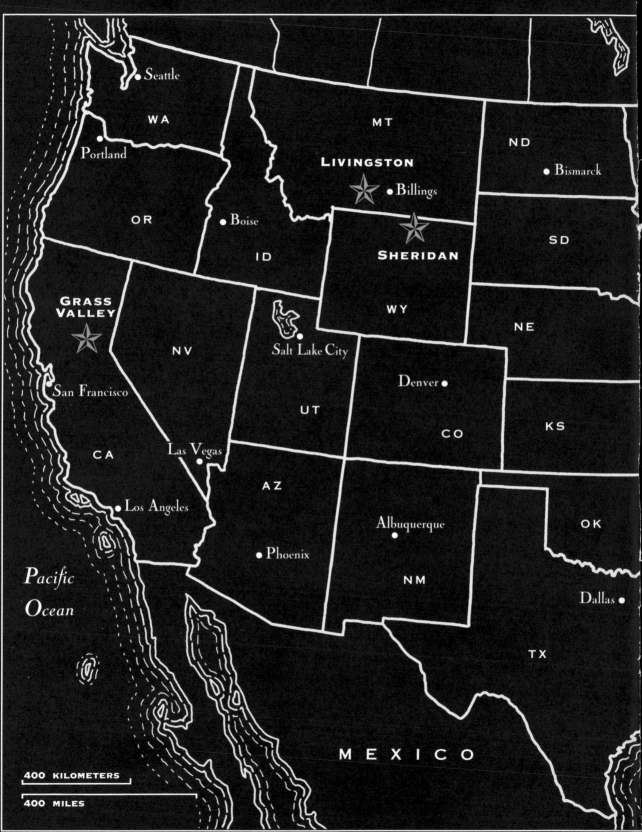